Through a series of case studies from the mid-eighteenth century to the start of the twenty-first, this collection of essays considers the historical insights that ethno/auto/biographical investigations into the lives of individuals, groups and interiors can offer design and architectural historians. Established scholars and emerging researchers shed light on the methodological issues that arise from the use of these sources to explore the history of the interior as a site in which everyday life is experienced and performed, and the ways in which contemporary architects and interior designers draw on personal and collective histories in their practice.

Historians and theorists working within a range of disciplinary contexts and historiographical traditions are turning to biography as means of exploring and accounting for social, cultural and material change – and this volume reflects that turn, representing the fields of architectural and design history, social history, literary history, creative writing and design practice. Topics include masters and servants in eighteenth-century English kitchens; the lost interiors of Oscar Wilde's 'House Beautiful'; Elsa Schiaparelli's Surrealist spaces; Jean Genet, outlaws, and the interiors of marginality; and architect Lina Bo Bardi's 'Glass House', São Paulo, Brazil.

Anne Massey is a Professor of Design at Middlesex University, London, UK, and is a design writer and researcher.

Penny Sparke is a Pro Vice-Chancellor (Research and Enterprise), a Professor of Design History and the Director of the Modern Interiors Research Centre at Kingston University, London, UK.

Biography, Identity and the Modern Interior

Edited by Anne Massey and Penny Sparke

Routledge
Taylor & Francis Group

LONDON AND NEW YORK

First published 2013 by Ashgate Publisher

2 Park Square, Milton Park, Abingdon, Oxfordshire OX14 4RN
711 Third Avenue, New York, NY 10017

Routledge is an imprint of the Taylor & Francis Group, an informa business

First issued in paperback 2018

British Library Cataloguing in Publication Data
A catalogue record for this book is available from the British Library.

The Library of Congress has cataloged the printed edition as follows:
Biography, identity and the modern interior / edited by Anne Massey and Penny Sparke.
 pages cm
 Includes bibliographical references and index.
 ISBN 978-1-4094-3944-8 (hardcover : alk. paper)
 1. Interior architecture--Social aspects. 2. Domestic space. 3. Identity (Psychology) in architecture. 4. Identity (Psychology)--Social aspects.
 I. Massey, Anne, 1956- editor of compilation. II. Sparke, Penny, editor of compilation.

NA2850.B56 2013
729--dc23

2013004618

ISBN 978-1-4094-3944-8 (hbk)
ISBN 978-1-138-54827-5 (pbk)

Contents

Illustrations

Rome, Mario Praz Museum–National Gallery of Modern Art. By permission of Ministero per i Beni e le Attività Culturali.

10 Art, Architecture and Life: The Interior of *Casa de Vidro*, the House of Lina Bo Bardi and Pietro Maria Bardi

10.1 Lina Bo Bardi, *Glass House (Casa de Vidro)*, São Paulo, 1951. Sketch – perspective of the inside, coloured pencil and Chinese ink, 10.9 × 11.8 cm. © Instituto Lina Bo e P.M. Bardi, São Paulo, Brazil.

10.2 Lina Bo Bardi, *Glass House (Casa de Vidro)*, São Paulo, 1951. View of the living room, 1998. Photographer: Arnaldo Pappalardo. © Instituto Lina Bo e P.M. Bardi, São Paulo, Brazil and Arnaldo Pappalardo.

11 Negotiating Interiority: Displacement and Belonging in the 'Autoportraits' of Lydia Maria Julien

11.1 Lydia Maria Julien, *Crossing*, 2006. Courtesy of the artist.

11.2 Lydia Maria Julien, *En Stasis*, 2007. Courtesy of the artist.

11.3 Lydia Maria Julien, *WNPG06*, 2008. Courtesy of the artist.

12 The Private Self: Interior and the Presenting of Memory

12.1 Louise Bourgeois, *Maman*, 1999. Bronze, stainless steel and marble, 927.1 × 891.5 × 1,023.6 cm. Installed at Tate Modern, London in 2007. Photographer: Marcus Leith, © Louise Bourgeois Trust.

12.2 Michael Landy, *Semi-Detached*. Installation shot at Tate Britain (back view), 18 May–12 December 2004, © Tate, London 2011.

Contributors

Editors

ANNE MASSEY is a Professor of Design at Middlesex University and is a design writer and researcher. She is joint editor of the journal *Interiors: Design, Architecture, Culture* and Research Associate, ICA Archives. She is the leading expert on the interdisciplinary history and contemporary significance of the Independent Group. She has written seven books – *Interior Design of the Twentieth Century* (Thames & Hudson, 1990); *Blue Guide: Berlin and Eastern Germany* (A & C Black, 1994); *The Independent Group: Modernism and Mass Culture in Britain, 1945–59* (Manchester University Press, 1995); *Hollywood Beyond the Screen: Design and Material Culture* (Berg, 2000); *Designing Liners: Interior Design Afloat* (Routledge, 2006); *Chair* (Reaktion, 2011); and *Out of the Ivory Tower: The Independent Group and Popular Culture* (Manchester University Press, forthcoming).

PENNY SPARKE is a Pro Vice-Chancellor (Research and Enterprise), a Professor of Design History and the Director of the Modern Interiors Research Centre at Kingston University, London. She graduated from Sussex University in 1971 and was awarded her doctorate in 1975. She taught History of Design from 1972 to 1982 at Brighton Polytechnic and at the Royal College of Art in London from 1982 to 1999. She has lectured widely, and published over a dozen books and numerous essays and articles in the field of design history with an emphasis, since the mid-1990s, on the relationship between design, gender and the interior. Her books include *As Long as It's Pink: The Sexual Politics of Taste* (Pandora, 1995); *An Introduction to Design and Culture – 1900 to the Present* (Routledge, 2004); and *Elsie de Wolfe: The Birth of Modern Interior Decoration* (Acanthus, 2005). *The Modern Interior* was published by Reaktion in June 2008.

Authors

CRISTÓBAL AMUNÁTEGUI received his professional degree from Universidad Católica de Chile. In 2010 he was awarded a Master of Science degree by the Graduate School of Architecture, Planning and Preservation at Columbia University, New York. Cristóbal has taught in different schools of architecture, in the departments of Design and History and Theory. After many years of collaboration he established his own practice with Alejandro Valdés in 2011, founding Amunátegui Valdés architects. He currently edits the journal *Potlatch*, published by Columbia GSAPP, and is a PhD candidate at Princeton University School of Architecture.

GENE BAWDEN is Senior Lecturer in the Faculty of Art, Design and Architecture at Monash University, Australia. He lectures full-time in graphic design, typography and illustration and coordinates the Faculty's Visual Communication degree programmes. A childhood spent in the outback sparked his desire to better comprehend how white Australians used domestic interiors to construct havens of civility and European belonging in places of desperate isolation. His research has unveiled an idiosyncratic attachment of settler Australians to 'tableau' interiors; domestic spaces constructed purely for display rather than use. The spaces are rich in personal and social narratives. The interior – infinitely more than its mythologized landscape – has become one the most defining characteristics of the Australian psyche.

ALINE COELHO SANCHES CORATO is a PhD candidate in Architecture at the Politecnico di Milano. Her thesis examines the work of Italian artists and architects who emigrated to Brazil after the Second World War, focusing on the interweaving of art and architecture. Aline received her BA degree in 2000 and her Master's degree in Architecture and Urban Planning from São Paulo University in 2004. Her MA dissertation on the work of architect Giancarlo Palanti was published in Brazilian journals and magazines and as conference proceedings. She has worked in the field of architectural planning since 2001 carrying out architectural research for two Brazilian municipalities. From 2004 to 2007 she lectured at Brazilian universities and from 2008 to 2009 she worked as tutor to Daniele Vitale's planning course at the Politecnico di Milano.

EMMA FERRY read History at the University of Southampton. Having worked at Southampton Art Gallery and at the National Trust, she was later awarded the Oliver Ford Scholarship to study the History of Design at the Victoria and Albert Museum and the Royal College of Art (1995–97).

Emma studied for a second MA in Ninteenth Century Studies at the University of Worcester (2001), before being awarded a scholarship by Kingston University to study for her doctorate, which she received for interdisciplinary research carried out on Macmillan's 'Art at Home Series' (1876–83) in December 2004. Emma currently works as a Senior Lecturer in Design and Visual Culture at the School of Art & Design, Nottingham Trent University and is an Associate Researcher at the Modern Interiors Research Centre at Kingston University, London.

INGA FRASER is Assistant Curator of Contemporary and Twentieth Century Collections at the National Portrait Gallery, London and Associate Curator of Fashion in Film at Central Saint Martins College of Art and Design, London. Her research focuses on the uses of dress and interior in constructions of the self in the context of art, film and performance. She has curated and contributed research to exhibitions including *Man Ray Portraits* (NPG, 2013); *Patrick Heron* (NPG, 2013); *Poetry of Motion* (NPG, 2012); *On Paper: Portraits of Writers* (NPG 2012); *Colour-Inventory* (Arnhem Mode Biennale, 2011); *Hoppé Portraits* (NPG, 2010); *Beatles to Bowie* (NPG, 2009); and *The Golden Age of Couture* (V&A, 2007), and has spoken on topics relating to portraiture and to clothing in the moving image at conferences and symposia internationally. She has previously written on the costuming of the silent cinema vamp in *Birds of Paradise: Costume as Cinematic Spectacle* (ed. Marketa Uhlirova, 2013) and for periodicals including *Costume: the Journal of the Costume Society*.

VESNA GOLDSWORTHY is Professor in English Literature and Creative Writing at Kingston University, London. She is the author of *Inventing Ruritania: The Imperialism of the Imagination* (Yale, 1998), which was translated into Bulgarian, Greek, Romanian and Serbian, and the editor of *Norwich Exchanges* (Pen & Inc Press, 2006). Her acclaimed memoir, *Chernobyl Strawberries* (Atlantic, 2005), was serialized in *The Times* and read by Goldsworthy herself as 'Book of the Week' on BBC Radio Four. It was widely translated and became a bestseller in many European countries. Her Crashaw Prize winning poetry collection entitled *The Angel of Salonika* (Salt, 2011) featured in *The Times* 'Best Poetry Books 2011'.

RICHARD W. HAYES is an architect and architectural historian, educated at Columbia and Yale Universities. In 2007, he published his first book, *The Yale Building Project: The First 40 Years*, a comprehensive history of an influential programme in architectural education. His previous publications include the essay 'An Aesthetic Education: The Architectural Criticism of E.W. Godwin' in the book *E.W. Godwin: Aesthetic Movement, Architect and Designer*,

edited by Susan Weber Soros. The book received numerous awards and was selected as 'one of the notable books of the year' by the *New York Times Book Review*. Hayes has received grants and awards from the Fulbright Foreign Scholarship Board, the American Institute of Architects, the American Architectural Foundation, the Graham Foundation for Advanced Studies in the Fine Arts, the Paul Mellon Centre for Studies in British Art and the MacDowell Colony. In 2009–2010, he was a visiting fellow at the University of Cambridge.

BARBARA PENNER is Senior Lecturer in Architectural History at the Bartlett School of Architecture, University College London. She is author of *Newlyweds on Tour: Honeymooning in Nineteenth-Century America* (UPNE, 2009) and co-editor of *Ladies and Gents: Public Toilets and Gender* (Temple University Press, 2009). She is presently working on *Bathroom* (Reaktion, 2013).

CHARLES RICE is Professor of Architectural History and Theory and Head of the School of Art and Design History at Kingston University London. His research considers questions of the interior across the arts. He is author of *The Emergence of the Interior: Architecture, Modernity, Domesticity* (Routledge, 2007), and is editor of *The Journal of Architecture* (Routledge/RIBA).

HARRIET RICHES completed her doctoral research at University College London on the performativity of the photographic medium in the self-representational photography of Francesca Woodman, and has published on this topic in *Oxford Art Journal* and *Photographies*. Since then her writing and research has focused on issues of identity and the self in women's photography, and she is now writing a book on gender and the historiography of photography. She also writes regularly on contemporary photography for the journal *Afterimage*. Harriet is currently Senior Lecturer in Art History and Visual Culture at Kingston University, London.

SHAX RIEGLER is a PhD candidate at the Bard Graduate Center in New York City, where he is researching the life and work of Mario Praz. He also works as the executive editor at *House Beautiful* magazine. Since 1992 he has worked and written for several US publications including *Elle Decor*, *House & Garden*, *The Magazine ANTIQUES*, *Martha Stewart Living*, *The New York Times*, *Travel & Leisure*, *Vogue* and others. He has taught classes on various aspects of the history of design at the Rhode Island School of Design, the School of Visual Arts, Bard College, Bard Graduate Center, and Parsons the New School for Design. In 2011 he published *Dish: 813 Colorful, Wonderful Dinner Plates* (Artisan Books).

CAROLYN STEEDMAN is Professor of History at the University of Warwick. Her most recent book was *Labours Lost: Domestic Service and the Making of Modern England* published by Cambridge University Press in 2009. She is currently working on the meaning of law in everyday life at the turn of the English nineteenth century.

TOM TREDWAY is a PhD candidate at the Bard Graduate Center: Decorative Arts, Design History, Material Culture, and a Visiting Assistant Professor in the History of Art and Design department at Pratt Institute. He is currently writing his dissertation, *Dinner at Tiffany's: Van Day Truex and Postwar American Design*.

Acknowledgements

The editors would like to offer special thanks to Patricia Lara-Betancourt and Fiona Fisher for their work in editing and supporting the production of this volume. We are also grateful to Ashgate and particularly to Margaret Michniewicz and Meredith Norwich for their professional support in bringing this publication to life.

The editors would like to assert that they have made every effort possible to locate the copyright owners of the images included in each chapter and to obtain the necessary permissions for their publication.

Introduction

Penny Sparke and Anne Massey

The discipline (or rather the multi- or inter-discipline) of 'life-writing' has been extensively explored in recent years. The conventional forms of written autobiography or biography, which have been widely discussed for many years by literary historians and scholars, have been augmented by discussions about diaries, oral histories and the numerous other ways – many of them not scripted and non-verbal – in which people embody and demonstrate reflexivity about their own, and other people's lives. That reflexivity can also be expressed and represented, on an individual basis and with a high level of self-consciousness, through the creation of artworks or artistic performances, or, less self-consciously and more communally, through the enactment of rituals. Recently, in the presentation of this broad picture of 'life-writing' literary scholars have been joined by others from, among other disciplines, art history, the social sciences (anthropology in particular, demonstrated in the emergence of ethno-biography) and history.

From the 1970s onwards feminist writing has encouraged the personal life, or subjectivity, of the scholar/writer to break through the surfaces of what had previously been thought of as necessarily objective studies that concealed their personality. Building upon that autoethnography is a new, and particularly revealing, approach to academic writing, which picks up on this reflexivity across disciplinary boundaries. It is an approach that overtly recognizes and acknowledges the link between the self and academic research. As Tessa Muncey[1] has argued:

In order to take the leap into creating an autoethnography one has first to recognise that there is no distinction between doing research and living a life. The person who suffers from a long-term condition cannot be separated from the researcher investigating it, who has him/herself experience of the condition. Just as a counsellor is both a therapist and a client, the autoethnographer is both the researcher and the researched.[2]

This is echoed in the work of the geographers, Mike Crang and Nigel Thrift, who have asserted:

the practices of knowledge are bound into a messy entanglement of the knowing and the known. Theory can no longer (openly at least) claim that the author stands outside what is depicted and that the position of authorship is both exterior and superior – standing not only outside space but also time.[3]

This approach, which acknowledges the presence of the self in research, and in many cases, the development of particular disciplines over time, has also come to the fore in the work of historians, such as Jeremy Popkin who has explored the contribution that autobiographies written by historians can make to the understanding of the subject.[4] Feminist historian Carolyn Steedman, a contributor to this book, explored her own childhood and the place of working-class life-writing in her book, *Landscape for a Good Woman*, which acknowledged the power of placing the self into any narrative: 'What a successful analyst might do is to give the analysand possession of her own story, and that possession would be a final act of appropriation, the appropriation by oneself of one's own history.'[5]

But autoethnography is less developed as a methodological approach in the study of the interior and the history of design. There is one important strand of closely related research, which investigates the intersection of identities and the interior more broadly. One key example is the edited collection by Susie McKellar and Penny Sparke, *Interior Design and Identity*. This series of essays investigated links between public and private spaces, and their varied inhabitants or users.[6] The topographies of gender and class inform the book, which investigates the 'dynamic process whereby individuals have created spaces through which to express themselves and/or others, while those individuals have, in turn, formed their own identities in response to the spaces in which they have found themselves'.[7]

More recently, Alla Myzelev and John Potvin's edited collection, *Fashion, Interior Design and the Contours of Modern Identity* looked at the intersection of clothing, the body and the interior space.[8] However, the use of autobiography as opposed to the concept of identity is comparatively rare in research about the interior or design history. There are some notable exceptions, particularly in the work of Pat Kirkham[9] and of the authors of this introduction, which has been tangentially informed by an autoethnographical approach and which, in turn, had its origins in feminist writing. Penny Sparke reflected on the experience of motherhood in her design historical text, *As Long As It's Pink: The Sexual Politics of Taste*[10] and Anne Massey used a similar approach in her 'Introduction' to *Hollywood Beyond the Screen: Design and Material Culture*, which was essentially a feminist reading of popular culture in which she used her family history as a map.[11]

This approach is new, therefore, to the study of the interior and its contents in relation not only to the architect or designer but also to the user and the author. As the historian Leora Auslander outlined in the introduction to her book, *Taste and Power: Furnishing Modern France:*

In certain conjunctures, objects are … *both* constitutive and representative. They represent people's conscious identities and unconscious desires and fears; they also constitute them, because objects carry multiple potential meanings to different users and to the same user. When I go into a store to buy a chair, I carry Rose and Ida (as well as the rest of my family and digested and undigested childhood experiences) with me, both consciously and unconsciously. I also carry my – complicatedly generated – interpretative grid of what certain styles signify, in terms of social and political position. This baggage produces a judgement, or taste. I choose a chair. I take that chair home. Over the next months and years guests respond to me and to my chair, some seeing in it one thing, some another. They cannot see in it what I hoped for them to see because what I hoped was itself necessarily contradictory and occluded. They respond with their interpretations of my chair and me; I respond and am changed by their responses. I have been made by that chair and I have made the chair. The chair was full of meaning over which I had no control, and of which I had only partial knowledge when I acquired it. In my home it acquired new meanings. My guests have a certain understanding of me when they arrive in my home; as a result of viewing my chair they have somewhat different understandings. In their eyes I become different – perhaps also in my own.[12]

Architectural historian, Alice T. Friedman, has considered the interior in terms of her own life history in her article 'Home on the Avocado-Green Range: Notes on Suburban Decor in the 1950s' in which she explored her own childhood experiences of growing up in suburban Newton Centre, Massachusetts in the 1950s.[13] Her account relates the development of her own awareness of social divisions of taste, related to the discourses of 'good taste' and design in post-war America generally. However, these examples represent an exception in writing on the history of the interior, which is, in itself a relatively new subject for academic attention.

This volume brings together a broad range of authors, from a variety of disciplines, all of whom explore history, life-writing and the interior in relation to the field of visual, material and spatial culture. The scholars included in this volume have the skills to address the subtleties of the relationships between the interior spaces within which most people lead the majority of their lives and their influence on the lives lived in them. *Biography, Identity and the Modern Interior* sets out to redress that imbalance and to demonstrate the very close, two-way relationship that has existed, and continues to exist, between people's lives and the spaces they have inhabited. In so doing it focuses on the era of modernity from, that is, the eighteenth century to the present day. Central to that relationship is 'identity', a social and psychological concept, the formation of which is closely intertwined with the environments – interior spaces (especially those of the 'home') in particular – in which people live their lives.

The essays in this volume demonstrate several of the many and complex ways in which the idea of a 'life' (or 'lives') lived out can intersect with, and influence, an analysis of the interior and, equally, how that analysis can shed light on the nature of the life lived within it. On the simplest level our lives are mostly (although not, of course, exclusively) lived out within interior spaces and the meanings of those lives are thereby imprinted on to, and remembered by, the material artefacts and spatial frames that surround and envelope them, influencing the lives of the objects and interiors themselves. That transference of significance from the 'life' to the 'lived-in' has more than a mere metaphorical status, however: it implies a personification of interior spaces and their contents, and that to talk about the life of an interior denotes a meaningful existence for it over time. This, in turn, can be 'read' in a manner that parallels the way in which the narrative of a life can be recounted, either by the human being who is living it (autobiography) or, usually, but not always, retrospectively, by someone else (biography).

The subtle imprint of human life on to the interior within which it is lived happens invisibly and silently. At the same time as responding to that life, however, the interior also follows a life-cycle of its own that can be discussed independently of its inhabitant/s. Interiors are designed, created, lived in and, in the majority of cases, destroyed, or, to use a series of metaphors derived from human life, it is born, exists for a period of time (during which it may change its character several times) and then dies. It can also be moved from one building to another and change some or many of its constituent parts, sometimes to the point of near extinction.

Yet another relationship between interiors and human lives finds a place within this set of essays. Human beings themselves have 'interior' lives, i.e. in addition to the public personae that people present to the world they also experience a level of existence determined by their private, innermost thoughts, their personal experiences, and by their own self-identities – a level that has been called one of 'interiority'. This discussion reverses the metaphorical relationship between human beings (defined here as inhabitants) and interiors described above inasmuch as attributes of the interior are, in this context, abstracted and applied to a description of an aspect of human experience.

The analogy between a human life and that of an interior is not a simple one, therefore. Indeed the 12 essays in this volume approach it from several different perspectives, fleshing out its complexities in the process. Covering the period from the eighteenth century up to the present day, and addressing specific examples selected to illuminate the multi-faceted idea of 'interior lives', they both render it problematic and enrich it. Presented in chronological order, the essays embrace a wide range of ways into the theme that both holds them together and justifies their inclusion in this volume.

The eighteenth century is represented by Carolyn Steedman's essay, 'No Body's Place: On Eighteenth-Century Kitchens'. The way in which the interior under scrutiny – the generic idea of the kitchen in the home of wealthy householders who could afford to employ servants – is addressed bypasses its specific visual, material and spatial characteristics and focuses, instead, upon the meaning of that 'place' in relation to the significance of the lives lived within it and the legislative framework that underpinned its inhabitation. Most significantly it was not owned by anyone – neither the wife of the householder, who retained a distance from it most of the time, nor the servants who spent most of their time there but had no ownership of it – but it sustained lives and lived experiences within it nevertheless. Key to the lives of the servants who inhabited it was the tension that emanated from the fact that they had no rights of possession and yet spent most of their lives there. More than a mere backcloth to the emotional lives and experiences of its inhabitants, therefore, the kitchen was directly implicated in, and bore witness to, the ways in which those tensions were negotiated and lived out. In Steedman's words the kitchen in that context was both 'contradictory and liminal'.

Three essays address the book's central theme from the perspective of the nineteenth century. While Barbara Penner and Charles Rice's 'The Many Lives of Red House', Richard Hayes's 'At Home, 16 Tite Street' and Emma Ferry's 'Writing Home: The Colonial Memories of Lady Barker, 1870–1904' all focus on the final decades of that century, each reveals a new and different way of bringing the idea of a life (or lives) and the interior together. The first acknowledges the life of an interior – described as a site of contestation over the legacy of the Arts and Crafts Movement by the authors – that experienced a very short existence under the ownership and creative impetus of William Morris (he only stayed a few years) and a much longer one under that of the architect Edward Hollamby, who had his own ideas about the way in which to create an interior which could both represent and support the life of its designer and act as a symbol of an idealized life. Described by the authors as 'intricate and layered', the interior, in this context, had its own life, with its own life changes built into it, as well acting as a representation of the design ideals of its inhabitants, the first (although his period of occupation was short) who became hugely influential, and the second (who lived in it for much longer) who was much less so.

Richard Hayes's essay presents another example of an interior created to express the idealistic vision of its inhabitant, this time Oscar Wilde. The space in question, located in 16 Tite Street, London, was not created by Wilde, however, but by E.W. Godwin, chosen because he understood what Wilde wanted in his home. In this case-study the inhabitant becomes a decorative addition to his own domestic interior which, in turn, is transformed into a mirror of his personal commitment to celebrity, hospitality, self-display and

sociability, a stage, that is, which enabled those rituals of Wilde's life to be enacted upon it. In sharp contrast to the self indulgence of Wilde's interiors, which were reported extensively in the media, those of Lady Barker, as documented by Emma Ferry, are 'essays' which form a part of the writer's own autobiography, partly expressed through her household advice to others and partly through her journalism. Intrinsically linked to her life as it was lived, they provide her with a subject that she could address in her work, essentially a form of 'life-writing'.

Four essays cover the book's theme as it presented itself in the inter-war years of the twentieth century. The first, Inga Fraser's 'Body, Room, Photograph: Negotiating Identity in the Self-Portraits of Lady Ottoline Morrell', gets to the core of the physical and psychological relationship between interiors and the lives lived in them in terms of the creation of individual identity, in this instance a feminine one. Both a 'subject' in her own home and an 'object' in her self-portraits, Lady Morrell's sense of self was utterly dependent upon her settings, which included the immediate interior 'frame' that surrounded her, and a complex relationship is established through the presence, in her own interior, of her framed self-portraits which depicted her in that same, albeit objectified, setting. Tom Tredway's 'Inside Out: Elsa Schiaparelli, Interiors and Autobiography', also addresses the construction of a feminine self-identity formed by its presence in an interior space. He extends that discussion, however, to the notion of autobiography, thereby adding the new dimension of a life self-consciously narrated over a period of time. That life is not narrated in a conventional manner, however, but rather through an accumulation of the various ways in which Schiaparelli presented herself to the world, i.e. as modern woman, a couturière, an artist, and as a woman inhabiting a world that was simultaneously domestic and commercial. Working with the French interior decorator, Jean-Michel Frank, Schiaparelli used the construction of her domestic and commercial interiors to express the multiple facets of her identity, which, in turn, she used, ultimately, as a strategy to market and sell her clothes and accessories. The link between her apartment and her boutique was a continuous one: both were self-consciously designed to demonstrate the consistency of her modern identity and, as a consequence, the attractiveness to other women of her designed goods.

Gene Bawden's 'Illusion and Delusion: Validating the Artificial Interior' focuses on the subject of portrait photography, in particular on an image of his own grandfather, taken in a photographer's studio. His essay builds upon that single image of a man in a constructed interior, evoking a middle-class parlour, to describe how the reality of the life that was actually lived by his grandfather was at odds with the identity suggested by the photograph. The artificiality of the presented interior is emphasized by a comparison with the sitter's real home in a sugarcane town in Queensland, which was inevitably much humbler. That tension between aspiration and reality is

emphasized through a comparison between a reading of the life hinted at in the snapshot (which only captured a single moment) and the actual life lived by Bawden's grandfather, which took place over a period of time and was utterly different from the one suggested by the fiction of the photograph. This chapter demonstrates what happened when the people's lives, their identities and their interiors were subjected to the power of the media (in this case photography), which had the capacity to add a new level of aspirational fantasy to what was already a very complex relationship.

Finally in this period, Cristóbal Amunátegui's essay, 'Jean Genet, or the Interiors of Marginality in 1930s Europe', also addresses an interior dwelling space which, like Bawden's grandfather's real home, is located outside the bourgeois norm that usually characterizes discussions about domesticity. The French writer Jean Genet, who inhabited a world of criminals, lived in, among other spaces, a room which was 'darkened by wet clothes drying on ropes which zigzag from wall to wall'. Descriptions such as this populate Genet's 1949 autobiography, *The Thief's Journal*. Not only do they provide a vivid backcloth for the writer's extraordinary life, they also challenge the idea that all lives are lived in a world of comfortable domesticity. These spaces sit at the margins of comfort. They are usually temporary, make-shift and uncomfortable, but, nonetheless, like the bourgeois domestic interior they are identity-forming and integral to, and marked by, the lives that are lived in them. Unlike bourgeois domesticity they are not aspirational nor are they used by their inhabitants to serve as display areas of social status. Rather they are functional and pragmatic, linked to survival and concealment from the authorities rather than with middle-class fashionableness.

Four essays focus on the period from 1945 to the present day. Shax Riegler writes about the literary critic, art historian and collector Mario Praz, a man for whom his life, his interior environment and the artefacts within it were as near to being united into a single entity, or identity, as they possibly could be. This was consciously expressed by Praz in his 1958 autobiography, *The House of Life*, an autobiographical study, simultaneously, of both Praz himself and of his home, seen as two sides of the same coin. He created the house and, in turn, it created him. Writing the book linked Praz to a number of earlier, male autobiographers who valued their interior environments as key formers of their identities – Xavier de Maestre, Edmond de Goncourt and Edward Knoblock among them. Their books established a modern tradition of masculine life-writing that was very different from the feminine convention of domestic advice writing, such as that of Lady Barker, which, although it also touched life-writing, did not put so much emphasis on the concept of the personalized 'collection'. What emerges ultimately from the work of Praz, however, is the importance of autobiography and biography as a form of writing on the interior and as an investigative and analytic tool that, especially in the private sphere, helps us unpack its full meaning.

Aline Coelho Sanches Corato's essay, 'Art, Architecture and Life: The Interior of *Casa de Vidro*, the House of Lina Bo Bardi and Pietro Maria Bardi', designed by the architect, Lina Bo Bardi, immediately cuts across that generalization, however, inasmuch as it is Lina's art collection that is carefully arranged within the Brazilian house in which she lived with her husband, Pietro Maria Bardi, for 41 years. The introduction of a temporal dimension is key to this study, which focuses on the changes that occurred within the space which acted as a frame for the ancient and modern pictures, objects, sculptures and furniture that lived in it alongside its human inhabitants. As was the case with Praz's house, this home was defined by the acts of self-conscious and continual curation that its inhabitant engaged in within it. For Lina Bo Bardi the space in the house offered her the possibility to introduce objects with which she felt an affinity and which she wanted to live her life alongside while continually changing their location, nonetheless, in search of an ideal arrangement that could never be achieved. The display was, in effect, a marker of Lina Bo Bardi's evolving taste as she gradually introduced both industrial and hand-made indigenous Brazilian objects into what had started off as an exclusively internationally and fine art-defined environment. Above all the chapter highlights the way in which a professional architect, with a highly developed sensitivity to the visual, material and spatial environment, used her skills to elaborate her private interior. It also shows the strong link that existed within modernist architectural and design thinking between the house, the interior and its artefacts, and the life lived within it, and the controlling power of the architect to ensure the existence of that link.

The relationship, in autobiography and life-writing in general, between fiction and non-fiction is explored by Harriet Riches in her essay, 'Negotiating Interiority: Displacement and Belonging in the "Autoportraits" of Lydia Maria Julien'. Indeed the photograph increases the potential complexity of the relationship between a life and the interior in which it is lived inasmuch as it can be simultaneously referential and non-referential, and the spaces it portrays both real and imagined. In claiming her photographs as 'autoportraits', Riches explains, Julien was claiming a high level of reality for her images and a high level of significance for the spaces within which her subject (herself) was photographed but there is room, nonetheless, for the creation of an imagined world and a constructed relationship between the sitter and the sitted-in.

Finally, Vesna Goldsworthy's essay, based on her *Chernobyl Strawberries*, brings the emphasis back upon the written word and to the particular literary genre of the 'memoir'. As Julien had the power to do in her photographs, so Goldsworthy has the power to mix the real and the imagined, the fictional and the non-fictional, in her evocation of her own life and the spaces it was lived in, and her poetic analysis of the 'remembered' relationship between the two. As in Steedman's essay, the interiors in question are evoked rather

than seen and hence have the power to change and transform themselves for the reader. Also, as in all forms of creative practice and representation – artworks, performances, photographs, autobiographies, biographies and memoirs among them – the complexity of actual relationships between the lived and the lived-in is rendered much more so by the 'poetic licence' of the creative or performing artist, in this case the memoir-writer, Goldsworthy, to construct and reconstruct her own memories and the way in which they are narrated to a reader.

As stated earlier, these essays demonstrate and elucidate many facets of our 'interior lives'. Ultimately they indicate that the relationship that exists between the life/lives lived and the lived-in, as well as that between life-writing and a range of other disciplines, is an open, rather than a closed, one. It has been clearly shown that architectural and design historians – experts, as they are, in the fields of visual, material and spatial culture – have an important role to play in deciphering the many and complex forms in which the lives of people and their interiors have interacted with each other. Also, given that they have the freedom to draw on any source material, those creative and performing artists who have chosen to work in this area, have also contributed enormously to our understanding of the rich vein of ideas offered by 'Interior Lives'. Together these scholars and artists have created an area of study that has proven to be worthy of attention. While this book has gone a long way towards defining its parameters and its key themes it is, however, only a beginning.

Notes

1. Director of the Institute of Health and Social Work in the School of Healthcare, University of Leeds.

2. Tessa Muncey, *Creating Autoethnographies* (London, 2010), p. 3.

3. Mike Crang and Nigel Thrift (eds), *Thinking Space* (London, 2000), p. 3.

4. Jeremy Popkin, *History, Historians and Autobiography* (Chicago, 2005).

5. Carolyn Steedman, *Landscape for a Good Woman* (London, 1986), p. 131.

6. Susie McKellar and Penny Sparke (eds), *Interior Design and Identity* (Manchester, 2004).

7. Sparke, ibid., p. 3.

8. Alla Myzelev and John Potvin (eds), *Fashion, Interior Design and the Contours of Modern Identity* (Aldershot, 2010).

9. See Pat Kirkham, 'Dress, Dance, Dreams, and Desire: Fashion and Fantasy in *Dance Hall*', *Journal of Design History*, 8/3 (1995): pp. 195–214.

10. Penny Sparke, *As Long As It's Pink: The Sexual Politics of Taste* (London, 1995), pp. ix–x.

11. Anne Massey, *Hollywood Beyond the Screen: Design and Material Culture* (Oxford, 2000).

12. Leora Auslander, *Taste and Power: Furnishing Modern France* (London, 1996), pp. 18–19.

13. Alice T. Friedman, 'Home on the Avocado-Green Range: Notes on Suburban Decor in the 1950s', *Interiors: Design Architecture Culture*, 1/1–2 (2010): pp. 45–60.

No Body's Place: On Eighteenth-Century Kitchens

Carolyn Steedman

Now, a kitchen is nobody's premises; a kitchen is not a ware-house, nor a wash-house, a brew-house, nor a bake-house, nor an inn-house, nor an out-house, nor a dwelling-house; no, my Lord, 'tis absolutely and *bona fide* neither more nor less than a kitchen, or as the law more classically expresses, a kitchen is, *camera necessaria pro usus cookare; cum sauce-pannis, stew-pannis, scullero, dressero, coal-holo, stovis, smoak-jacko, pro roastandum, boilandum, fryandum, et plum-pudding mixandum, pro turtle soupos, calve's-headhahibus, cum calipee et calipashibus* … But we shall not avail ourselves of an *alibi*, but admit of the existence of a cookmaid: now my Lord, we shall take it upon a *new* ground …

George Alexander Stevens, *A Lecture on Heads*, 1799

A nod and a wink, cod-Latin much appreciated, 50 year's worth of audiences delighted at the bathos of bringing some kitchen dispute about a dripping pan into the high courts. Models of fops' heads, old maids' heads, bibulous foreigners' heads … produced on stage to the accompaniment of a satiric monologue on social types and their habits and manners.[1] The *Lecture* was first presented in London in 1764 and became a theatrical staple of the anglophone world up until the end of the century.[2] Here, it is the Lawyer's turn to be mocked ('when the Law don't find mistakes it is the business of law to make them') as he defends Dishclout the Cookmaid in the case brought against her by Daniel the Footman. They are both servants in the same family. Returning home drunk, Daniel goes into the kitchen, bends down to dip a piece of bread in the dripping pan; Dishclout gives him a shove; his clothes are splattered to ruination; he is persuaded to bring an action against her. The tactic of Dishclout's counsel is to demonstrate that as this all happened in the strange, liminal, nowhere place of a kitchen, it did not happen at all. (And he does submit successfully for a new trial.)

Stevens's book was literally about heads: a series of comic routines, dramatic monologues … delivered by and concerning the human head. Perhaps Alan

Bennett once encountered it.[3] There were a lot of jokes like 'Dishclout' about in the later eighteenth century. They were told in Parliament – about the ridiculousness of bringing colanders and cheesecloth within the purview of high law; they were told in one-page jest sheets and in joke books, and in the everyday correspondence of employers. Eighteenth-century audiences enjoyed them mightily; this was only the most sustained and long-lasting comic contemplation of Nobody's Place.[4]

Kitchens have remained Nobody's Place in the writing of modern historians discussing the domestic spaces in which self was articulated. Amanda Vickery's *Behind Closed Doors* is marvellous on the literal absence of kitchens in the lives of London lodgers across the long eighteenth century, as they cooked on the grate in their rented room, or ate a dinner purchased from the chophouse on the upturned box that served as a table. Some of them were given permission by a landlady to use the house kitchen for a specified hour on certain days of the week, under which circumstances it became doubly an unpossessed place, neither the owner's nor the user's premises. Lodgers' marks of self and identity (clothes and keepsakes and other things) were kept in a box under the bed, or secreted in the chimney piece, or carried about on their person.[5] The rooms and apartments and houses of the better sort inscribe their identity, in furnishings and drapery selected, and wallpaper patterns pondered over, long and hard.[6] Some of the better sort also cook in their rooms, or at least make tea at the hearth (or have their servant make it for them). Young couples about to set up home together discuss kitchen equipment and decor avidly. 'The kitchen was at the forefront of technological innovation in Georgian England', and it excited many a prospective husband.[7] But the kitchens in *Behind Closed Doors* are unpeopled: servants emerge *from* them, bearing a tea tray; or the labour performed in them by domestic servants is abstracted into the account book kept by the lady sitting in the parlour.

I have argued elsewhere that jokes about servants and kitchens were something to do with the tensions and difficulties provoked by the law and the political philosophy underpinning it. At the end of the seventeenth century John Locke had not only theorized the modern possessive, property-owning individual, but had also indicated that the servant who performed labour for a master or mistress was, by virtue of the contract between them, the employer's proxy, or substitute. The famous Lockean formulation was: 'the grass my horse has bit, the turfs my servant has cut … become my property … The labour that was mine removing them out of the common state they were in, has fixed my property in them.'[8] The servant was the employer's prosthesis, or extra limb. The property created by the servant made the modern person – his legal identity and his persona; but the man or woman doing the work was not a person in the same way – certainly not a propertied individual. Throughout the following century, high court judges, lawyers and legal theorists reiterated these fundamental principles of personhood and identity. This model of

selfhood underpinned the mundane deliberations of magistrates when they heard domestic service disputes in their justicing rooms. Ordinary employers were instructed in the seventeenth-century philosophy that underpinned everyday life. In 1799 John Barry Bird told masters and magistrates that really, 'in strictness every body ought to transact his own affairs', but that 'by the favour and indulgences of the law ... he can delegate the power of acting for him to another' – Locke's political philosophy, reformulated for a modern commercial world. Lockean formulations explained why 'the acts of servants are in many instances deemed the acts of the masters', he said.[9] Jokes explored the rather disconcerting consequences of the thesis. And jokes were also a contemplation of the contradictory and liminal spaces that eighteenth-century kitchens *were*, in the imagination of those whose daily life was reproduced there by servants, and in the imagination of those who laboured therein. This chapter explores those contradictions about the eighteenth-century kitchen and its strange place in the political, social, and cultural theory that underpinned the making of the modern self.

An ordinary, non-élite, eighteenth-century household with a couple of servants might designate one of them cookmaid, though it was unlikely that her work be confined to the kitchen and to cooking. 'Could you recommend me a good cook?' wrote the Reverend Bowness to a Norwich friend in 1794. 'I shall most likely part with Betty Byford tomorrow. The poor girl is ... so ill in mind ... that she is quite incapable of any business ... I am really much concerned on her account; and not a little on my own for she is a quiet servant and pleased me much as a cook ... I have a good deal of company coming to dinner to day and Betty's total incapacity rather unhinges us.'[10] What employers were after in a young woman like Betty Byford was a wide range of skills, including kitchen business. 'One that is not very Young', specified Mrs Cooke of Doncaster in 1766; 'clean ready & handy in doing her family business.' Can she 'Wash & get up Linning well & sow plain work well'? she asked. Does she know 'how to Clean rooms well?' Could her current employer oblige by giving 'her leave to be as much in the Kitching as she can ... & ... your Housekeeper ... instruct her to make different kinds of Pastry &c'?[11] Servants were moved about between households sometimes not knowing that it was cooks they were about to become as in Birmingham in 1754:

Dear Kitty This comes to desire you to acquaint Sally Killingley that my maid Alice goes away this Day fortnight and I would have Sally come that week that the other Leaves me I think the best way for her to come will be with the carrier she understands I suppose that it is a cooke maid I want my Place is not a hard Place for two far from it.[12]

Employers got maids (and sometimes men) to become cooks by many devices, but found much work for them to do outside the kitchen once they had made the bargain: all servants in modest households were multi-tasking young women and men.

Much depends on dinner, and the sudden absence of a cook (committed to bedlam, gone home to mother, in bed with the ague, just – gone) forced contemplation of cooks far more than was the case for other categories of domestic servant – particularly among the men of a household. They figured in the anxious and lubricious imagination of several eighteenth-century gentlemen. There was no reason for James Boswell to imagine making love to a cook, yet he did, musing that 'there is something I think particularly indelicate and disgusting in the idea of a cook-maid. Imagination can easily cherish a fondness for a pretty chambermaid or dairymaid, but one is revolted by the greasiness and scorching connected with the wench who toils in the kitchen.'[13] Cookmaids were called nastier and more demeaning names than other categories of domestic; 'Dishclout' is the most unpleasant of them all. When jesting masters and mistress congratulated themselves on seeing through their servants, being up to the mark with all their wily little depredations, the cook could stand in for the whole lying, cheating race of them. 'Dorothy Redfist' writes to the *Wit's Magazine* on her qualifications as a modern maidservant:

Eighthly. If there is a crust of bread harder than ordinary, I always carry it
to my master's table … Ninethly. If there is any kind of greens for dinner
… I always take care to send the outside leaves … and detach the best part
in a cullender, over some hot water, till they have done: for why should not
sarvants know what's good as well as their masters and mistresses?[14]

In this comic literature the category 'cook' emerges in the 1780s ('cook' as opposed to 'servant who cooks'). The cook has a range of specific skills acquired at the hiring, and this genre of literature mocks them – those who sell the skills and those who purchase them, as in the anonymous *Trial of Betty the Cook-maid*.[15] Betty was hired by the plaintiff's:

loving and virtuous lady, to serve in the rank, degree, or situation of a cook
maid, when in consideration of the annual sum of seven pounds, she then [sic]
prisoner undertook to roast, boil, hash, mince and broil for me and all my family,
to scower my brass and pewter, with all the dishes of my scullery, and do and
perform all … the duties and services appurtenant or appendant to a Cook-maid.

What *was* the point of this little squib of two folded pages? Perhaps the way in which the law of service operated here to everybody's satisfaction. Its hyperbole is engaging: the huge weight and majesty of the law is brought to bear on the not very important household of the plaintiff. What is mocked is the pretentious, jumped up, middling sort, who assign so many offices to a girl who after all, just chops carrots and keeps the kitchen fire going, as if for all the world they were running a much grander establishment than their own.

Employers wrote about their own servants, and invented fictional ones in order to complain about them. And from the other side of the kitchen door, cooks

– and maidservants who cooked – complained and wrote back. Or just wrote, as part of the job. Discussing the twentieth-century development of recording and writing systems among the Vai people of Liberia, the anthropologist Jack Goody notes in passing that several of the Vai records he consulted had been compiled by men who had worked as cooks and thus become familiar with elementary book keeping during their working life.[16] Many cooks kept these homemade, on-going records. In eighteenth-century England if you wanted writing abilities that *had some use* in a household servant, then it was in the cook you wanted them. In modest households, in a cash-short economy, it was the kitchen door that was the egress for most small coin; it needed to be accounted for on a daily basis. Christian Tousey's 'Book' was compiled by two hands, the second most likely to have been the mistress's (or the master's) detailing payment to unspecified others (probably charwomen, or bought-in work-boys) and to washer women. The way in which a single-servant household was managed and maintained by the employment of a supplementary stream of casual domestic workers or 'helpers', the calculations for paying them, as well as records of daily marketing, meant that an account book like Tousey's was likely to come under regular scrutiny by the employer.[17]

At the other end of a scale of literacy, there were maids who wrote poetry. The popularity of servant-verse is sometimes attributed to a proto-Romantic taste for humble genius – for plebeian literary creativity – and to the satisfaction of contemplating talents that might, without your charitable donation to their subscription list, have been lost forever to the back kitchen.[18] Mary Leapor was a cook among a household retinue of servants (or a 'menial Train', as she put it); not a jobbing girl in a single-servant household turning her hand to everything, but rather, hired in the capacity of a cook to a gentry family, and in no other. In 'Crumble Hall' the servant-poet wanders the corridors, chambers and grounds of the country house regretting all the changes it has seen. She spends most time in the kitchen, visiting it twice in the course of her tour. She describes its larder stores of 'good old *English* Fare' sketches out a recipe (for cheese cakes), admires the skill (her own) that went into the 'soft Jellies' and gives the menu for the servants' dinner (boiled beef and cabbage). Jeannie Dalporto has said that it might be disconcerting for a member of the employing classes to see depicted 'servants who have lost sight of their servitude', behaving as if their place in the big house is assured by affective relationships – not by contract or hiring agreement, or by the system of capital and agricultural investment the country estate represented.[19] But there is more to the affront than this. In this poem the servants carry on their complex lives as if the family of the house simply does not exist; affective relationships are between them, not between servant and employer. The kitchen is a social universe presented as completely independent of the economic structures actually inscribed in 'Crumble Hall'. In this poem, labour and the objects of labour, belong entirely to the workers. The ploughman resting by the kitchen

fire dreams of '*his* Oxen', and when rain threatens worries for '*his* new-mown Hay'. Urs'la the kitchen maid, in love with the unresponsive Roger, works entirely for him, not for the Family on the other side of the door. 'For you *my* Pigs resign their morning due', she cries to his snoring form slumped across the kitchen table:

My hungry Chickens lose their Meat for you:
And was it not, Ah! Was it not for thee,
No goodly Pottage would be dress'd by me.
For thee these Hands wind up the whirling Jack,
Or place the Spit across the sloping Rack.
I baste the Mutton with a chearful Heart,
Because I know my *Roger* will have a part.

Rhetorically at least, the Crumble Hall servants reject the Lockean conception of the servant's labour as belonging to the master, and claim his property as their own: the product of *their* labour.[20] To employ a poetical maid might be a fashionable thing to do and literacy in a cook certainly a useful commodity; but perhaps these factors did not outweigh the discomfort of realizing that the servants might live autonomous lives in your kitchen, quite independent of what law and legal theory said they were: mere aspects of your personality, exercising your own (unused) capacity to turn spits and collect egg. In smaller, far more modest households than the ones Leapor cooked in, a mistress might welcome a literary – or at least a literate – servant. Writing skills were particularly useful in a cook maid, for the purposes of reckoning and accounting; they were also a means by which, when she left, as she surely would, you could get to keep some of the skills and abilities you had acquired at the hiring.[21]

In servants' poetry and employers' satires, social prejudice and social resentment were voiced, from both sides of the service relationship. Employers expressed most anxiety and resentment about – used their most outrageous and denigrating terms – about servants in the kitchen. They could not really police what happened here, in the workplace that produced the means of their material existence on a daily basis, though their housekeeping books, or the insistence that Mrs Tousey record every farthing she spent, are testaments to their determined attempts to do so. The better sort sometimes described opening the kitchen door and finding another life enacted there; it is a trope of eighteenth-century journal writing. James Boswell descends to Dr Johnson's kitchen and by the light of the fire discovers Frank Barber and all his friends drinking round the kitchen table (one of the few fragments of evidence we have of networking among London's black servants).[22] The farce *High Life Below Stairs* was the theatrical formalization of this scene on the threshold between two spaces and two social worlds.[23] There is always a flash of dislocating *astonishment* as the door is opened and employer and servants look at each other.

Kitchen labour occupies hands, as does all labour. But it was different for the cook compared with a ploughman, a thresher or a journeyman weaver. In a kitchen there were surfaces to rest on; there was paper of a sort around and perhaps something to write with (anyway, the cook could always whip up a little ersatz ink, from soot, or a little scraping from an iron pot and some very strong tea. And the gall bladder of a recently eviscerated chicken would have been useful in fixing her ink). Cooking processes are irregularly timed and leave moments for composition. No wonder that it was the cook who wrote.[24]

The kitchen was not the master's premises – it was a Nowhere – but neither was it the servants': they were birds of passage in all the rooms of a house; the kitchen just happened to be the Nowhere-place in which they served out most of their time.

But thinking was done *in* kitchens by servants like Mary Leapor, and *with* kitchens (the idea of a kitchen) by the employing classes, in many kinds of text. We can discover a great deal about what kind of space – literary and social – the kitchen was. In the literary realm we find fictional servants sitting round kitchen fires to discuss in detail and at length the shortcomings of their employers' children (and their parents) for the purposes of infant improvement.[25]

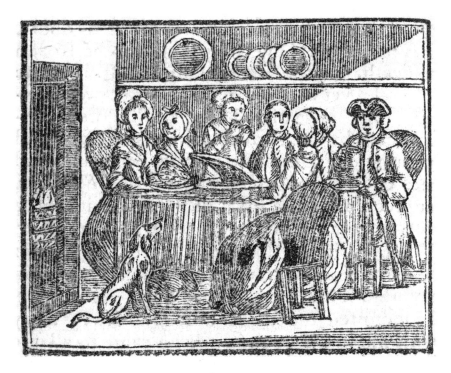

1.1 In an eighteenth-century book for children, the servants settle down for a ten-page moan about the children of the household (and their parents).

For the same purposes, extremely recalcitrant (fictional) children are banished to the kitchen to eat with the servants.[26] Famous misers demonstrate their extreme meanness by living in the kitchen with their one servant.[27] Popular history shows an early modern English king to be as useless in the kitchen as was Alfred the Great.[28] In popular 'travelling-tales', pins and pennies make fictional journeys through entire social orders, spending much time in kitchens and holding conversations with many servants there.[29] In the autobiographical realm a (non-fictional) Nigerian prince, house-slave in New York, is frightened by tales of the devil told by another black servant in the kitchen. He thus inscribes his life story in relation to the most repeated childhood experience of the bourgeois possessive individual, who can only grow successfully to man's estate if kept away from kitchen-stories of Raw-bones and bugaboos.[30] The philosophical history of civil society and the modern, possessive individual is discussed in kitchens; in a wide range of eighteenth-century texts kitchens are the site for articulating economic and social theory.

Kitchens are liminal places, to which no one and nothing belongs, but servants *emerge* from them, into the narrative of many novels. In all sorts of fiction, even at the further gothic reaches of the Minerva Press, a maidservant pauses in her dusting to relate dramatic circumstances to her employers, or to rehearse a family genealogy that makes (nearly) everything clear. Or, dusting a desk, she will uncover – her eyes will fall upon a letter, a message, a signature that is equally the story of what *has* happened, and of what now *must* follow.[31] Social verisimilitude, even in the most exotic realms, demands that the maid is dusting in a house place, not scouring the kitchen floor, for that is where standing, she encounters her betters, and has conversation with them. She is a plot mechanism, for fiction and the stage. Even the most *jejune* actress, of no matter how uncertain gentility, will not appear on her knees, with scrubbing brush in hand.[32] Indeed, dusting, being a relatively clean and genteel task, is something that young ladies in instructional literature may themselves attempt, though they needs must be reduced to an orphan state before undertaking it.[33] Very occasionally, a maidservant in a novel may be espied sweeping, but is rarely engaged in conversation by her social superiors in this activity, even though her presence is the mark of some plot development, or some moment of revelation (as in 'That is Clarinda's maid! So this is her mansion!') to the gentleman or lady doing the observing.[34] Sweeping a floor simply does not allow for the richness of event, sequence, timing and history that can flow from a dusting session – in the novel, or on the stage.

We could discover much more than we know already about life in eighteenth-century households by focusing on kitchens. We could start with the comings and goings through both its doors, which have been emphasized here: who and what came in, who went out? By paying attention to the labour that was undertaken in kitchens, and those performing it, we will learn not only

about the experience of the largest eighteenth-century occupational category – domestic servants – but also about the way in which the law interpellated kitchen labour. We will learn even more about the way in which law informed and structured the imagination of those employing, and those labouring. Legal and political philosophy was enacted, articulated and reformulated in kitchens, fictional and real. This is a way into the eighteenth-century home and the minds of those who inhabited it: a way into understanding the making of selfhood, using the means of interpretation and imagination available to workers and employers in the long eighteenth century. And if we take notice of the intense and anxious interest that was paid to the no-place kitchen, then we might pay some attention to the 'No-body' (to whom it doesn't belong). *Nobody*, who was well known to eighteenth-century culture, didn't have a body; or rather, in the English language as opposed to those of Continental Europe, where he also figured in folklore, he doesn't have a body. There were opportunities for punning offered by 'No-body' compared with 'un homme de rien' or 'Niemand', for example. This folk character is said to have entered European literature from the story of Odysseus and the Cyclops. In England 'No-body' came to represent humble and honest 'Have-nots' as opposed to powerful and arrogant 'Haves' – Mr Some-bodies – very early on indeed.[35] That's another story, about identity, selfhood and the modern interior (but it won't turn out be about Nothing).[36]

Notes

1. Geo. Alex. Stevens, *A Lecture on Heads with additions by Mr Pilon, as delivered by Mr Charles Lee Lewes, to which is added an Essay on Satire, with Forty-Seven Heads by Nesbit, from Designs by Thurston* (London, 1812), p. 69. http://www.gutenberg.org/files/21822/21822-h/21822-h.htm, accessed February 2012.

2. Gerald Kahan, *George Alexander Stevens and the Lecture on Heads* (Athens GA, 2008).

3. Alan Bennett, *The Complete Talking Heads* (London, 2007). The first series of these comic monologues was broadcast in 1988.

4. Carolyn Steedman, 'Poetical Maids and Cooks Who Wrote', *Eighteenth-Century Studies*, 39/1 (2005): pp. 1–27; *Parliamentary Register*, vol. 12, pp. 108–9 (11 June 1800) for MPs having a good laugh at a kitchen/dishclout joke.

5. Amanda Vickery, *Behind Closed Doors: At Home in Georgian England* (New Haven CT and London, 2009), pp. 34–48.

6. Vickery, *Behind Closed Doors*, pp. 166–83.

7. Vickery, *Behind Closed Doors*, pp. 265–70.

8. John Locke, *Two Treatises of Government* (1689) (London, 1993), p. 128. (Book Two 'Concerning the True Original Extent and End of Civil Government', Chapter 5 'Of Property', Section 27). http://www.efm.bris.ac.uk/het/locke/government.pdf, accessed February 2012.

9. James Barry Bird, *Laws Respecting Masters and Servants, Articled Clerks, Apprentices, Manufacturers, Labourers and Journeymen* (3rd edn) (London, 1799), p. 6.

10. Norfolk County Record Office, BOL. 2/13, 2/15, Bolingbroke Collection, Leahes Family Papers, Letter … re getting Mr Bowness's cook into the Bethel Hospital.

11. Doncaster Metropolitan Archives, DD.DC/H7/1/1, Davies Cooke of Ouston, Mrs Mary Cooke, Copy letter book, 1 vol., 1763–1767, December 1766.

12. Birmingham Central Library Archives, Hutton 12, Hutton Family, Letters and Papers, Letter from a daughter of Ambrose Rusdell's to Catherine Perkins re … the employment of Sally Killingley as maid, 22 April 1754.

13. Margery Bailey (ed.), *Boswell's Column. Being his Seventy Contributions to the London Magazine, under the Pseudonym The Hypochondriack from 1777 to 1783* (London, 1951), p. 99 (No. XVII 'On Cookery', Feb 1779).

14. 'Qualifications of a Modern Maidservant', *The Wit's Magazine*, 2 vols (London, 1784–5), vol. 2 (December 1784): p. 466.

15. *Trial of Betty the Cook-maid, Before the Worshipful Justice Feeler, for Laying a Bed in the Morning* (London, 1795).

16. Jack Goody, *The Interface between the Written and the Oral* (Cambridge, 1987), p. 212.

17. Wiltshire County Record Office, 776/922A, Household Account Book, kept by Christian Tousey of Salisbury.

18. William J. Christmas, *The Lab'ring Muse: Work, Writing and the Social Order in English Plebeian Poetry, 1730–1830* (Newark NJ, 2001) for the market in 'rustic' poetry and 'unlettered Muses'; also Betty Rizzo, 'The Patron as Poet Maker: the Politics of Benefaction', *Studies in Eighteenth-century Culture*, 20 (1990): pp. 241–66.

19. Mary Leapor, '*Poems upon Several Occasions*' (two volumes, 1748 and 1751), in Richard Greene and Ann Messenger (eds), *The Works of Mary Leapor* (Oxford, 2003), 'Crumble Hall', pp. 206–10, http://www.orgs.muohio.edu/womenpoets/leapor/, accessed February 2012. Jeannie Dalporto, 'Landscape, Labor and the Ideology of Improvement in Mary Leapor's "Crumble Hall"', *The Eighteenth Century. Theory and Interpretation*, 42/3 (2001): pp. 228–44.

20. Carolyn Steedman, 'The Servant's Labour: The Business of Life, England 1760–1820', *Social History*, 29/1 (2004): pp. 1–29.

21. As in the very detailed cheese cake recipe written out by the 'most Humbol tho unworthy Sarvants James and Mary Williams' for their mistress: 'Madam the Season for making Bambory Chess is from Lamos to all Holontids and Let your veats [?] be A bout A inch & a hf Dress and Scald with whay and water mixed.' Somerset County Record Office, DD/GB, 148–9, Gore Family Papers, 1521–1814, vol. 1 DD/GB/148, p. 264.

22. Aleyn Lyell Reade, *Johnsonian Gleanings. Part II. Francis Barber, the Doctor's Negro Servant* (London, 1952), p. 15.

23. James Townley, *High Life Below Stairs. A Farce of Two Acts. As it is Performed at the Theatre-Royal in Drury-Lane* (London, 1759).

24. Steedman, 'Poetical Maids.'

25. *The Adventures of a Pin, Supposed to be Related by Himself, Herself, or Itself* (London, 1790), pp. 40–50.

26. Richard Johnson, *Tea-table Dialogues, between a Governess, and Mary Sensible … and Emma Tempest* (London, 1796), p. 77.

27. Edward Topham, *The Life of Mr Elwes, the Celebrated Miser. With Singular Anecdotes, &c* (London, 1792), p. 37.

28. *A Third Collection of Scarce and Valuable Tracts, on the Most Interesting and Entertaining Subjects: but Chiefly such as Relate to the History and Constitution of these Kingdoms. … Particularly that of the late Lord Somers. Revised by Eminent Hands* (4 vols) (London, 1751), vol. 2, p. 317.

29. Miss Smythies, *The History of a Pin, as Related by Itself. … By the Author of The Brothers, a Tale for Children* (London, 1798).

30. James Albert Gronniosaw, *A Narrative of the Most Remarkable Particulars in the Life of James Albert Ukawsaw Gronniosaw, an African Prince, as Related by Himself* (Bath, Bristol and London, 1780?), pp. 18–19. John Locke, *Some Thoughts Concerning Education* (London, 1693), pp. 206, 330; John Locke, *An Essay Concerning Human Understanding. In Four Books* (1689) (7th edn, London, 1715–16), vol. 1, p. 367. In the *Essay* servants' tales demonstrate the psychological principle of the association of ideas ('The *Ideas* of Goblings and Sprights, have really no more to do with Darkness, than Light; yet let a foolish Maid inculcate these often upon the Mind of a Child, and raise them there together,

possibly he never shall be able to separate them again so long as he lives, but Darkness shall ever afterwards bring with it those frightful *Ideas*'). The *Thoughts* warns parents about servants 'whose usual Method' is to control children 'by telling them of *Raw-head and Bloody-bones*, and such other Names, as carry with them the Idea's *[sic]* of something terrible and hurtful'.

31. Miss Smythies, *The Brothers. In Two Volumes. By the Author of The Stage-coach and Lucy Wellers* (2nd edn, 2 vols) (London and Colchester, 1759), vol. 2, p. 219; Susannah Gunning, *Family Pictures, a Novel. Containing Curious and Interesting Memoirs of Several Persons of Fashion in W-----re. By a Lady. In Two Volumes* (Dublin, 1764), vol. 2, pp. 22–32; *Louisa Matthews. By an Eminent Lady* (3 vols) (London, 1793), vol. 2, pp. 209–10; Mary de Crespigny, *The Pavilion. A Novel. In Four Volumes* (London, 1796), vol. 2, p. 105; *Agatha; or, a Narrative of Recent Events. A Novel, in Three Volumes* (London, 1796), vol. 2, pp. 4–5; Fanny Burney, *Camilla: or, a Picture of Youth. By the Author of Evelina and Cecilia. In Five Volumes* (London, 1796), vol. 2, p. 63; *Human Vicissitudes; or, Travels into Unexplored Regions* (2 vols) (London, 1798), vol. 1, p. 171; Mrs Showes, *The Restless Matron. A Legendary Tale. In Three Volumes* (London, 1799), vol. 1, pp. 119–30; John O'Keeffe, 'The Doldrum, or, 1803', in John O'Keeffe, *The Dramatic Works of John O'Keeffe, Esq. Published under the Gracious Patronage of His Royal Highness the Prince of Wales. Prepared for the Press by the Author. In Four Volumes* (London, 1798), vol. 4, pp. 463–505 (Act I, Scenes II and III), http://www.ebooksread.com/authors-eng/john-okeeffe.shtml.

32. *The Complete Letter-Writer. Containing Familiar Letters on the Most Common Occasions in Life. Also a Variety of Elegant Letters for the Direction and Embellishment of Style, on Business, Duty, Amusement, Love, Courtship, Marriage, Friendship, and other Subjects* (Edinburgh, 1768), pp. 27–8, http://www.archive.org/details/completeletterw00unkngoog.

33. Mary Pilkington, *Tales of the Cottage; or Stories, Moral and Amusing, for Young Persons. Written on the Plan of … Les Veillees du Chateau, by Madam Genlis* (London, 1799), p. 139; 'No. 79 … To the Author of the Lounger', *The Lounger. A Periodical Paper Published at Edinburgh in the Years 1785 and 1786* (3 vols) (Edinburgh, 1787), vol. 3, pp. 96–100. This interesting tale (a purported autobiography) of service in reduced circumstances and social attitude constructed around household and personal objects, went into six editions (all published in London) in ten years, and was liberally extracted from and anthologized.

34. Eliza Haywood, *The Invisible Spy. By Explorabilis. In Two Volumes* (3rd edn) (London, 1767), http://www.archive.org/details/invisiblespy01haywiala.

35. Jenny Uglow, *Hogarth. A Life and a World* (London, 1997), pp. 217–59, 644–5; Anston Bosman, 'Renaissance Intertheater and the Staging of Nobody', *ELH*, 71/3 (2004): pp. 559–85; Peter Womack, 'Nobody, Somebody, and King Lear', *New Theatre Quarterly*, 23 (2007): pp. 195–207; R.A. Foakes, *Illustrations of the English Stage, 1580–1642* (Stanford CA, 1985), pp. 94–5; *Nobody and Somebody, with the True Chronicle History of Elydure* (London, 1606).

36. Carolyn Steedman, 'Sights Unseen, Cries Unheard: Writing the Eighteenth-Century Metropolis', *Representations* 118 (Spring 2012).

The Many Lives of Red House

Barbara Penner and Charles Rice

It is commonplace to read domestic interiors for evidence of the lives of those who inhabited them. It is a far less common proposition to suggest that interiors can have lives of their own, with autonomy and agency in the world. Aren't interiors simply contexts, background environments for living which takes place in the foreground? This sounds reasonable, yet the activity of making a life in an interior involves wresting meaning and significance from objects that might have existed elsewhere, in relation to different lives. The interior in theory is any possible combination of images and objects that circulate in the world, and any specific interior is formed in the context of an active set of relations between a life lived and a living environment.

This understanding of the interior helps to explain why it can be seen separately from architecture, taking on a life of its own and circulating independently of it. Interiors exist physically as environments that can be lived in and visited; they also exist in images and objects that travel through space and across time and seed new ideas about decoration, style and inhabitation as they go. The question of 'interior lives', then, can extend far beyond the idea of the interior as a bounded enclosure.

In this chapter we aim to demonstrate the ways in which the interior is never static or fixed in one place by focusing on one particular case study: the interior of Philip Webb's Red House, built for his life-long friend William Morris in Bexleyheath, near London, in 1859. We have chosen Red House because it has seen many occupants pass through it. In fact, it has been continuously lived-in since the time of its completion until 2003, when it was taken over by the National Trust. It is now a house museum. Traces of its previous occupants still exist in the house, however, and this makes it an ideal site to explore the transactions between different lives, objects and decorations, and how these constructed interiors at particular moments in time.

Red House: The Morris Years (1859–1865)

We begin with Red House's construction in 1859. Famously, William and Janey Morris, and their friends, including Webb, Edward and Georgiana Burne-Jones, Dante Gabriel Rossetti, Lizzie Siddal and Charles Faulkner came together and decorated the interior by hand, painting directly onto walls, making tapestries, and constructing furniture. Many of the designs that were tested out at Red House or were inspired by it, such as 'Trellis' wallpaper, would later be manufactured by Morris, Marshall, Faulkner and Co. In this way, the first Red House interior spawned objects and decorations that would go on to constitute numerous other interiors worldwide. As the business grew, Morris and his family left Bexleyheath for a central London location. Once Morris moved out in 1865, the interior of Red House became home to a whole host of other things which moved in, other decorative treatments that took on their own life, and themselves were sent back out into the world.

Since 1900, Red House has been cited as one of the most important or at least best known exemplars of progressive English domestic architecture. The architectural historian Nicholas Cooper has traced how Hermann Muthesius, Nikolaus Pevsner, Mark Girouard, Peter Blundell-Jones, and many others, have been united in viewing it as a seminal building, but, significantly, disagree exactly as to why.[1] Some believe that Red House was the precursor to the Arts and Crafts Movement, others the Queen Anne Style, others the Modern Movement. Some say its most distinctive contribution is its plan, others its unity inside and out, and others its plainness and material honesty. Surveying the field, Cooper dryly observes, 'in opinions about Red House there is variety enough to support almost any reappraisal' and concludes that, while none of these interpretations are false or invalid, they reflect nothing so much as the values of the historians who make them.[2]

Cooper's overview of the changing assessments of Red House is useful; however, it overlooks something vital. It is not only the case that historians' values fluctuated, but that the way the house was presented also fluctuated and changed depending on who occupied it and how they occupied it. And as we shall see, some of the occupants of Red House were particularly active about constructing an image of the house that then shaped how the house was received. Even if their interpretations emphasize different aspects of the house's significance, architectural historians have responded for the most part to what is permanent and has not been radically altered: the materials, structural details (the tilework, brickwork, joinery, and ironwork), plan, siting, etc. Indeed, part of the building's fame may reflect the fact that from an architectural perspective it remains generally intact, largely because the house was occupied by sympathetic owners who admired Morris or Webb and who made almost no alterations to the *exterior*

of the building. Yet over time, and despite, or in some cases because of, its owners' admiration for Morris, the *interior* has changed dramatically. Red House and its interior, then, can be seen as two different things. While the story of Red House's architecture has been frequently told, that of its interior has barely emerged.

Changes to the interior can be seen in images of Red House made at different times. There are no visual records of the interior from Morris's day, but, in the 1860s, visitors described rooms that were dark and rich with Gothic furniture and stained glass. A remnant of this medieval treatment remains in the 'dragon's blood' used in Webb's famous dining room sideboard.[3] By contrast, in the first known photographs and illustrations of Red House's interior, taken in the 1890s, the drawing room was thoroughly aestheticized and filled with oriental objects. By the 1910s and 1920s, it had become much more mundane. An album of sales particulars from that period, now in the possession of the National Trust, shows the interior fitted with banal furniture of the time, the walls of the entrance hall covered in a busy floral paper. At different phases, Morris & Co. or Webb designs have been added to emphasize the house's link to its first inhabitant, but these are not 'original' in the strict sense of the word.

To date, while several bibliographic surveys exist, there has not been a thorough comparative analysis of these various visual records. While this would be of historical value, this is not the aim of this chapter, which expands on another point. Visual records make clear that the inhabitants of the house often favoured a very different aesthetic to that of Morris. But on another level, we argue, they were very faithful to his model of occupation in that they actively used Red House to showcase, and even to publicize, modes of decoration and life locally and internationally. In this reading, then, the interior of Red House emerges as something that itself generates a network of influences and connections.

Since William and Janey Morris moved out, Red House has had approximately 12 owners and lessees, the majority of whom lived there for substantially longer than Morris.[4] It is worth focusing on two of the most significant: Charles Holme and his family, who resided there between 1889 and 1903; and Ted Hollamby and his family, who remained there between 1952 and 2003. Both men are interesting in their own right: Charles Holme is best known today as the founder and editor of *The Studio* magazine, the most important voice for the Arts and Crafts and Art Nouveau movements. (Indeed, it is surprising how few people have remarked that the pre-eminent journal of the new artistic styles was established when its proprietor was residing at Red House.) And Ted Hollamby was a modernist architect of note, working first for the London County Council, and then for the London Borough of Lambeth.[5] In short, both men were cultural insiders and propagators with active roles in shaping the contemporary

zeitgeist. Red House became a staging ground for the interests of both men, highlighting that historians have certainly not been the only actors whose values have influenced the reception and perceived significance of the house over time.

Red House: The Holme Years (1889–1903)

The Red House interiors during Holme's residency are known today thanks to a remarkable family photo album, which is now in the possession of the National Trust.[6]

The photos startle contemporary viewers who expect the house always to have been a paragon of simplicity. The rooms featured a dense and diverse array of oriental objects – prints, ceramics, lacquer boxes, figurines, screens, cabinets, even swords from all over Asia. Historian Jan Marsh suggests that it was Holme who was responsible for adding dado panelling and wooden battens to the ceiling of the drawing room to give it a more 'baronial' feel, and covered other walls with embossed Japanese leather paper or Indian-style gilt paper. The overall effect was grand, exotic, gilded and busy. Marsh provides an evocative description:

Inside the house resembled an oriental bazaar or part of Liberty's
department store. Photographs show silk and embroidered fabrics, inlaid
Indian chairs, Japanese prints, lattice-work lanterns, tea-bowls, figurines,
lacquer boxes, Nankin china, folding screens, Kakomon silk paintings, a
Paulownia marriage chest, and a Koran stand amongst other Oriental *objets
d'art*. Holme also collected dead butterflies, with bejeweled wings.[7]

By contrast, even though he was interested in Oriental art, Morris biographer Fiona MacCarthy notes that Morris always strove to reduce his own interiors to their essentials: 'No pictures … no occasional tables, no chairs like feather-beds, no litter of any sort.'[8]

But perhaps the similarities between Holme and Morris are ultimately more important than their aesthetic differences. Notably, both men made their living by supplying furnishings to and shaping the domestic styles of the bourgeoisie, and frequently decorated their interiors with their own products. Holme had been involved in an import/export business with Asia since 1874, but, in 1879, in partnership with Christopher Dresser, he began supplying Asian furnishings to major UK companies, including Liberty, and exhibited in various international exhibitions alongside Morris & Co.[9] Holme seems to have given up active trade by 1889 when he bought Red House from Edmund Charlesworth, a stock-broker, for the sum of £2,900 and moved there with his wife and four children. But he remained busy: he became a founder member of the Japan Society in 1892, and founded *The*

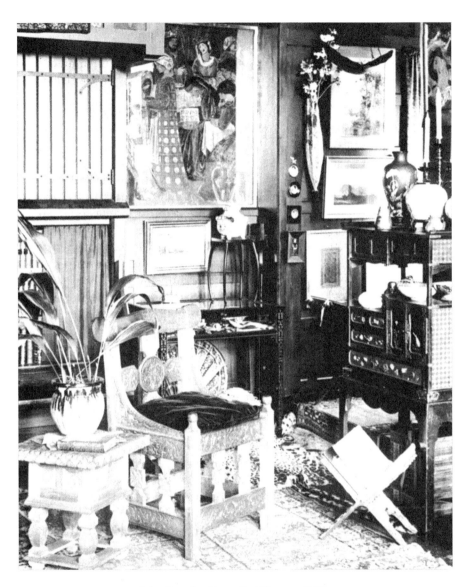

2.1 *Drawing Room, Red House,* c.1890s.

Studio in 1893. Thus, for much of his time at Red House, Holme pursued two not incompatible aims: the promotion of good design – whether through commercial trade with Asia or through the championing of new art and architecture – and the improvement of Anglo-Japanese social and political relations.[10]

As part of his mission, Holme hosted many events at Red House during his years there. He seemed to view his socializing as a significant activity in its own right – very much like Morris who had designed Red House for collegiality and conviviality.[11] Holme invited visitors to the house to inscribe their names into the glazed screen built to divide the back corridor from the main hallway; by ensuring that this delicate but indelible trace of his own social activities remained on the house's surface (as opposed to, say, in a visitor's book), Holme betrays a consciousness about Red House's historical importance as well as that of his guests. Indeed, this record of names is impressive, and includes everyone from distinguished Japanese visitors like Goh Daigoro, Chancellor of the Imperial Japanese Consulate-General in London, to significant Arts and Crafts figures like Baillie Scott, Charles Harrison Townsend and Arthur Liberty. Morris's daughter, May's, signature is also inscribed there. The signed glass panels testify to the fact that Red House occupied an important place in a culture of international exchange around the turn of the twentieth century.

When Morris died in 1896, *The Studio* published an ungenerous but revealing assessment, possibly penned by Holme himself: 'The loss of William Morris, great as it is, must not be over-estimated; his real work was accomplished years ago.'[12] By 'real work years ago', Holme no doubt had Red House in mind, as it was starting to be claimed either as the progenitor of the Arts and Crafts movement or of the Queen Anne revival. In the first biography of Morris, written in 1897, Aymer Vallance, a contributor to *The Studio* and a signatory of the glazed panels, claimed that Red House's frank use of local red brick had ushered in 'a new era of housebuilding'. He elaborated: 'It is indeed remarkable as being the first example of the artistic use revived of red brick for domestic purposes.'[13] The biography also marks the point at which images of the house enter the historical record and begin to circulate publicly, as Vallance illustrated his commentary with two exterior views (both from the garden, emphasizing the house's L-shape and picturesque detailing), two interior views (one of the entrance hall staircase, one of the upper landing), and three views of decorative elements (two of Burne-Jones's stained glass windows in the ground floor passage, and one of Webb's dining room dresser). Although Holme is not mentioned, the interiors do bear his stamp; his taste is particularly evident in the view of the upper landing, where his prints, oriental objects and gilt wall coverings are all visible.

Red House's importance to the history of architecture was reiterated in the next biography of Morris in 1899 by Burne-Jones's son-in-law John William

2.2 *View of Upper Landing, Red House*, Vallance, 1897.

Mackail. This biography placed more emphasis on the house's unity, inside and out, and its custom-designed furnishings and utensils. Mackail was evidently aware of the changes Holme had made to the house's interiors; unlike Vallance, who did not explicitly distinguish between the original decorative features and the later additions, Mackail was scrupulous about differentiating between the two periods in the house's history. To set the stage, he first rolled back time, reminding readers of a moment when Red House was a 'shell … clean and bare among the apple trees', an empty vessel, waiting to be filled. He wrote:

Only in a few isolated cases – such as Persian carpets, and blue china or delft for vessels of household use – was there anything then to be bought ready-made that Morris could be content with in his own house. Not a chair, or table, or bed; not a cloth or paper hanging for the walls; nor tiles to line fireplaces or passages; nor a curtain or a candlestick; nor a jug to hold wine or a glass to drink it out of, but had to be reinvented, one might almost say, to escape the flat ugliness of the current article.[14]

Once he had stripped the rooms back to bare essentials (and banished Holme's orientalist clutter from his readers' minds), Mackail began to fill them again with their original furnishings. He informed readers, for instance, that: 'Much of the furniture was specially designed by Webb and executed under his eye: the great oak dining-table, other tables, chairs, cupboards, massive copper candlesticks, fire-dogs, and table glass of extreme beauty.'[15] Mackail's imaginative evocation of the interior was enabled by the fact that Burne-Jones, Webb, and members of Morris's family had all shared their recollections of the house and its furnishings with him. (They had refused to speak to Vallance.) In this way, the first substantive description of Morris's Red House interior entered the historical record – nearly 35 years after Morris and his family had left and most of its furnishings had been dispersed.

Although they were quite distinct from each other, the two biographies together put Red House permanently, if belatedly, on the architectural map, Mackail in particular being the basis for many subsequent scholarly encounters with the house. Yet it should not be forgotten that, at the very moment that it was beginning to be championed for its local vernacular style and artistic unity, Red House had become a showcase for objects and furnishings that Holme had imported. Thus, Red House's interior was also at the centre of international exchanges that defined the new artistic culture, both reflecting and shaping a cosmopolitan way of life.

Red House: The Hollamby Years (1952–2003)

The story of how current inhabitants shaped the reception of Morris and Red House becomes even more tangled when we consider our next case. What

you see when you visit the house presently is the interior left by its last owner, Ted Hollamby, and his wife Doris, who occupied it for an incredible 51 years. In 1952, Hollamby's family came to live in the house along with the family of fellow architect Dick Toms, who bought the house. Both men were working as architects at the London County Council (LCC) at the time and had previously talked about sharing a house together. In 1957 another LCC architect, Jean Macdonald, and her husband David bought the house from the Toms.

Over 13 years, the Macdonalds and Hollambys occupied the house together. Though they each maintained separate rooms, kitchens and bathrooms, everyone participated in different ways with fixing, restoring and decorating the house.[16] As Hollamby told us in an interview shortly before his death in 1999, the house was very much as it had been in Morris's day, where 'everybody was doing something, making something'. As Jean Macdonald recounted, during the course of their own decorative activities, they discovered original decorations from Morris's time, and tried as best they could to preserve them. Significantly, however, this did not hinder their own decorative forays made in the spirit of Morris, including a bookshelf designed by Jean and tenant David Gregory-Jones, which remains in the drawing room today.[17] A photograph of the drawing room (which excludes the modern bookshelf) reproduced in *Country Life* in 1960 testifies to the fact that the Macdonalds, who used this room during their time at the house, in

2.3 *Drawing Room, Red House*, 1960. *Country Life*, 16 June 1960.

no way tried slavishly to reproduce Morris's aesthetic. The image reveals a clean white interior – Holme's gilding is long gone. As the Ernest Race armchairs and rush-seated Danish rocking chair prove, their desire as modernist architects was clearly for up-to-the minute comfort, style and practicality. Jean Macdonald remarks how the drawing room settle 'adapted well to house modern hi-fi equipment. The speakers were concealed behind the parapet of the "minstrel's gallery," the turntable and amplifier hidden in a cupboard.'[18]

Over time, however, Hollamby attempted to redecorate the house with Morris & Co. products. He had used hand-blocked Morris paper in two schools he designed in Hammersmith in the early 1950s,[19] and as resources became available, he began to cover walls in Red House with Morris papers and to cover furnishings with Morris fabrics by Liberty and John Lewis. Other walls were simply left white or light in colour.[20] Hollamby's relationship with the wallpaper company, Sanderson, apparently became so close that the company asked if Red House could be used by them as an exhibition space for a week during Architectural Heritage Year in 1975. Hollamby recalled the company's display of wallpapers and fabrics set up on frames in the hallway and gallery, and people traipsing through the house to look at them.[21] Earlier, in 1953, with Nikolaus Pevsner in attendance, the William Morris Society was formed at an inaugural meeting at Red House, and the Society celebrated the centenary of the house in 1959 with a party at which John Summerson spoke.[22]

It is an intricate and layered story, for Hollamby effectively describes how, retroactively, he turned Red House into a showcase of Morris's designs, and helped in the renewal of architectural interest in the house.[23] There is nothing 'authentic' about his redecoration of Red House in the sense that the Morris & Co. products he used were designed well after the time Morris had lived in Red House. But he is rightly credited with improving the condition of the house and garden, and maintaining them until his death, even if Hollamby was clear that he didn't see his aim as preservation.[24] He remarked:

Conservation isn't preservation. It isn't restoration to what was believed to be what it was, static and never changing. But the spirit of something and the spirit of Red House I think is still here. We wanted it to be here, but it couldn't be here in the same form as it was for Morris. It would have to be adapted.

The reconstituted interior of Hollamby's time was a fusion of Arts and Crafts decoration and Modernist furnishings that was quite distinct in its effect from either Morris's medieval or Holme's oriental construction. In the rooms the Hollambys occupied, a Marcel Breuer Isokon nest of tables sat quite happily amongst chairs covered in Morris fabrics, and a purpose-designed desk and architect's drawing table was built into the Morris-wallpapered study. In their spirited occupation of the house, both Holme and Hollamby, while respectful

of the house's architectural value, appeared to understand instinctively the interior as something made from things and images that freely circulate and pass through a house, and participate in various lives.

Red House is in the midst of a new phase of its life as it transitions from an occupied house to a house museum. While Hollamby opened the house to the public during his time there, and his own additions are still a visible part of its presentation, the National Trust is undertaking extensive analysis of the original decorative treatments, and presents the house in the context of the time Morris inhabited it.[25] This presentation, not unreasonably, reinforces the house's architectural significance, which stems from the vision of its original owner. Unlike many heritage properties in which the illusion of inhabitation is complete, however, the thorough dispersal of Red House's original furnishings – to Morris's other home, Kelmscott Manor, or to his close friend Emery Walker's house in London or to various museum collections – means that the property today is rather sparsely furnished.[26] Ironically, the contemporary experience of Red House is not so far removed from what Mackail invoked: a 'shell … clean and bare among the apple trees'.

This clean shell does, however, bear the traces of the different interiors its successive inhabitants constructed there. Evidence for these interiors still exist at the house: the decorations painted directly onto surfaces by Morris and his friends, Holme's battens in the drawing room and the etched glass screen, Hollamby and his co-inhabitants' addition of wallpaper and other decorative and functional treatments. Crucially, also, visual images and written accounts from different times record and evoke a range of objects and schemes which passed through the house.

Though this evidence is less tangible than the bricks and mortar which ensure the house's continued architectural presence, a no less real sense of the house's significance can be revealed through the interior; that is, through the dynamic and changing nature of its inhabitants' lives there. Red House's importance as a case study of the modern interior is revealed here. While there have always been decorative schemes for domestic environments, the modern interior emerged from the beginning of the nineteenth century when there was a new consciousness about objects and decorative treatments being specifically brought together and constructed *as an interior*, and when images were made to represent these specific constructions. For the first time, these decorative schemes and their images were conceived as a spatial totality separately from the architecture that would support them.[27] The separateness of the interior from architecture meant that the interior could have its own life and its own significance. As Morris and Holme so clearly demonstrated during their time at Red House, one's own interior could be the testing ground for products and schemes produced or traded commercially, things that would circulate in the world and be acquired to construct numerous interiors in many different contexts. Shopping at John Lewis and Liberty, Hollamby

did not betray the authenticity of inventing and making-do underpinning Red House's original decorations. Rather, he confirmed the trajectory of this beginning point, even if Morris may never have intended, nor could have foreseen, the extent of the commercialization and proliferation of his designs.

Though architectural scholars may continue to debate the reasons for Red House's canonical status for years to come, the house's value to scholars of the interior is evident, even if what is now to be found at the house is something more akin to a shell. Indeed, it is precisely because there is no 'original' interior to be found at the house, that the condition of the interior's modernity is all the more clearly displayed. Tracing how its interior has been constructed and propagated through the circulation of images and objects, we touch on what makes the interior modern: the modern interior has a life – and a significance – all its own.

Notes

1. There have been important dissenting voices, however. Robin Evans argues that there is nothing radical about Red House. Its plan exemplifies the technique of 'room and corridor' planning which, by the time of its construction, reinforced middle-class conventions. The corridor promotes the separation of and controlled interconnection between rooms; Evans notes that this creates a way of living where unnecessary and unplanned contact is avoided and a strict division between served and servants is enforced. For all the talk of communal living, Evans concludes, Red House's plan manifests a typically Victorian reticence towards contact. Robin Evans, 'Figures, Doors and Passages', in *Translations from Drawing to Building and Other Essays* (London, 1997), pp. 80–83.

2. Nicholas Cooper, 'Red House: Some Architectural Histories', *Architectural History*, 49 (2006): p. 217.

3. Cooper, 'Red House', p. 216.

4. For a full list of owners and occupiers of Red House, see Sonia Ashmore and Yasuko Suga, 'Red House and Asia', *The Journal of William Morris Studies* (Winter 2006): p. 6.

5. Edward Hollamby, interview with Barbara Penner and Charles Rice, Red House, Bexleyheath, 1 December 1999. Unless otherwise stated, quotations from Hollamby are from this interview; Jonathan Glancey, 'Edward Hollamby', *The Guardian* (Monday 24 January 2000), http://www.guardian.co.uk/news/2000/jan/24/guardianobituaries, accessed October 2012.

6. Tessa Wild, Curator of the Thames and Solent region of the National Trust, with responsibility for Red House, first published an account of these photographs. See Tessa Wild, 'More a Poem than a House', *Apollo: The International Magazine for Collectors* (April 2006). www.apollo–magazine.co.uk/april-2006/more-a-poem-than-a-house.thtml, accessed July 2009.

7. Jan Marsh, *William Morris & Red House* (Great Britain, 2005), p. 106.

8. Fiona MacCarthy, *William Morris* (London, 1994), p. 395.

9. See Ashmore and Suga, who describe the first company's activities as exporting woollen fabrics from Bradford to Asia, and importing carpets, embroideries, shawls and silks, and later, furnishings and ceramics. Ashmore and Suga, 'Red House and Asia', p. 9.

10. Ashmore and Suga provide an excellent overview of Holme's activities during his time at Red House. Ashmore and Suga, 'Red House and Asia', pp. 5–26.

11. MacCarthy, *William Morris*, p. 155.

12. *The Studio*, 1894, pp. 99–101, quoted in Marsh, *William Morris & Red House*, p. 110. Marsh asserts that Holme was the 'probable' author of this piece.

13. Aymer Vallance, *The Life and Work of William Morris* (London, 1986 [1897]), p. 44. Vallance had also interviewed Morris for *The Studio* in 1894.

14. John William Mackail, *The Life of William Morris* (2 vols, London, 1912 [1899]), vol. 1, p. 147.

15. Ibid. The Red House glasses can now be seen in the Webb-designed display cabinet in the drawing room of the Emery Walker House at 7 Hammersmith Terrace, London.

16. For a good account of Morris's commitment to these values, see MacCarthy, *William Morris*, especially pp. 63–8; 129–34; and 154–96. For an account of Morris's influence on Hollamby, see Ted Hollamby, 'The Influence of William Morris: A Personal Recollection', in Alan Crawford and Colin Cunningham (eds), *William Morris and Architecture (Papers from the Annual Symposium of the Society of Architectural Historians of Great Britain)* (1996): pp. 101–14.

17. Jean Macdonald, 'Red House after Morris', *The William Morris Society Newsletter* (Winter 2004): pp. 6–10.

18. Macdonald, 'Red House after Morris', p. 6.

19. Ted Hollamby, 'The Influence of William Morris', pp. 104–5; 109–10; 114.

20. Hollamby remarked how one of the first things done in redecorating the house was to remove brown Lincrusta wall covering from the entrance hall. This covering, together with floral wallpaper on the stairwell, can be seen in photographs of the interior taken as part of a general building survey by the National Monuments Record in 1944. Though an up-to-date photographic survey of the interior had been published in *Country Life* in 1960, these National Monuments Record photographs were used to accompany an excerpt from Muthesius's *The English House* published in *Architectural Design* in 1980. See Hermann Muthesius, 'Extract from *Das Englische Haus*', *Architectural Design*, 50/1–2 (1980), pp. 21–4.

21. Unfortunately, Sanderson were unable to verify or provide further details of their decision to use Red House to promote Morris's products. Personal communication to Charles Rice and Barbara Penner from Freddie Launert, Sanderson, 19 January 2000.

22. Macdonald, 'Red House after Morris', pp. 5, 10.

23. Hollamby opened the house to the public by appointment once a month, and published his own history and guide to the house. Edward Hollamby, *Red House. Philip Webb* (London: 1991).

24. Jean Macdonald gives an account of the state the house was in when the Hollambys and the Toms moved in: old Victorian plumbing had to be removed, floors sanded, windows repaired, the brick chimney breast in the drawing room scrubbed of its red overpaint, stable roofs replaced, and the garden cleared of large amounts of rubbish and brought back under control. In 1962 the entire roof of the house was replaced, funded by a grant from the Ministry of Works. New bathrooms and kitchens were also fitted for each family. See Macdonald, 'Red House after Morris', pp. 4–5, 8.

25. For the latest information on Red House, see the National Trust website: http://www.nationaltrust.org.uk/red–house/, accessed February 2012.

26. Both Kelmscott Manor and the Emery Walker House can be visited today. In particular, the fascinating but little known Emery Walker House offers visitors the chance to experience more 'intact' Arts & Crafts domestic interiors than the Red House itself as it is filled with objects and furnishings produced by both Webb and Morris; see www.emerywalker.org.uk, accessed April 2012. See also Aileen Reid, '7 Hammersmith Terrace, London', *The Decorative Arts Society Journal*, 28 (2004): pp. 184–203.

27. See Charles Rice, *The Emergence of the Interior: Architecture, Modernity, Domesticity* (London, 2007).

At Home, 16 Tite Street

Richard W. Hayes

One of the most well-known facts in British Aestheticism is that in 1884 Oscar Wilde hired architect E.W. Godwin to design the interiors of his London home on Tite Street in Chelsea (Figure 3.1).[1]

Often referred to as the 'House Beautiful' after Wilde's lecture with that title, the project has long been the absent presence of the Aesthetic Movement, since its contents were sold and interiors destroyed after Wilde's 1895 prosecution and imprisonment. Only a few fragmentary sketches survive (Figure 3.2). Recollections by third parties – including Wilde's son, Vyvyan, writer William Butler Yeats, and family friends Anna de Brémont and Adrian Hope – offer tantalizing glimpses of the now-lost interior realm, but some of these descriptions contradict one another, suggesting that changes occurred in the course of the ten years Wilde and his family lived in the compact, four-storey house.

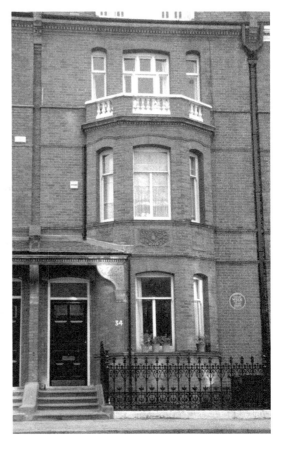

3.1 Photograph of *16 [Now 34] Tite Street, Chelsea, London.*

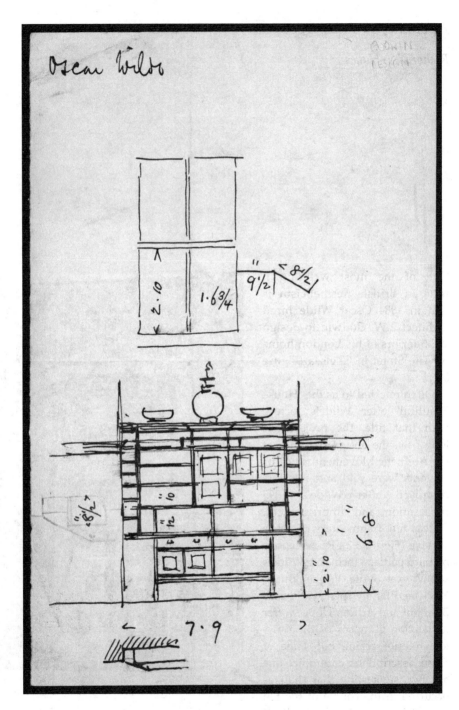

3.2 E.W. Godwin, *Design for a Sideboard for Oscar Wilde*,
16 Tite Street, London, 1884. Pen and ink.

Wilde's house has usually been interpreted in terms of the decorating manuals that proliferated during the second half of the nineteenth century. Writers such as Charles Locke Eastlake, the Reverend Loftie, Rhoda and Agnes Garrett, and Mary Eliza Haweis brought attention to the middle-class domestic interior, turning it into a subject of intense discussion and debate.[2]

In this chapter, however, I am proposing an alternative approach from studying Wilde's London home in light of these decorating manuals. This volume's theme of interior lives offers the opportunity to inquire into the lives lived at 16 Tite Street, the place of the house in Wilde's biography, and its relationship to the writer's long-standing interest in the decorative arts. A consideration of Wilde's friendship with some of the most important designers and artists of the Aesthetic Movement will, I hope, underscore the significance of the interior realm to Wilde. What will emerge is how the writer understood the domestic interior as the setting for subjective inwardness, as facilitating sociability, and as a key element in the cosmopolitan experience of the metropolis. Finally, the house will be seen to occupy a distinct phase in Wilde's biography, to be surpassed as a locus of interest once his playwriting career and homosexual experiences burgeoned.

Chairs and Chatter

A good, if inevitable, place to begin is with a quote from Wilde. In 1890, just after completing *The Picture of Dorian Gray*, Wilde turned down an invitation to Bournemouth from novelist Beatrice Allhusen, writing, 'I have just finished my first long story and am tired out. I am afraid it is rather like my own life – all conversation and no action. I can't describe action: my people sit in chairs and chatter.'[3] The remark hints at the significance of the interior realm to Wilde. To sit and chatter, one needs chairs, possibly a settee, maybe a tea table, and a room to enclose them. Such an elemental *mise en scène* is at the heart of all of Wilde's major works. The importance of the interior to Wilde is further conveyed in the opening lines of his provocative philosophical dialogue, *The Decay of Lying: An Observation*, in which the character Vivian states, 'I prefer houses to the open air. In a house we all feel of the proper proportions. Everything is subordinated to us, fashioned for our use and our pleasure. Egotism itself, which is so necessary to a proper sense of human dignity, is entirely the result of indoor life.'[4]

As the passage suggests, fashioning the interior as a setting for the cultivation of the self is one of Wilde's most important themes, and it is fruitful to look at his role of 'Professor of Aesthetics' in the light of this. What Wilde called 'indoor life' as the setting for self-culture is of pivotal importance to his career, and his interest in furniture, decorating and the decorative arts follows from this theme. Wilde pursued an individual

interpretation of the ideal of self-fashioning enunciated by his former Oxford teacher, Walter Pater. In his chapter on Winckelmann in *The Renaissance*, for example, Pater expressed his admiration for Hegel's interpretation of Greek sculpture: 'They are great and free, and have grown up on the soil of their own individuality, creating themselves out of themselves, and moulding themselves to what they were, and willed to be.'[5] In narratives like 'The Child in the House' of 1878, Pater traced the psychological ties between the material world – concretized in an old house – and subjective experience. For Pater, the capacity to respond with both empathy and aesthetic attentiveness to life derives its core strength from an experience of interiority.[6] In a similar vein, Wilde's attention to ties between self-culture and 'indoor-life' has an intellectual dimension that sets him apart from the decorating manuals he nevertheless read.

Wilde was also fortunate to live during an era characterized by an outstanding level of achievement in domestic architecture. Architects and designers such as William Burges, Christopher Dresser, E.W. Godwin, Thomas Jeckyll, William Morris, Richard Norman Shaw and Philip Webb all made significant contributions to design history through their houses, furniture and designs for the applied arts. This is the period studied by the German diplomat and architect, Hermann Muthesius, in his three-volume opus, *Das englische Haus*, in which he wrote, 'the modern English house engages our attention largely because of the high level of culture it expresses'.[7] Contemporary architectural historian Barry Bergdoll has recently argued that the most progressive architects of the second half of the nineteenth century created realms for personal realization and the cultivation of individual subjectivity.[8] As a youth, Wilde was clever enough to seize this cultural moment, seeing it as a field for his project of self-invention and subject matter for his paradoxical habit of thought.

This is true of Wilde when he was an undergraduate at Magdalen College, Oxford, where one of his chief interests was in furnishing his rooms, for which he purchased expensive china and ornaments. During this period, Wilde famously declared, 'I find it harder and harder every day to live up to my blue china.'[9] As Deborah Cohen has observed, the pungency of the comment lies in the substitution of domestic décor for religion, the occlusion of the spiritual by the decorative.[10] Its pointedness was clearly understood by contemporaries. The rector of St Mary's, the university church of Oxford, felt compelled to chastise the speaker in a sermon a few years later: 'when a young man says not in polished banter but in sober earnestness, that he finds it difficult to live up to the level of his blue china, there has crept into these cloistered shades a form of heathenism which it is our bounden duty to fight against and to crush out', thundered Dean Burgon.[11] Paradoxically inverting religious values, the remark heralds Wilde's insight that the domestic interior was the place from which to issue oracular pronouncements.

After taking his degree from Oxford in 1878, Wilde came to London intent, as Richard Ellmann noted, on being at the centre of metropolitan life. Wilde shared a house with artist Frank Miles on Salisbury Street, between the Strand and the Thames. In these London lodgings, Wilde sought to continue the atmosphere of his rooms in Magdalen. According to Ellmann, the interior was notable for 'a long sitting room done entirely in white paneling … there was blue china and lilies were everywhere. Edward Poynter's portrait of Lillie Langtry stood on an easel at one end of the room like an altar.'[12]

Wilde insinuated these carefully arranged interiors into his letters, most of which consist of invitations to tea, advertising the artistic surroundings and alluding to Miles's models. In a letter of 1879 to an undergraduate at Balliol, for example, Wilde wrote, 'I very often have beautiful people to tea, and will always be very glad to see you and to introduce you to them.'[13] In other letters, Wilde mentioned Miles's recent award from the Royal Academy to lure guests. 'Will you come and see Frank Miles's picture which got the Turner silver medal this year and have some "Tea and Beauties" at 3:30 tomorrow'? Wilde wrote to an art collector, for example.[14] Not merely settings of subjective inwardness, the aesthetic interior became a component of Wilde's strategies of self-promotion, a quasi-public setting for self-presentation. Wilde mastered the techniques of a burgeoning mass media and the distinctively designed interior – ornamented with blue and white china, populated by professional beauties – was a way to catch the attention of London society. Asking visiting celebrities to write their names across the white-painted woodwork, Wilde blurred the boundaries between privacy and publicity. For Wilde, self-culture required an audience. The aesthetic interior was a complement to Wilde's dandyism, as the young writer sought self-display in interiors arranged to facilitate his remarkable powers of conversation. In so doing, Wilde participated in the network of causeries that characterized the Aesthetic Movement.[15]

The interior as a carefully composed setting for self-display and sociability may have ties to the aristocratic tradition of the salon; it relates as well to the Irish hospitality of Wilde's forbears, particularly his mother, Lady Jane Wilde, who was known for her Saturday afternoon 'at-homes'. Lady Wilde followed her son to London and established herself first in Ovington Square and then in Grosvenor Square, where she presided over a tea table that welcomed prominent guests. She saw it as her duty to contribute to social life. Describing her as a *grande dame*, Ellmann wrote, 'Lady Wilde was a guileless and good-hearted show-off. Her house became a place to meet people, and guests such as Bernard Shaw and Yeats, newcomers to London, were grateful to her.'[16] The American Anna de Brémont described these 'at-homes' as somewhat eccentric yet memorable affairs, given with

much éclat by Lady Wilde, who dominated her surroundings by force of her personality. According to de Brémont, Lady Wilde gave the 'impression that it was she who made the room' even when high-profile guests were present.[17] Wilde himself acknowledged 'usually some good literary and artistic people take tea with her' and he learned from his mother the importance of fashioning the home as a cynosure of hospitality, self-display and sociability in the metropolis. What Wilde added was not only the most up-to-date aesthetic décor, but an appreciation of how the private interior could be inserted into the mechanisms of mass media and celebrity culture. Wilde thus anticipates what contemporary theorist Beatriz Colomina has defined as an essential characteristic of modernity: using the mass media to make the private public.[18]

After a year on Salisbury Street, Miles and Wilde moved to what was becoming the fashionable neighbourhood for London's finest artists: Chelsea, and specifically the recently developed Tite Street, which runs along the southwestern perimeter of the Royal Hospital. In 1878 Miles commissioned architect E.W. Godwin to design a combined house and studio on the west side of the street, almost directly opposite the house Godwin had designed the year before for American expatriate painter James Whistler, a design that is often considered to be one of the era's most progressive works of domestic architecture.

'The Greatest Aesthete of Them All'

E.W. Godwin was one of the leaders of the Aesthetic Movement, described by Max Beerbohm as 'the greatest aesthete of them all' and saluted by Wilde as 'one of the most artistic spirits of this century in England'.[19] Born in 1833 in Bristol, Godwin took an early interest in architecture and theatre, publishing drama criticism while using his Bristol home as a laboratory for design reform. Beginning as early as the 1860s Godwin designed simple and elegant interiors, characterized by bare wood floors covered with Chinese matting, walls painted in soft colours instead of papered in bold patterns, and sparse groupings of furniture, thin and tapering in shape.[20] Godwin's innovations in interior design helped effect what has been called 'the great cleaning up' of the typical Victorian interior with its overstuffed upholstery, heavy drapery, and cluttered rooms.[21]

Godwin's radicalism as a designer is most apparent in his furniture, such as his design for an ebonized sideboard that has become emblematic of the Aesthetic Movement (Figure 3.3). In this and similar designs, Godwin attenuated historical precedent and focused on internal relationships of solid and void in a way that seems to anticipate the formal autonomy of modern sculpture.

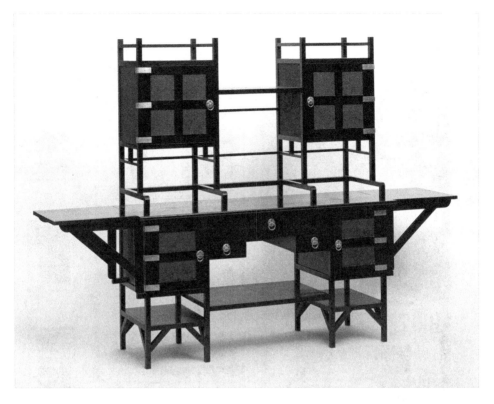

3.3 E.W. Godwin, *Sideboard*, 1867–1870. Mahogany with silver-plated handles and inset panels of embossed leather.

Godwin's original scheme for Frank Miles's house and studio was one of his finest designs, the façade of which was a near-abstract composition of interlocking rectangles, influenced by his study of Asian art. Wilde's role, if any, in the design process for this house has never been clear. It does seem that from the beginning of the project a room was set aside for Wilde as tenant. Additionally, Wilde's letters from this period suggest he played a role in furnishing the house. In August 1880, for example, he wrote, 'I am trying to settle a new house, where Mr Miles and I are hoping to live.'[22] Ironically describing the rigors of decorating, Wilde observed, 'nowadays the selection of colours and furniture has quite taken the place of the cases of conscience of the middle ages, and usually involves quite as much remorse'.[23]

It was during the period when Miles's house was designed, constructed and furnished that Wilde became a close acquaintance of Godwin. Godwin was meticulous in record keeping, evincing a pernicketiness somewhat at odds with his bohemian lifestyle. His unpublished office diaries reveal that he and Wilde moved in each other's orbits to a noteworthy degree during

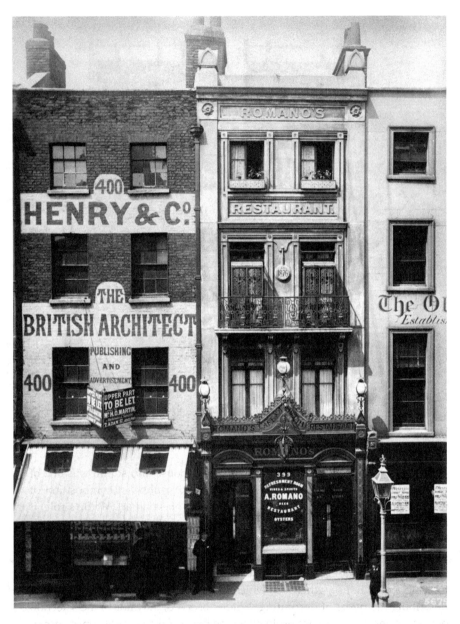

3.4 Photograph by Bedford Lemere of *Romano's Restaurant and Adjoining Buildings on the Strand, London*, 1885.

the years 1879 and 1880. Godwin also became close to Wilde's mother and brother Willie during this period. Initially, the architect took Lady Wilde and her sons to see his previously completed buildings. Later, he began attending the Saturday at-homes of Lady Wilde, and Oscar and Willie dined with Godwin at his own home. Oscar also dined frequently with Godwin at restaurants that have come to be considered characteristic locales of the Aesthetic Movement: Kettner's in Soho, the Café Royal in Piccadilly and Romano's in the Strand (Figure 3.4).

Godwin's Diaries

Wilde first appears in Godwin's diaries on 2 July 1879, when the architect wrote, 'To lunch then w[ith] wife + self in cab to Oscar Wildes + on to Robertsons [;] dined there [;] back to Wilde's [;] met Lady Campbell.'[24] By August, Godwin was writing: 'To Mays to lunch [;] met Lady Wilde + her sons [,] dined at Monaco['s] together.' By the autumn of 1879, Godwin had become a member of Lady Wilde's *cénacle*, and a characteristic entry in October is 'On to Lady Wilde's at 6. Oscar + I dined at Romano's.' A little later that month, Godwin recorded, 'I called for Lady Wilde [;] took her to see houses in Tite St [;] Oscar joined us.' A month later: 'With O. Wilde to Bond St galleries [;] dined with him + Miles at Romano[']s. Wilde + self to Robertson's, late.' The diaries limn a narrative of sociability in the metropolis, an urban geography of the Aesthetic Movement, as restaurants, theatres and galleries become sites of planned or chance encounters. On 24 October 1879, for example, Godwin noted, 'Evening, took wife to Sadler's Wells to see Romeo + Juliet. Oscar Wilde there.' A similar entry recounts, 'Met Oscar Wilde passing Lyceum. After, supped at Albion.' Wilde became a regular dinner companion of Godwin's, as for example, the architect wrote on 6 November, 'O. Wilde returned home with me to dine.' On 13 November: 'Oscar Wilde dined here.' These get-togethers continue through the spring of 1880, as on 8 February Godwin noted, 'In evening Oscar Wilde + Norman Robertson came [home]' followed the next day by 'Eveg. [,] dined with O. Wilde at Romano[']s.'[25] And on 2 March 1880 the simple note: 'Oscar Wilde to dine.' By the end of 1881, Wilde had severed his friendship with Miles, and, looking for a way to earn money, left London for a year-long lecture tour of North America.

Godwin's diaries are instructive for the extent to which they portray Wilde as embedded in a network of family relationships during the years immediately after he left Oxford. They also intimate thematic connections among domestic design, theatre-going, and art world camaraderie. Far from a declaration of artistic autonomy, the diaries suggest how the Aesthetic Movement was anchored in a continuum of sociability and

shared experience of the city. It seems reasonable to posit that it was in the course of their many meals together that Godwin tutored the young Wilde in issues of design. As a laureate in *literae humaniores* at Oxford, Wilde had no background in design culture, and a number of the prescriptions he went on to espouse in his lecture 'The House Beautiful' bear the imprint of Godwin, as architectural historian Henry-Russell Hitchcock pointed out in 1958.[26]

It should therefore come as no surprise that when Wilde was ready to move into his own home, he returned to the milieu of Tite Street and hired Godwin to design its interiors. In 1884, the writer married Constance Lloyd, and with money from the estate of her grandfather, the couple leased a terraced house at 16 Tite Street, one of a row of residences built on speculation a few years earlier.[27]

'The Unpretentious House on Tite Street'

Each floor of the house had a front and back room along with the staircase hall. The basement contained kitchen, pantry, scullery and servant's room. On the ground floor were Wilde's study at the front and dining room at the rear. The first floor held the drawing room, divided into two, with the rear used as a smoking room and decorated in Near Eastern motifs. The floor above contained two bedrooms, Constance's at the front; Wilde's at the rear. Another study for Wilde was located on the top floor; later, there were nurseries for the couple's sons, Cyril, born in 1885 and Vyvyan, born in 1886. After the birth of the boys, the household included a cook and butler, along with a series of maids.

Godwin focused his attention on the first two floors, where he prepared a distinctive design strategy for each room. Most notable was the ground floor dining room with its white woodwork and white furniture. Godwin's notes to the painters reveal the painstaking care he took in achieving the desired tone for the space. He wrote, 'the whole of the woodwork to be enamel white the walls pt in oils enamel white and grey to the height of 5 [feet]-6 [inches]. The rest of the walls and ceilings to be finished in lime-white with slight addition of black to give the white a greyish tone.'[28]

One of the room's most unconventional features was a continuous shelf along the walls, only nine inches deep, used to serve from during meals. Such a design was a conceptual deconstruction of the traditional sideboard, distributing its functions throughout the room in order to impart a sense of lightness and volumetric cohesion to the space. Traditional sideboards were usually substantial, if not cumbersome, presences in dining rooms, laden with serving ware and displaying prize china or silver. They exemplified what literary critic Michael Riffaterre described in another context as 'a

particularly tangible kind of reality: the pride of bourgeois life, the ultimate actualization of presence in a house, of its completeness as a social status symbol'.[29] Godwin subverted such associations by literally displacing the presence of the sideboard, turning it into a minimally intrusive, built-in feature. One of Wilde's letters to Godwin reveals that, like many clients, he was wary of his architect's unconventional design. Wilde wrote, 'As regards the shelves for the dining room, the wall is 14 ft long. Don't you think this too long for a single shelf? I was thinking they need not go right across, but designs are being prepared.'[30]

Godwin nevertheless prevailed and the dining room was a study in lightness, delicacy and simplicity; it was the room most visitors remarked on for its novelty. Anna de Brémont, for example, included a vivid description of the room in her account of a reception at the Wildes:

I was not prepared for the crush of fashionable folk that crowded the charming rooms of the unpretentious house on Tite Street. There was an air of over brightness and luxury about it ... A smart maid opened the door and I found myself drawn with the crowd in the wide hallway towards the dining-room. There tea was served in the most delightfully unconventional manner from a quaint shelf extending around the wall, before which white enameled seats – modelled in various Grecian styles – were placed ... I presently found myself sitting in one of the white Greek seats, drinking tea out of a dainty yellow cup that might have been modelled from a lotus flower and being talked to by a young poet, while I watched the company passing in and out of that very aesthetic dining-room, that by its very simplicity, harmonised with the variegated summer costumes of the women, and the grey suits or black frock-coats of the men.[31]

As de Brémont's account suggests, Godwin created a distinctive and memorable setting for receptions and dinner parties by recalibrating the 'at-homes' of the milieu that Oscar and Constance moved among, including Lady Wilde's, which Godwin himself had attended. These 'at-homes' – or 'crushes' – usually consisted of a social parade that began with a reception on the ground floor, light refreshments in the dining room, concluding in conversation with the host and hostess in a second floor drawing room. De Brémont commented on the popularity of such receptions, noting 'the crowded At Homes, where people crush like sardines in a box, happy in the idea that they are enjoying themselves in proportion to the crowd'.[32]

Wednesday evening was the day the Wildes set aside for their 'at-homes', as revealed in letters where Wilde advised correspondents to 'keep yourself free for Wednesday night'.[33] Similar to the ways in which Wilde tweaked conventions in his society plays – leading one twentieth-century critic to label him a 'conformist rebel'[34] – Godwin in his design for Oscar and Constance recalibrated prevailing domestic conventions without countermanding them. The dining room's white colours alluded to the avant-garde artist studios Wilde sought to be associated with; yet the room functioned equally well for

luncheon parties held by Constance, who may have appreciated the feminine character of the design. The very emphasis on the dining room in the house's overall scheme suggests the importance of entertaining to Wilde, whose conversation was legendary, often causing, as Merlin Holland noted, 'dinner-tables to fall silent to listen to him talk'.[35]

The design for the front drawing room on the first floor was consonant with the dining room, with slightly greater colour range: above the white-painted wood wainscot, the walls were painted flesh pink up to a cornice in lemon gold. Godwin's notebooks indicate only a few pieces of furniture for the drawing room, once again suggesting a spare environment. The room was nevertheless the prime representational space of the residence, serving to set off Wilde's art collection, which Godwin took particular care in arranging.[36] The room was also where the family itself was displayed: Vyvyan Holland recounted that it was in the drawing room that he and Cyril were periodically 'exhibited to guests, a ceremonious procedure we viewed with disfavor and avoided whenever possible'.[37]

If the front drawing room was the house's representational space, Wilde's library on the ground floor was among the most private, closed to the children and described by Holland as sacrosanct, 'this holy of holies', focused on a writing table believed to have been owned by Thomas Carlyle.[38] Godwin's notes called for a darker and more variegated palette, with russet woodwork, dark blue walls and a pale gold ceiling. Holland, however, remembers yellow walls and enamelled red woodwork, suggesting that changes occurred in the course of the decade the family lived in the house. That the library was the sentimental heart of the house for the writer is clear from De Profundis, where Wilde plaintively rued the loss of 'my Library with its collection of presentation volumes from almost every poet of my time ... with its beautifully bound editions ... its wonderful array of college and school prizes, its éditions de luxe'.[39] As this plangent passage suggests, Wilde's library was an on-going, autobiographical construction, a spatial manifestation of his ideal of self-culture. Wilde's growing awareness of his homosexuality may also have been manifested in a statue of a nude Hermes prominently displayed in the library.[40]

Seeking to locate encoded messages of Wilde's homosexuality in his family home, however, may be problematic. A few years after the births of his sons, Wilde developed the habit of renting rooms in the West End or lodgings out of town in order to write, to carry on his affair with Lord Alfred Douglas, and to entertain rent boys, entanglements that took him away from the family home. This pattern suggests Wilde's ability to compartmentalize his life, as more and more he kept his writing and erotic life separate from the house on Tite Street. In 1891, for example, he began Lady Windermere's Fan while staying in the Lake District. That same year, he wrote most of Salomé in Paris, completing it in Torquay. In 1892, he rented a farmhouse in Norfolk to commence writing

A Woman of No Importance. The next year, he worked on *An Ideal Husband* in a rented cottage at Goring-on-Thames. In 1894, *The Importance of Being Earnest* was written in part in Worthing, Sussex. Furthermore, as Ellmann notes, during the 1890s, Wilde 'established a practice of staying at hotels, ostensibly so he could work, actually so he could play as well'.[41] Wilde took rooms at the Savoy Hotel in the Strand, the Avondale Hotel in Piccadilly, the Albemarle Hotel in Mayfair, and for five months in 1893–1894 he rented rooms at 10–11, St James's Place. In *De Profundis*, Wilde described his daily routine by noting, 'I arrived at St James's Place every morning at 11:30 in order to have the opportunity of thinking and writing without the interruptions inseparable from my own household.'[42] The location in St James's was also convenient for dining with Douglas in nearby restaurants like Willis's in King Street. Wilde's penchant for rented rooms in the West End spatializes his disaffection from Constance and loss of interest in the role of husband, as his affair with Douglas blossomed. At one point in 1893, Constance traversed London to bring Oscar's mail to him while he was staying with Douglas at the Savoy Hotel;[43] by early 1895, she had to ask Wilde's friend and sometime lover Robert Ross the whereabouts of her husband.[44]

Wilde's distancing of himself from the family home thus gives a somewhat somber note to the auction list prepared when the house's contents were sold after Wilde's bankruptcy following his 1895 conviction. Hastily composed, the sale catalogue lists a jumble of 'Valuable Books, Pictures, Portraits of Celebrities, Arundel Society Prints, Household Furniture, Carlyle's Writing Table, Chippendale and Italian Chairs, Old Persian Carpets and Rugs, Brass Fender, Moorish and Oriental Curiosities, Embroideries, Silver and Plated Articles, Old Blue and White China, Moorish Pottery, Handsome Ormolu Clock, and numerous Effects.'[45] Under the impassive gaze of the auctioneer, the house here seems to be little more than a container of things. Well before his consignment to prison, in the series of rooms he rented in and around London, Wilde was no longer at home.

Notes

1. This study draws on some material previously included in my essay, 'Objects and Interiors: Oscar Wilde', in Claire I.R. O'Mahony (ed.), *Symbolist Objects: Materiality and Subjectivity at the Fin de Siècle* (High Wycombe, 2009), pp. 25–46.

2. Charles L. Eastlake, *Hints on Household Taste in Furniture, Upholstery and Other Details* (London, 1868); W.J. Loftie, *A Plea for Art in the House* (London, 1876); Rhoda and Agnes Garrett, *Suggestions for House Decoration in Painting, Woodwork and Furniture* (Philadelphia, 1877); Mary Eliza Haweis, *The Art of Decoration* (London, 1881).

3. Oscar Wilde, *The Complete Letters of Oscar Wilde*, ed. Merlin Holland and Rupert Hart-Davis (New York, 2000), p. 425.

4. Oscar Wilde, 'The Decay of Lying: An Observation', in Richard Ellmann (ed.), *Artist as Critic: Critical Writings of Oscar Wilde* (New York, 1969), p. 291.

5. Walter Pater, *The Renaissance: Studies in Art and Poetry* (Oxford, 1986), p. 141.

6. Maureen Moran, 'Walter Pater's House Beautiful and the Psychology of Self-Culture', *English Literature in Transition, 1880–1920*, 50/3 (2007): p. 301.

7. Hermann Muthesius, *The English House*, trans. Janet Seligman (London, 1979), p. 8.

8. Barry Bergdoll, *European Architecture, 1750–1890* (Oxford, 2000), p. 269.

9. Richard Ellmann, *Oscar Wilde* (New York, 1988), p. 45.

10. Deborah Cohen, *Household Gods: The British and their Possessions* (New Haven CT, 2006), p. 79.

11. Ellmann, *Oscar Wilde*, p. 45.

12. Ibid., p. 109.

13. Wilde, *Letters*, p. 85.

14. Ibid., p. 86.

15. Ana Parejo Vadillo, 'Aestheticism "At Home" in London: A. Mary Robinson and the Aesthetic Sect', in Gail Cunningham and Stephen Barber (eds), *London Eyes: Reflections in Text and Image* (New York, 2007), pp. 67–8.

16. Ellmann, *Oscar Wilde*, p. 125.

17. Anna, Comtesse de Brémont, *Oscar Wilde and his Mother: A Memoir* (London, 1911), p. 47.

18. Beatriz Colomina, *Privacy and Publicity: Modern Architecture as Mass Media* (Cambridge MA, 1994).

19. Oscar Wilde, 'The Truth of Masks', in Ellmann, *Artist as Critic*, p. 418.

20. Susan Weber Soros, 'E.W. Godwin and Interior Design', in Susan Weber Soros (ed.), *E.W. Godwin: Aesthetic Movement Architect and Designer* (New Haven CT, 1999), p. 185.

21. Peter Thornton, *Authentic Décor: The Domestic Interior, 1620–1920* (New York, 1984), p. 313.

22. Wilde, *Letters*, p. 94.

23. Ibid.

24. Victoria and Albert Museum, *E.W. Godwin Office Diaries*, 1879, AAD4/4–1980, n.p.

25. Victoria and Albert Museum, *E.W. Godwin Office Diaries*, 1880, AAD4/5–1980, n.p.

26. Henry-Russell Hitchcock, *Architecture: Nineteenth and Twentieth Centuries* (Harmondsworth, 1958), p. 217.

27. Mark Girouard, *Sweetness and Light: The Queen Anne Movement, 1860–1900* (New Haven CT, 1984), p. 178.

28. H. Montgomery Hyde, 'Oscar Wilde and His Architect', *The Architectural Review*, 109 (March 1951): p. 175.

29. Michael Riffaterre, *Semiotics of Poetry* (Bloomington IN, 1984), p. 17.

30. Wilde, *Letters*, p. 239.

31. De Brémont, *Oscar Wilde and his Mother*, pp. 87–8.

32. Ibid., p. 59.

33. Wilde, *Letters*, p. 263.

34. Norbert Kohl, *Oscar Wilde: The Works of a Conformist Rebel*, trans. David Henry Wilson (Cambridge, 1989).

35. Merlin Holland, 'Introduction', in Wilde, *Letters*, p. xiii.

36. Victoria Rosner, *Modernism and the Architecture of Private Life* (New York, 2005), p. 48.

37. Vyvyan Holland, *Son of Oscar Wilde* (New York, 1954), p. 32.

38. Ibid., pp. 30–31.

39. Wilde, *Letters*, p. 713.

40. Michael Hatt, 'Space, Surface, Self: Homosexuality and the Aesthetic Interior', *Visual Culture in Britain*, 8 (Summer 2007): pp. 118–19.

41. Ellmann, *Oscar Wilde*, p. 389.

42. Wilde, *Letters*, p. 686.

43. Ellmann, *Oscar Wilde*, p. 394.

44. Ibid., p. 437.

45. A.N.L. Munby (ed.), *Sale Catalogues of Libraries of Eminent Persons*, vol. 1 (London, 1971), p. 373.

Writing Home: The Colonial Memories of Lady Barker, 1870–1904

Emma Ferry

I don't suppose any human being except a gipsy has ever dwelt in so many widely-apart lands as I have. Some of these homes have been in the infancy of civilization, and yet I have never found it necessary to endure, for more than the first few days of my sojourn, anything in the least uncomfortable. Especially pretty has my sleeping-room always been, though it has sometimes looked out over the snowy peaks of the Himalayas, at others, up a lovely New Zealand valley, or, in still earlier days, over a waving West Indian 'grass piece'. But I may as well get out the map of the world at once, and try to remember the various places to which my wandering destiny has led me.[1]

Having made homes across the British Empire in locations that included an army camp in India; a prefabricated sheep station in New Zealand; a 'cottage' in South Africa; and governors' residences in Mauritius, Western Australia and Trinidad, the Jamaican-born author, Lady Barker was famous for the books she wrote about her experiences in the colonies. A twice-married mother of six children, she was also the first 'Lady Superintendent' of the National School of Cookery in London; the editor of a family magazine; and the author of 18 books, including three domestic advice manuals based upon first-hand experience of household management.

Elsewhere, I have considered Lady Barker's numerous publications as examples of colonial literature; texts concerned with colonial expansion 'written by and for colonizing Europeans about non-European lands dominated by them'.[2] However, this chapter examines the autobiographical material incorporated within her domestic advice writing; Lady Barker's experiences of colonial life, with which her reading public were familiar, and which conferred upon her the authority to offer advice about *The Bedroom and Boudoir* for Macmillan's 'Art at Home' series' (Figure 4.1).[3] Here I want to suggest that advice literature – a genre that depends to some extent upon personal experiences – could be understood as a form of autobiographical writing.

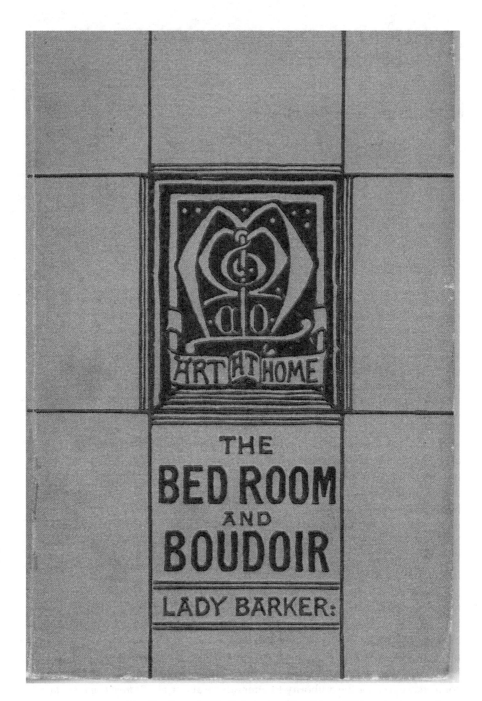

ART AT HOME

THE
BED ROOM
AND
BOUDOIR

LADY BARKER:

4.1 Front cover, *The Bedroom and Boudoir* (1878).

Lady Barker (1831–1911): A Biography

Lady Barker was born Mary Anne Stewart on 29 May 1831[4] in Spanish Town, Jamaica, the eldest child of 'the last "Island Secretary"'.[5] Much of her childhood was spent in the homes of relatives in Ireland and England. Indeed, in her last book *Colonial Memories* (1904) she commented: 'I began to wander to and from England before I was two years old and had crossed the Atlantic five times by 1852.'[6] She returned to Jamaica in December 1847, later using her childhood experiences on the island as the basis for tales in several children's books, including *Stories About* (1870) and *A Christmas Cake in Four Quarters* (1871).

In 1852 she married Captain George Barker RA, the aide-de-camp to the Governor of Jamaica, and in August of that year they moved to England.[7] While Mrs Barker spent the next eight years in London facing the practical difficulties of home-making and childbearing, her husband fought in the Crimean War, where he rose rapidly to the rank of Colonel.[8] Sent to India during the Mutiny, Barker was instrumental in the relief of Lucknow. Consequently, he was 'created KCB for services in the field' and offered the command of the Royal Artillery in Bengal.[9]

In October 1860, leaving her two surviving sons with relatives in England, the newly-titled Lady Barker undertook the journey to meet her husband in Calcutta. Travelling north to Simla, she later used the domestic concerns of camp life experienced during this four-month military promenade in *Stories About* (1870). Tragically, during her stay in India, George Barker became seriously ill and died. The widowed Lady Barker returned alone to her family in England, where, for the next four years, she 'lived quietly with my two little sons among my own people'.[10] In 1865, however, her colonial adventures began once more when she met Canadian-born Frederick Napier Broome, 'a young and very good-looking New Zealand sheep farmer'.[11] Broome, who was 11 years her junior, persuaded Lady Barker to marry him and leave England for a sheep station on the Canterbury Plains.[12]

She wrote: 'I often wonder how I could have had the courage to take such a step, for it entailed leaving my boys behind as well as all my friends and most of the comforts and conveniences of life.'[13] They established their own sheep station, 'Broomielaw', on the Canterbury Settlement in the South Island of New Zealand, and despite the death of their baby son, Lady Barker later described this period as 'three supremely happy years which followed this wild and really almost wicked step on our parts'.[14] Her experiences were described in two best-selling books, *Station Life in New Zealand* (1870) and *Station Amusements in New Zealand* (1873), which were written on her return to London in 1869. With typical self-deprecating humour, Lady Barker explained that: 'Mr Alexander Macmillan, who was always kindness itself to both of us, [...] was responsible for putting the idea of writing into my head. At his

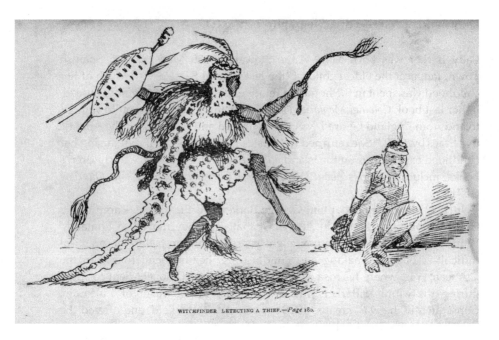

WITCHFINDER DETECTING A THIEF.—*Page* 180.

4.2 Witch-Finder from Lady Barker's *A Year's Housekeeping in South Africa* (1877).

suggestion I inflicted "Station Life in New Zealand", as well as several story-books for children, on a patient and long-suffering public.'[15]

Between 1869 and 1876, Lady Barker (who retained her former title and married name) wrote 13 books.[16] Her work falls into three categories: those books that recounted her life experiences in the colonies; others best described as juvenile fiction; and three domestic advice manuals. She also wrote stories for *Good Words for the Young*; reviewed novels for *The Times*; and, in 1874, became editor of the family magazine *Evening Hours*.[17] During this prolific period of writing, Lady Barker also gave birth to two more sons and became the first Lady Superintendent of Henry Cole's newly founded National School of Cookery following the publication of her highly successful book *First Lessons in the Principles of Cooking* (1874).

Her experiences of colonial life were to continue in 1875 when Frederick Broome was appointed Colonial Secretary to the Province of Natal.[18] Lady Barker and her two youngest sons left their South Kensington home, and went out to Africa to join her husband at 'poor sleepy Maritzburg', later recording her experiences in *A Year's Housekeeping in South Africa* (1877) (Figure 4.2).[19]

After a brief return to England in 1877, which saw the hurried production of *The Bedroom and Boudoir*, Lady Barker joined her husband in Mauritius where he served as Lieutenant Governor from 1880. However, serious bouts of malaria forced her to leave 'the Star and the Key of the Indian Ocean' and

to return to England until December 1882, when Broome was appointed Governor of Western Australia. Once again she travelled to the southern hemisphere; taking up residence at Government House in Perth.

Broome's governorship of this colony, which was demanding self-government, was often turbulent and Lady Barker was to describe their life in Australia in *Letters to Guy* (1885), a book of 'letters' addressed to their eldest son, who had remained at school in England. Knighted in 1884 and leaving Western Australia in 1889, Broome was appointed Acting-Governor of Barbados in 1891; and, finally Governor of Trinidad, a post which he held until just before his untimely death in 1896.[20]

Returning to England for the last time, Lady Barker (now styled 'Lady Broome') lived in straitened financial circumstances: having always assumed that Frederick would survive his wife, no financial provision had been made for her.

Despite receiving a small pension from the Government of Western Australia, Lady Broome was obliged to supplement her income by writing articles for the *Cornhill Magazine* and the ladies' journal, the *Boudoir*, which were published together in her last book, *Colonial Memories* (1904). This, the only book to be published under the name 'Lady Broome', recounted her experiences across the British Empire including significant events such as the abolition of slavery, the Indian Mutiny and the Zulu Wars. Here she commented poignantly:

I often wonder which is the dream – the shifting scenes of former days, so full of interest as well as of everything which could make life dear and precious, or these monotonous years when I feel like a shipwrecked swimmer, cast up by a wave, out of reach of immediate peril it is true, but far removed from all except the commonplace of existence. Still it is much to have known the best and highest of earthly happiness; to have 'loved and been beloved', and to have found faithful friends who stood fast even in the darkest days.[21]

Lady Broome's death on 6 March 1911 was noted by *The Times*, where her obituary largely recorded the careers of her father and husbands, but did comment that 'She was a woman of no small ability.'[22]

Fact or Fiction?

The cultural products of British colonialism, Lady Barker's books have been discussed by international scholars, many of them based in the former 'white Dominions' of New Zealand, Australia and South Africa.[23] Historians and biographers have tended to interpret her books as a straightforward account of the way people lived on Canterbury's back-country sheep stations during the 1860s[24] or using them to reconstruct the life of Lady Barker, who, to quote

her earliest biographer: 'was one of a small number of women who during the nineteenth century sailed, pen in hand, to the less-frequented parts of the world and set down their impressions for the stay-at-homes.'[25]

Of these biographers, Betty Gilderdale has constructed the most comprehensive life story in her study *The Seven Lives of Lady Barker* (1996). Relying heavily upon Lady Barker's publications and interpreting them as historical evidence rather than as literature, Gilderdale justified this decision, stating: 'Almost all her books, for children and adults, are autobiographical, based on her observations and experiences. Owing to the scarcity of other material, they necessarily form the main sources for her biography.'[26]

This was certainly the contemporary understanding of her work; a view encouraged by the literary device of the 'letter home', which Lady Barker often employed, and one supported by the 'Preface' to *Station Life in New Zealand* (1870) written by her husband, which comments that the letters 'Simply record the expeditions, adventures and emergencies diversifying the daily life of the wife of a New Zealand sheep-farmer.'[27] Contemporary reviews of her books published in *The Times* also commented upon the authenticity of her experiences. While one reviewer felt that the stories could only be 'from her own life, for they are too real to be anything else',[28] another remarked that whether the stories were 'in all respects true is more than we can vouch for, but at least they wear the garb of truth'.[29] More recently, literary critics and historians have discussed the notion of 'truth' in Lady Barker's work. Lydia Wevers cites *A Christmas Cake in Four Quarters* (1871) as a typical example of the colonial short story 'which begin as tales and yarns which represent experience as orally authenticated and basically documentary even if the realism is heightened or exaggerated for comic or dramatic effect'. She comments that Lady Barker's recording presence gives the narrative 'the character of archive, life as it is lived rather than literary experience'.[30] Others have examined Lady Barker's use of the letter form, suggesting that it 'is largely, perhaps entirely, a device'[31] and rejecting 'realist' readings of this genre as simple autobiography that provides the historian with 'a readily comprehensible and valid, if partial, account of the past'.[32]

The authenticity of Lady Barker's colonial stories as a form of life-writing is arguable, but an explicitly autobiographical source can be found in her last book *Colonial Memories* (1904).[33] Written after an absence from the literary scene of almost 20 years, *Colonial Memories* is a series of short autobiographical essays that look back upon the 'wandering up and down the face of the globe'[34] she had undertaken. The introductory essay, titled 'A Personal Story' also acts as a reminder to Lady Barker's imagined readers who had 'perhaps read my little books in their childhood' and to whom she addressed 'these lines explaining as it were my personal story, with an entreaty for forgiveness if I have made it *too* personal'.[35]

Generally far less exciting than her colonial books, where household chores and everyday outings take on the characteristics of adventure stories, Lady

Barker's domestic advice publications have been largely ignored by her biographers. Alexandra Hasluck dismissed both *Houses and Housekeeping* and *The Bedroom and Boudoir* as 'two books on furnishing which are very much pot-boilers', while Nelson Wattie simply noted that she 'also wrote two books, written in a journalistic style, on furnishing a house'.[36]

Nonetheless, Lady Barker's work in this genre is based upon lived experiences that not only reveal contemporary concerns with domestic *and* colonial ideologies, but which also explain her authorship of *The Bedroom and Boudoir* (1878).

Domestic Advice: The Bedroom and Boudoir

By the time Lady Barker began to write advice literature, her reading public was already familiar with her domestic concerns and the decoration of her colonial homes. In *Station Life in New Zealand* (1870) she described 'Our Station Home':

My greatest interest and occupation consist in going to look at my house, which is being *cut out* in Christchurch, and will be drayed to our station, a journey of fifty miles. It is, of course, only of wood, and seems about as solid as a band-box, but I am assured by the builder that it will be a 'most superior article' when it is all put together. F- and I made the little plan of it ourselves, regulating the size of the drawing-room by the dimensions of the carpet we brought out.[37]

Later on she was to produce *Houses and Housekeeping* (1876), a book that was originally serialized in *Evening Hours* (1875) as seven articles, each one dealing with a different room in an imaginary London house; some of these articles would later be reworked for chapters in *The Bedroom and Boudoir*. The first article deals with the attic rooms allotted to servants; the second and third consider 'The Nursery'; the fourth deals with 'Bedrooms'; the fifth is titled 'The Dining-Room'; the sixth is 'The Drawing-Room'; and, the final article looks at 'Kitchens'. Here, Lady Barker drew upon her experiences of life in Jamaica, India and New Zealand; *exporting* the English home to the colonies and *importing* the Empire into the domestic spaces of England. Thus, when advising on suitable decoration for a London drawing room, she recalled 'a drawing-room of canvas … which moved twenty-five miles ahead every day'; an officer's quarters decorated with 'the most hideous and ghastly wall-papers which could be procured for love or money'; and, 'a little wooden house, up a quiet valley on a New Zealand station' where 'every article of furniture had been slowly and expensively conveyed over roads which would give an English upholsterer a fit to look at'.[38] It was precisely these colonial experiences that made Lady Barker the perfect contributor to Macmillan's 'Art at Home' series; though more for reasons of publishing expediency than professional expertise.

In March 1877, the American art critic, Clarence M. Cook, wrote to the publisher, Frederick Macmillan, offering him the British publication rights to a series of articles titled 'Beds, Tables, Stools and Candlesticks' that he had written for *Scribner's Illustrated Monthly*.[39] Macmillan refused this proposal but instead offered to buy electrotypes of the original engravings that illustrated the articles; many of which represented imported oriental furnishings displayed in a New York furniture store.[40] He wrote: 'the only plan that seems to us practical would be for us to buy the very beautiful illustrations & to re-cast or re-write the text so as to suit it to English requirements.'[41]

Before the plates had even crossed the Atlantic, George Lillie Craik, a partner in the publishing house, set about finding authors who would be willing to write new books *around* the illustrations; Lady Barker, as an established Macmillan author, was among those he approached:

We have a series of small books to hand called the 'Art at Home' series – If you have not seen them I wish you would let me send you the three that have been published – by Mr Hullah on Music at Home and by the Misses Garrett and William Loftie on matters of Art. Mr Loftie is the editor. He would greatly like to get you to do a book on the Bedroom. We have got some excellent illustrations together. I feel confident you would like the task.[42]

In the event, Lady Barker was offered £50 for suitable text to complement the electrotypes, which Craik suggested should amount to about 80 pages. He also hinted that there might be sales in America: this despite an earlier letter from Scribner's which had informed Macmillan that Cook's pictures were under copyright.[43]

The correspondence in the General Letterbooks of the Macmillan Archive recorded that the proofs were at the printers by February 1878 and were published later that month, just after Lady Barker's departure for Mauritius. A second printing followed in July 1878: in total 5,000 copies of *The Bedroom and Boudoir* were issued. The production of the book is barely mentioned in the Macmillan correspondence, though there seems to have been a minor disagreement between Lady Barker and the editor of the series, the Reverend W.J. Loftie, over the title of the volume, with 'Bowers' and 'Boudoirs' both being proposed. Frederick Macmillan attempted to resolve this problem and suggested: 'Suppose we go round the difficulty by calling Lady Barker's book simply "*The Bedroom*"?'[44]

Given her colonial writings, when the plates from Cook's articles were divided among the commissioned authors, Lady Barker was apportioned any that illustrated non-European furniture or vaguely exotic furnishings. These eventually included a Chinese washing-stand, an Indian screen (Figure 4.3), a Chinese cabinet and a bamboo chair 'of a familiar pattern to all travellers on the P. and O. boats, and whose acquaintance I first made in Ceylon';[45] interestingly, all these illustrations originally appeared in Cook's chapter on *The Living Room*.[46]

The difficulties posed by the reuse of these images was most apparent in her chapter fittingly titled 'Odds and Ends of Decoration', where she managed to describe a picture stand, a bamboo sofa, a piano and 'a great deal of "rubbish" dear, perhaps, only to the owner for the sake of association'.[47] Here, in an ironic reference to this unhappy mix of text and images, Lady Barker commented:

The worst of such a delightful den as I am imagining, or rather describing, is the tendency of the most incongruous possessions to accumulate themselves in it as time goes on.[48]

A review of *The Bedroom and Boudoir* published in *The Spectator* (1878) commented unfavourably upon the illustrations:

We cannot conclude without a word or two about the numerous illustrations; […] Lady Barker herself cannot be satisfied with them, and they are most detrimental to the book, as ones eye is naturally first caught by them, in turning over the leaves. A few carefully chosen and carefully drawn subjects would have been far better in every way.[49]

In eight short chapters, Lady Barker examines different aspects of *The Bedroom and Boudoir*: 'An Ideal Bedroom – its Walls'; 'Carpets and Draperies'; 'Beds and Bedding'; 'Wardrobes and Cupboards'; 'Fire and Water'; 'The Toilet'; 'Odds and Ends of Decoration'; 'The Sick Room'; and, 'The Spare Room.' While some sections of the text are clearly based on her earlier articles for *Evening Hours*, particularly those on 'Bedrooms' and 'The Nursery', the passages that described the illustrations, draw heavily on Cook's original text. The most glaring example concerns the description of a Japanese chest, which was described in detail by Cook:

No one but a man knows what a blessing this shirt-drawer is. It will hold the week's wash of shirts without tumbling or crowding, and nothing else need be allowed to usurp a place in it. In these four drawers is room for all one man's linen; and in the little closet, which contains three drawers and a hiding-place for money (which the owner did not discover until after a year's possession), there is room for all his trinkets and valuables. When the two boxes are placed together, the whole measures three feet one inch in length by three feet four high, and one foot five deep.[50]

Lady Barker's version altered very little:

But the male heart will be sure to delight specially in that one deep drawer for shirts, and the shallow one at the top for collars, pocket handkerchiefs, neckties, and so forth. The lower drawers would hold a moderate supply of clothes, and the little closet contains three drawers, besides a secret place for money and valuables. When the two boxes, for they are really little else, are placed side by side they measure only three feet one inch long; three feet four high, and one foot five deep.[51]

Another discordant note is struck, by the final chapter on 'The Spare Room', where Lady Barker issued the following warning to her readers:

To a professional man, with a small income, the institution of a spare room may be regarded as an income tax of several shillings in the pound. It is even worse than that; it means being forced to take in a succession of lodgers who don't pay, who are generally amazingly inconsiderate and *exigeante*, and who expect to be amused and advised, chaperoned and married, and even nursed and buried.[52]

However, this final chapter of *The Bedroom and Boudoir* had originally been published two years earlier in the *Saturday Review* as a short article written by Mrs Loftie, author of *The Dining Room* in the 'Art at Home' series. Witness the following paragraph from Mrs Loftie's original version of 'The Spare Room':

To busy people of moderate wealth the acknowledged possession of a spare room represents an income-tax of several shillings in the pound. It means to be forced to take in lodgers all year round who do not pay, but who expect as much attention as if they were in an American Hotel – to be obliged, not only to supply them with free quarters, but to amuse, advise, chaperon, perhaps even nurse and bury them.[53]

Clearly Mrs Loftie's earlier article had been re-cycled, without attribution, for use in Lady Barker's volume in the 'Art at Home Series', which was edited by her husband. Significantly, a review of *The Bedroom and Boudoir* published in *The Spectator* in April 1878, had noted a change in style (if not author) and commented:

The chapter on the 'Spare Room' does not say much for Lady Barker's hospitality, though it strikes one that she has taken up her views on the subject more as an excuse for a little smart writing, than because they express her real opinion.[54]

However, elsewhere within the text Lady Barker's real opinions and personal experiences are far more evident. Her chapter on 'Beds and Bedding' drew upon her experiences of motherhood, offering advice on suitable mattresses, bed-clothes and dressing-gowns for children; while 'The Sick Room' combined advice on the arrangement and decoration of a room which was 'a very comfortable one *to be ill in*' with hints on practical nursing in the home.[55] The review in *The Spectator* commented on the inclusion of this subject:

The chapter on the 'Sick-room' is quite the best in the whole book. [...] Though it is not exactly what one would expect to find in a volume on Art, we can take no exception to it on that score, and Lady Barker combines so skilfully valuable advice on the serious work of nursing, with graceful hints as to what she has observed the weary eye of the sufferer take pleasure in, both in form and colour, that very many must be grateful to her for giving her own experience on these matters.[56]

Her experience on these matters enabled Lady Barker to give advice on suitable attire when attending in a sick room; on medicines and invalid food; on the

use of bed-rests and tables; and, on correct levels of sunlight and ventilation. She informed her readers that 'Few people understand what I have learnt in tropical countries, and that is how to exclude the outer air during the hot hours of the day.'[57]

Advocating 'a retreat in which to be busy and comfortable'[58] where 'all sorts of little eccentricities might be permitted to the decorator'[59] the central theme of her advice on decoration is the ability of women to transport and to transform their own surroundings: 'As long as a woman possesses a pair of hands and her work-basket, a little hammer and a few tin-tacks, it is hard if she need live in a room which is actually ugly.'[60]

This theme occurred throughout *The Bedroom and Boudoir* and related to her colonial experiences:

Necessity develops ingenuity, and ingenuity goes a long way. I never learned the meaning of either word until I found myself very far removed from shops, and forced to invent or substitute the materials wherewith to carry out my own little decorative ideas.[61]

Books in particular were noted as an essential element in the creation of this personal space, perhaps more so for Lady Barker because they were so portable: 'I never feel at home in any place until my beloved and shabby old friends are unpacked and ranged in their recess.'[62] Even the arrangement of the 'toilet-table' afforded an opportunity for Lady Barker to refer to her colonial experiences:

4.3 An Indian Screen from Lady Barker's *The Bedroom and Boudoir* (1878).

I have seen toilet-tables in Kafir-land covered with common sixpenny
cups and saucers, and shown as presenting a happy combination of
use and ornament, strictly in conformity with 'Engleez fasson'.[63]

Writing descriptions of remembered colonial bedrooms around illustrations
of exotic furniture, she gave advice on the most private space in the domestic
sphere. Inevitably the text described many of her colonial experiences:

I have slumbered 'aright' in extraordinary beds, in extraordinary places, on
tables, and under them (that was to be out of the way of being walked upon),
on mats, on trunks, on all sorts of wonderful contrivances. I slept once very
soundly on a piece of sacking stretched between two bullock trunks.[64]

Producing a text, geographically and metaphorically miles away from
the domestic design advice offered by her contemporaries, Lady Barker's
autobiographical anecdotes suggested that 'home' could be anywhere within
the British Empire:

it is possible to have really pretty, as well as thoroughly comfortable
dwelling-places even though they lie thousands of miles away from the
heart of civilisation, and hundreds of leagues distant from a shop or
store of any kind. I mean this as an encouragement – not a boast.[65]

Conclusion

Lady Barker's *The Bedroom and Boudoir* is the one of the very few nineteenth-
century publications that dealt exclusively with this subject.[66] However,
woven uneasily around often inappropriate imagery, this fascinating blend
of literary genres – autobiography, adventure and advice – forms a highly
problematic source for any historian of the Victorian domestic interior unaware
of the facts of its production or the life experiences of its author. Aimed at an
imagined lower-middle-class readership already familiar with Lady Barker's
adventures abroad, *The Bedroom and Boudoir* should be understood as a
historical document that engages with contemporary concerns about class,
race, gender, health and taste, *and* as collection of Victorian literary genres. It
should be placed in a context of other narratives, both historical and literary,
and explored using both historical methodologies *and* literary theories.
Without this type of interdisciplinary consideration the already 'imperfect
window' into the domestic interior of the past remains doubly distorted.

Notes

1. Lady Barker, *The Bedroom and the Boudoir* (London, 1878), p. 20.
2. Emma Ferry, 'Home and Away: Domesticity and Empire in the Work of Lady Barker', *Women's History Magazine* (Autumn 2006), pp. 4–12; Eleke Boehmer, *Colonial and Postcolonial Literature* (Oxford, 1995), pp. 2–3.

3. Emma Ferry, '"information for the ignorant and aid for the advancing ...": Macmillan's "Art at Home Series", 1876–1883', in Jeremy Aynsley and Kate Forde, *Design and the Modern Magazine* (Manchester, 2007), pp. 134–55.

4. FamilySearch™ International Genealogical Index for the Caribbean gives her date of birth as 1830 (film number 1903747).

5. Lady Broome, *Colonial Memories* (London, 1904), p. xxi.

6. Ibid., p. x.

7. Betty Gilderdale, *The Seven Lives of Lady Barker* (Auckland, 1996), pp. 40–48.

8. Colonel J. Jocelyn, *The History of the Royal Artillery: Crimean Period* (London, 1911), pp. 43–6 and pp. 203–4.

9. Frances Hays, *Women of the Day: A Biographical Dictionary of Notable Contemporaries* (London, 1885), p. 11.

10. Lady Broome, *Colonial*, p. xii.

11. Ibid.

12. FamilySearch™ International Genealogical Index gives the date of their marriage as 21 June 1864. Lady Barker gives it as the summer of 1865.

13. Lady Broome, *Colonial*, p. xii.

14. Ibid., p. xiii.

15. Ibid., p. xiv.

16. The retention of her first married name and title after her marriage to Broome is an act that troubles many scholars from the Southern Hemisphere, who interpret this as 'English snobbery'. Lady Barker was known as 'Mrs Broome' in New Zealand, but until Frederick Napier Broome was knighted in 1884, she retained the title 'Lady Barker'. Amusingly, in Nelson Wattie, 'An English Lady in the Untamed Mountains: Lady Barker in New Zealand', in K. Gross and W. Klooss (eds), *English Literature of the Dominions: Writings on Australia, Canada and New Zealand* (Würzburg, 1981), p. 98, Wattie comments on Lady Barker's aristocratic pretensions in retaining her title remarking that 'Her readers might be excused for thinking that "Lady" was her Christian name.'

17. Founded in April 1871 and edited initially by the Rev. E.H. Bickersteth, *Evening Hours* advertised itself as a 'Church of England Family Magazine'. Under Lady Barker's editorship from 1874, however, the emphasis of *Evening Hours* shifted away from religion to become 'A Family Magazine'. Many of Lady Barker's books were serialized in *Evening Hours* before publication in volume form.

18. In 1874, there had been an uprising in the Province of Natal led by Chief Langalibalele. Sir Garnet Wolseley replaced Natal's Colonial Governor and Broome was appointed his secretary.

19. Lady Barker, *A Year's Housekeeping in South Africa* (London, 1877), p. 59.

20. Broome was only 54 years old when he died; his widow was 65 years old.

21. Lady Broome, *Colonial*, pp. xxi–xxii.

22. Obituary: Lady Broome, *The Times*, 7 March 1911, p. 11.

23. Alexandra Hasluck, 'Lady Broome', *Western Australian Historical Society Journal*, 5/part 3 (1957): pp. 1–16; Alexandra Hasluck, *Remembered with Affection* (Melbourne, 1963), an edition of *Letters to Guy* with notes and a short biography; Wattie, 'An English Lady'; Fiona Kidman, 'Introduction' to Lady Barker, *Station Life in New Zealand*, reprinted with notes by Fiona Kidman (London, 1984); Peter Gibbons, 'Non-Fiction', in Terry Sturm (ed.), *The Oxford History of New Zealand Literature in English* (Auckland, 1991), pp. 23–104; Gilderdale, *The Seven Lives of Lady Barker*; Gillian Whitlock, 'A "White Souled State" Across the "South" with Lady Barker', in K. Darian-Smith, et al. (eds), *Text, Theory, Space: Land, Literature and History in South Africa and Australia* (London, 1996); Anita Selzer, *Governor's Wives in Colonial Australia* (Canberra, 2002).

24. Kidman, p. v.

25. Hasluck, *Remembered*, p. 1.

26. Gilderdale, p. xv.

27. Lady Barker, *Station Life in New Zealand* (London, 1870); Virago reprint, 1984, Preface.

28. *The Times*, 'Christmas Books: Stories About', 23 December 1870, p. 10.

29. The *Times*, 'Christmas Books: A Christmas Cake in Four Quarters', 25 December 1871, p. 4.

30. Lydia Wevers, 'The Short Story', in Sturm, *The Oxford History*, p. 205.

31. The New Zealand novelist, Fiona Kidman believed 'they were real letters' ('Introduction' to Lady Barker, *Station Life*, p. vii). For a contrasting interpretation see Gibbons, 'Non-Fiction', p. 47.

32. J. Haggis, 'White Women and Colonialism: Towards a Non-Recuperative History', in C. Midgley (ed.), *Gender and Imperialism* (Manchester: 1998), p. 47.

33. *Colonial Memories* begins with the following 'Note' dated October 1904: 'My cordial thanks are due – and given – to the Editor of the *Cornhill Magazine*, within whose pages some of these "Memories" have from time to time appeared, for permission to republish them in this form. Also to the Editor of the *Boudoir*, where my "Girls – Old and New" made their *début* last season M. A. B.'

34. Lady Broome, *Colonial*, p. xxi.

35. Ibid., p. xxii.

36. Hasluck, *Remembered*, p. 8; Wattie, 'An English Lady', p. 99.

37. Lady Barker, *Station Life*, p. 39.

38. Lady Barker, 'Houses and Housekeeping: The Drawing-Room', *Evening Hours*, 5 (1875): p. 315.

39. Clarence M. Cook's articles were collected and published as *House Beautiful: Essays on Beds and Tables, Stools and Candlesticks* (New York, 1878).

40. BL: Add. MS 55402/372. Macmillan & Co., to Messrs Scribner, Armstrong & Co., New York, 18 April 1877 and BL: Add. MS 55402/372. Macmillan & Co., to Messrs Scribner, Armstrong & Co., New York, 4 June 1877.

41. BL: Add. MS 55402/372 Frederick Macmillan to Clarence M. Cook, 18 April 1877.

42. BL: Add. MS.55403/301 George Lillie Craik to Lady Barker, 30 July 1877; BL: Add. MS. 55405/86 Frederick Macmillan to Lady Barker, 8 February 1878.

43. BL: Add. MS. 55405/86 Frederick Macmillan to Lady Barker, 8 February 1878.

44. BL: Add. MS. 55403/877 Frederick Macmillan to W.J. Loftie, 14 October 1877.

45. Lady Barker, *Bedroom*, p. 81.

46. Ibid.

47. Ibid.

48. Ibid., p. 90.

49. 'Art at Home', *The Spectator*, 13 April 1878, p. 476.

50. Cook, *House Beautiful*, pp. 290–91.

51. Lady Barker, *Bedroom*, pp. 50–51.

52. Ibid., pp. 115–16.

53. Mrs M.J. Loftie, 'The Spare Room', *The Saturday Review*, vol. XLI, April 29 1876, pp. 545–6.

54. 'Art at Home', p. 476.

55. Lady Barker, *Bedroom*, p. 96.

56. 'Art at Home', p. 476.

57. Lady Barker, *Bedroom*, p. 100.

58. Ibid., p. 84.

59. Ibid., p. 61.

60. Ibid., p. 20.

61. Ibid., p. 32.

62. Ibid., p. 89.

63. Ibid., p. 76.

64. Ibid., pp. 33–4.

65. Ibid., pp. 20–21.

66. Robert Kerr, *The Gentleman's House* (London, 1864); Charles Locke Eastlake, *Hints on Household Taste* (London, 1868); the Misses Rhoda and Agnes Garrett, *Suggestions for House Decoration in Painting, Woodwork and Furniture* (London, 1876); Cook, *House Beautiful*; John James Stevenson, *House Architecture* (2 vols, London, 1880); and Mrs Jane Ellen Panton, *From Kitchen to Garret* (London, 1889), all include brief chapters on the bedroom, but the only other publication dealing specifically with the bedroom I have located is the slightly later Mrs Gladstone's *Healthy Nurseries and Bedrooms Including the Lying in Room* (London, 1884), a 48-page publication produced in connection with the International Health Exhibition held in London in 1884.

Body, Room, Photograph: Negotiating Identity in the Self-Portraits of Lady Ottoline Morrell

Inga Fraser

Society hostess and patron of the arts, Lady Ottoline Morrell, lived from 1873 to 1938. Though she was born into a life of aristocratic privilege, it was not in these circles that she was to gain notoriety. Beginning with her Thursday Salons at her and her husband Philip Morrell's home at 44 Bedford Square in Bloomsbury and continuing at their subsequent residences: Garsington Manor in Oxfordshire and in Bloomsbury again at 10 Gower Street, Ottoline entertained numerous celebrated artistic, literary and political figures within lavishly decorated rooms, arranged according to her own idiosyncratic style.

It was amongst these people that she became known as something of an eccentric in both taste and personality. She sat for painters such as Augustus John, Charles Conder, Henry Lamb and even the Italian Futurist Giacomo Balla.[1] Ottoline also proved to be the inspiration for several literary works, some more benevolent in their characterization than others. Most famously, she was Hermione Roddice in D.H. Lawrence's *Women in Love* (1920) and Priscilla Wimbush in Aldous Huxley's *Crome Yellow* (1921). Other characterizations such as Lady Caraway in Walter James Redfern Turner's *The Aesthetes* (1927) and Caroline Bury in Graham Greene's *It's a Battlefield* (1934), are less well known. Ottoline kept diaries which, in the latter part of her life, enabled her to write her memoirs, but these were heavily edited in terms of both content and tone, first by her husband, and then by Robert Gathorne-Hardy, who published them in two volumes in 1963 and 1974.[2]

In lieu of these mediated representations of Ottoline's appearance and life,[3] the focus of this chapter is the way Ottoline negotiated her identity and a narrative of her life in her photographic self-portraits, kept within albums that are now held at the National Portrait Gallery. In her albums, there are over 50 self-portraits. The majority were taken indoors at Garsington in the mid-1920s

and in many we find a tripartite mode of display, beginning with the body, extending into the room in which Ottoline is figured and, finally, focused or contained within the photographic frame.

As a creative effort with some equivalence to autobiography, Ottoline's self-portraits augment or challenge themes found both within her own life-writing (in the form of manuscript memoirs and other unpublished material) and that of her contemporaries and biographers (at the time and since in their letters, memoirs and other literary works). With respect to content, composition, production and dissemination, the self-portraits are revealed, not as hard and fast evidence of the particular nature of Ottoline's character, but as utterances in Ottoline's voice: sources which add to our multi-layered posthumous understanding of this historical figure.

Body

Ottoline had an extraordinary flair for fashion and a vivid sense of colour; she made use of exotic fabrics gathered from her international travels. Her inspiration was found, not in the fashion pages, but in old masterpieces, of which she would purchase postcards to give to her dressmaker, Miss Brenton, to copy.[4] Her personal style is something much commented upon in many contemporary accounts. David Garnett, a young Oxford undergraduate at the time he visited Garsington, describes how once during a trip away, Ottoline:

suddenly appeared in a dress which she had not worn before during her visit. It might have been designed by Bakst for a Russian Ballet on a Circassian folktale theme. Russian boots of red morocco were revealed under a full, light-blue silk tunic, over which she wore a white kaftan with embroidered cartridge pouches on the chest, on to which fell the ropes of Portland Pearls. On her head was a tall Astrakhan fez.[5]

In his memoirs, Siegfried Sassoon notes that Ottoline was 'always original in her style of dress – which was often extremely beautiful' and, upon first meeting her, that she was wearing a pair of 'voluminous pale-pink Turkish trousers'.[6] Later he observes her wearing 'a Velasquez-like gown of rich brocade ...'[7] The Fashion Museum in Bath currently holds some of Lady Ottoline's clothes and accessories, bought by the museum from Ottoline's grandson Adrian Goodman in 2000.[8] The collection contains such items as the hat she wore for Augustus John's portrait, the bright yellow and purple embroidered dress worn in the photographs of Ottoline taken by Cecil Beaton, purple silk harem trousers and myriad dresses with her favoured leg-of-mutton sleeves.[9] We get an idea of how she wore such pieces in Beaton's portraits,[10] and in other photographs by Baron Adolph de Meyer[11] and Cavendish Morton,[12] in which Ottoline's flamboyant sense of dress is displayed to great effect.

As the half-sister of the 6th Duke of Portland, Ottoline was a public figure. Her appearance was noted in society and recorded by the press,[13] but not always positively. Stephen Spender refers to Ottoline's life as 'commedia'[14] and describes her appearance as somewhat ad hoc. He recounts that Ottoline confessed to him how she 'loved sailing through the streets in a tram – such a beautiful billowing motion – on a London tram she felt like Queen Elizabeth floating down the Thames in a royal barge ...' Yet she also admitted that, sadly, 'everyone had stared so ...'.[15] Though made from beautiful fabrics, upon inspection, many of the items held at the Fashion Museum are revealed to be of poor construction: collars and details are only tacked on, and dresses are often not lined, lending her clothes a theatrical air.

Exaggerating her already remarkable appearance, Ottoline created a certain distance between herself and others. She was over six feet tall but still wore heels; she had large feet but wore brightly styled and coloured shoes; she dyed her auburn hair a dramatic shade of red with henna. Such exaggeration is reflected in both factual and fictive accounts of Ottoline's person, which often tend towards the sensational. Writers who made her acquaintance ascribed a historical, mythological or geographical distance between themselves and Ottoline. She has been described as Elizabethan or Pre-Raphaelite,[16] Osbert Sitwell described her as 'an oversized infanta of Spain',[17] Virginia Woolf described her as a mermaid[18] and on another occasion as 'brilliantly painted, as garish as a strumpet'.[19] Leonard Woolf described her as 'a bird whose brightly and badly dyed plumage was in complete disarray and no longer fitted the body'.[20]

More recent biographers have also focused on the outlandish aspects of her appearance. For example, Kate Roiphe (in an account of Ottoline's affair with Bertrand Russell) describes her thus, 'With her copper hair, turquoise eyes, prominent nose, and gargantuan height, Ottoline was a true "jolie laide": a woman who could look stunning or grotesque depending on the angle.'[21] Rosemary Dinnage includes her in a review of 'outsider women', a context that cements Ottoline's persona on the level of caricature whilst ostensibly attempting to diminish it.[22]

If in literature Ottoline's baroque appearance is often portrayed negatively, as if accidental or a result of insufficient knowledge of current styles and modes, in her self-portraits Ottoline seems to engage with caricature and performance knowingly, wearing her clothes so as to underscore the staged aspect of her personal style. Ottoline can be observed trying out various personae or guises for the camera. In one self-portrait, she pictures herself smoking a cigarette with a fair amount of bravura but in another from the same sitting we see her standing shyly, half enveloped by the curtain. It is interesting that the former exists only as a negative and was not printed and pasted into her albums, giving us a sense of how Ottoline may have been fabricating her persona knowingly.

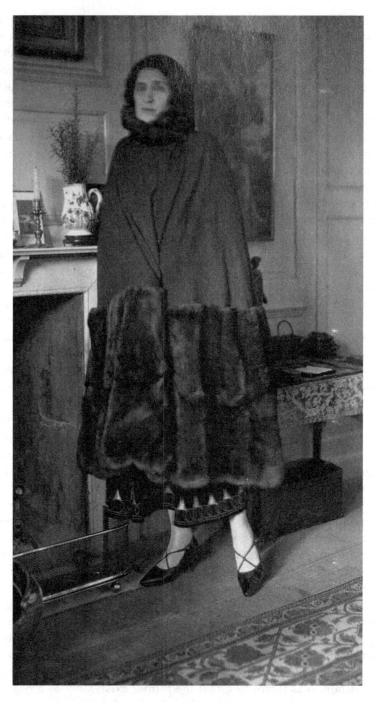

5.1 Lady Ottoline Morrell, *Lady Ottoline Morrell*, 1926, vintage snapshot print,
sitter's room, Garsington Manor, Oxfordshire.

Furthermore, the fetishistic nature of the photographic image works to inscribe or re-inscribe a certain distance between herself and others: a façade behind which she might hide certain aspects of her character. In a series of self-portraits taken at Garsington in 1926, Ottoline's cape and dramatic pose call to mind those found in the theatre postcards of the Edwardian era. In Figure 5.1, the geometric print hem of Ottoline's dress is just visible under the vast hooded and fur lined cloak that she holds tightly around herself. The bulky winter garment appears slightly strange in comparison with her delicate criss-cross evening shoes and the domestic interior of the room. She leans into the fireplace away from the camera, to which she shoots a sidelong, slightly wary glance. The photograph gives us an idea of Ottoline's dramatic sense, but also something of her inhibitions in the way she presents herself as cloaked or tentative. In her memoirs Ottoline confessed: 'I have a horror of opening myself to the world.'[23] It could be argued that Ottoline's elaborate fashions, whilst conspicuous, operated as a screen to deflect attention from more intimate public scrutiny.

Rather than presenting the unwitting eccentric we hear of in the descriptions written by her contemporaries, Ottoline's self-portraits provide us with a different interpretation of her fashions: as a conscious negotiation of identity or identities.

Room

In addition to reasons of ease and privacy, Ottoline's choice to picture herself within the different rooms of her houses lends a biographical significance to the interior, one that is, like her dress sense, reflected in both her own writing and in that of her contemporaries. For instance, in a letter written to her cousin Vera Holme (1881–1969), Constance Holme (1880–1955) describes Garsington as 'a lovely old place, not large, but full of atmosphere'. She goes on to describe the flora and fauna that made the house unique, 'It was a monks' house once, and there is a fish pond and a huge ilex tree and ghost. Two of the new young poets, Osbert and Sacherevell Sitwell came over while we were there.'[24] Another example is found in the autobiography of the poet Siegfried Sassoon who, describing a visit to Garsington, writes:

Here I sat, in this perfect bedroom with its old mullioned windows looking across the green forecourt to the tall wrought-iron gates. The moted [sic] sunlight of a sweet September evening was touching the tops of the high yew hedges; on the paved path below, the little Morrell girl was playing with the pub Socrates, and a peacock was parading with tail outspread.[25]

Ottoline's gardens and interiors were rich composites that drew on a number of influences. She was inspired by travel and history and, in particular,

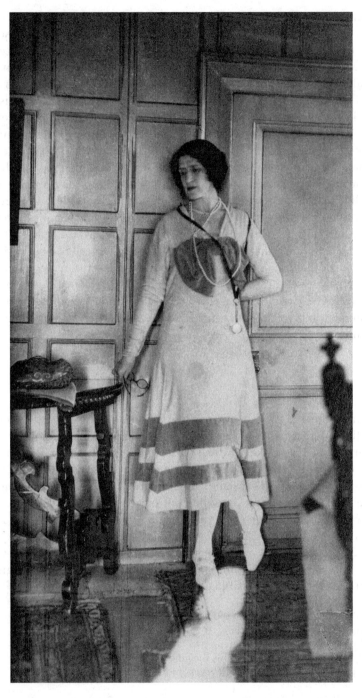

5.2 Lady Ottoline Morrell, *Lady Ottoline Morrell*, 1926, vintage snapshot print,
The Green Room, Garsington Manor, Oxfordshire.

a history to which she was personally related. The rich Venetian red and iridescent sea green of Garsington's two ground floor drawing rooms were colours chosen from the palette at Bolsover Castle, an estate within the family that Ottoline had visited as a child.[26] Something of their shimmering tone can be perceived in Figure 5.2, identified as the Green Room.

In her own memoirs, Ottoline wrote:

Furnishing and decorating houses is a thing my friends like to think that I have a special talent for … When people say to me, 'How you must enjoy decorating houses. It must be such fun,' I turn away, and in my thoughts answer, 'How little you understand or know all the anxiety and travail that this task is. It is no more pleasant or amusing than to paint a picture or to write a book.'[27]

Evidently, interior design was for Ottoline a prodigious and informed process. This is again reflected in the comments of others. Juliette Huxley (a Swiss girl hired as a governess for Ottoline's daughter) writes in her autobiography:

Both Garsington and later, Gower Street were works of art in themselves, creating their own special climate. For where Philip mostly chose the furniture, it was Ottoline who assembled the lovely colours, the harmony, the pictures, the shades which threw their light of intimate appeal. She gave the breath of life to her décor and within these walls, which reflected her personality, she moved with her own particular dignity.[28]

The writer Stephen Spender recalls the drawing room in Gower Street in detail in his autobiography:

I saw an enormous quantity of objects: pictures, looking-glasses, small boxes, vases, armchairs, sofas, large and small tables, beautifully bound books. On some tables, bowls were placed which contained heaps of pomanders. These gave out a musky odour, making the room smell like the inside of an Oriental cedar box. Long damask curtains hung on either side of tall windows which, at the back of the house, looked out on to a garden. In a prominent position on the wall there was a misty spiritualist painting by the Irish poet A.E., and there were other paintings by Sickert and Henry Lamb, and early Augustus Johns of figures in front of landscape.[29]

Sassoon remembers Robbie Ross's reservations about Ottoline in his autobiography: 'Her sensibilities … are over-elaborate and not always sensible, but she has exquisite taste in decoration and a genuine flair for spotting original artists.'[30] Some of Ottoline's other contemporaries were still less benevolent in their literary descriptions of her home. Lytton Strachey, writing after his first visit to Garsington to David Garnett, describes the house as 'a regular galanty-show … very like Ottoline herself, in fact – very remarkable, very impressive, patched, gilded and preposterous'.[31] Clive Bell described Garsington as 'a fluttering parrot house of greens, reds and yellows',[32] and David Garnett similarly dismissed it as 'a little too hothouse, too parrot-house'.[33]

When translated into fiction, Ottoline's caricature became even more exaggerated. In Turner's *The Aesthetes*, 'Lady Caraway' is reported as having:

appeared in bigger and stranger hats, took on the oddest and
most fantastic shapes, turned the brightest hues …[34]

around her lie the collected novels of Henry James, the poets in
scarlet and orange vellum, her Johns, her Conders, her painted fans,
her painted screens, her butterflies and jewelled birds. There she
sits waiting. Only night comes. When the sun goes, in agony she
brings out her cushions, her lampshades, her needlework.[35]

Later biographers also draw on descriptions of the interior to convey ideas about Ottoline's character. In her 1976 biography, Sandra Jobson Darroch effervescently describes how, at Garsington, Ottoline 'transformed the old house into something at once comfortable and exotic. Ottoline's vision now flew beyond the unorthodox décor of Bedford Square into a new realm of Bakst and Beardsley.' She describes 'Chinese boxes and cabinets, blue china and Chelsea porcelain, Samarkand rugs, silk hangings, lacquered screens.'[36]

Complimentary or derogatory, factual or fictive, it is worth noting that all accounts draw correspondences between the styling of Ottoline's house and Ottoline herself, whether it is by making a direct comparison, or by employing similar language and tone. In certain accounts, however; and in her self-portraits, a closer, almost symbiotic, relation between Ottoline and her home may be identified. In her obituary in *The Times*, Virginia Woolf uses the interior as a metaphor to explain Ottoline's approach to life, and even its end.[37] More directly, in his introduction to a published compendium of Ottoline's photographs, David Cecil writes:

the curtains were faded and the gilt a little rubbed, but this was not out
of keeping with the room, nor with the rest of the house either. Like Lady
Ottoline's clothes, her house did not go in for looking spick-and-span new. It
was beautiful and a little shabby, and the shabbiness enhanced the beauty.[38]

This theme is also taken up by Ottoline, who, in an unpublished essay, written in 1916 states, 'As I look at the house – compressed, piled up, erect, it has a proud reserve. It has its past, its secrets, its hidden knowledge of life – so have I ….' She goes on to stress this synergetic relationship between herself and the house:

The house has all the magic thrill to me, even tho' I have lived within its walls
and it has become absolutely familiar to me, pressed so near that we almost
seem one. I have interpenetrated the house – vivified it – filled it with flaring
orange – and reds and greens – filled it with myself – my thoughts – actions.[39]

Staged within the rooms of Garsington and elsewhere, Ottoline's self-portraits present a challenge to the florid literary descriptions. They depict both Ottoline and her interiors in a subtler, more contemplative light, calling to mind a Bachelardian conception of the house as a structure analogous to the structure of the mind and memory, in which the furnishings are imbued with particular characteristics, thoughts and mannerisms.[40] Importantly, it is Ottoline's figuration in the different rooms within her self-portraits; her relation to their contents in these images, that seem to indicate these different mental states, personalities or ideas.

Photograph

In many of the photographs, the imaginative elision between Ottoline and her house is evident when she is touching part of the room: assimilating herself within its structure. Figure 5.3 shows Ottoline pictured through a doorframe downstairs at Garsington. She again leans on the wall and, though it is perhaps only for support, the physical contact in the pose gives one the idea of a certain empathy existing between Ottoline and the room. This is enhanced by the type of dress she wears: a straight lined, solid – almost architectural – design that covers her completely, causing her to appear column-like in the doorway. Her body follows the line of the room: her feet stop at its threshold, the line of the curtain is continued by that of her dress, her face is almost hidden in shadow. She is integrated into the room.

In other self-portraits we see how Ottoline's relation to the interior in an image can indicate more specific information regarding her mood or situation at a particular time. One photograph from 1926 shows Ottoline resting on her bed in a nursing home at Ruthin Castle in Wales.[41] The wall stretches out blankly behind her, interrupted only by the metal bed head and the electric lamp attached to it. Dressed in a smart jacket and pearls, with her hair tied in a bun at the nape of her neck, she presents a figure at odds with her plain surroundings. Her pose – body facing the camera, head turned away – suggests a degree of shyness at being represented in the space of the nursing home. Ottoline was fairly secretive about her illnesses, though suffering greatly from a variety of maladies throughout her life (in this particular case it was severe back pain and anxiety about leaving Garsington). Her decision to picture herself in these environs and then to display the image into a publicly viewed album might be seen as a cautious effort to represent herself as ill, vulnerable or isolated.[42] Her body shows no sign of suffering but we get a sense of her illness through the figuring of her body in the blank, empty interior within the photographic frame: a contrast to her usual setting.

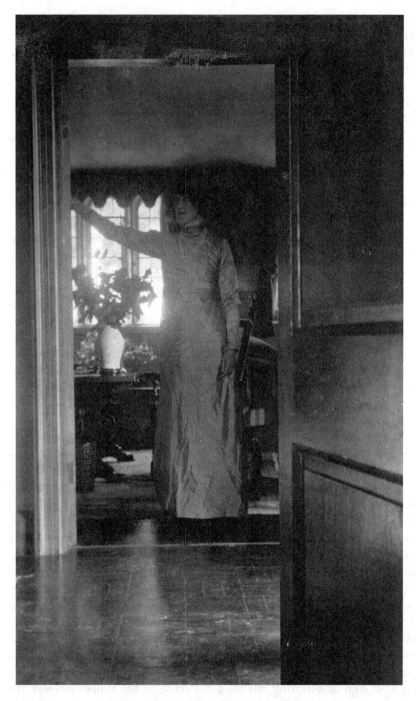

5.3 Lady Ottoline Morrell, *Lady Ottoline Morrell*, 1920,
vintage snapshot print, Garsington Manor, Oxfordshire.

A photograph taken towards the end of her life in 1932 shows Ottoline seated in a richly decorated room at Amerongen, the home of her Dutch relatives.[43] With her profile to the camera and her body dissected by the table, almost blending into the bookshelf, she contemplates the vast room and its contents. From the high vantage point, the portraits hanging on the wall return and challenge her gaze. The room, and Ottoline's position within it, conveys not only biographical details about Ottoline's aristocratic heritage, but also her ambiguous relationship to this heritage. Her small, out-of-focus figure, obscured by the antique furnishings, and towered over by family portraits, presents her as an outsider in this interior, as deferential. Ottoline's dislocation or isolation in the space evokes the difficult relationship she had with her aristocratic family.[44]

With hindsight, Ottoline's self-portraits seem to circumvent the traditional concerns of male theorists and philosophers relating to photographic representation. Jean-Paul Sartre described the production of an image/double as tantamount to theft, resulting in alienation and a loss of power because the subject is reliant on the mirrored self or 'other' for a unified conception that, essentially, remains external to his being.[45] Roland Barthes also describes the process of photographic portraiture as alienating: because the body is susceptible to representation via stereotype. Barthes's frustration results from his inability to produce a desired photographic image of his 'profound self'. Posing in front of the camera he feels as though he is playing a part and suffers from a sense of inauthenticity as a consequence.[46]

Whilst Sartre and Barthes view this multiplication of self in negative terms, theorists have, more recently, interpreted women's photographic practice as evidence of a positive affirmation of self in the private and public realms. Gen Doy has written that though traditionally in art history, objectification (often expressed through the pictorial coupling of woman and mirror) has been seen as repressive for women, if it is a woman who makes the image: she becomes an active participant in her 'objectification' which, instead of being understood as negative, can now be considered empowering: representative of a 'creative subject ... who constructs her own image'.[47]

Figure 5.4 shows Ottoline sitting at her dressing table on an earlier visit to Amerongen in 1925. She sits at her toilette, gazing into the mirror in search for an image of self, and two images look back. The photograph captures this moment of multiplication and (with the addition of the gaze of the portrait on the wall)[48] produces a further four doppelgängers within its frame. Ottoline is seen to embrace this objectification by calmly contemplating her doubles and actively adding to their number in the process of self-portraiture. By incorporating the fragmentation of self into an understanding of her identity, she maintains control over her own image.

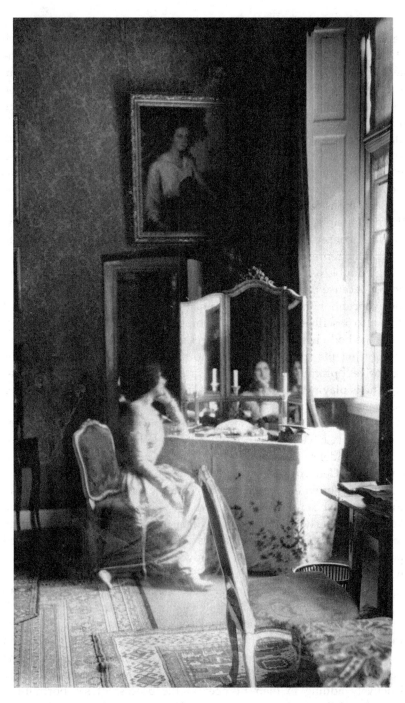

5.4 Lady Ottoline Morrell, *Mummy in Her Bedroom at Amerongen*
(Lady Ottoline Morrell), 1925, vintage snapshot print, Amerongen, Netherlands.

As Rosalind Krauss has written, the camera is not merely passive in photographic representation. It is, rather, to be considered "projective": helping to construct a fantasy of cohesion within the family or within the self.[49] This tendency is also to be found in methods of photographic display and distribution. Ottoline's self-portraits were displayed alongside other snapshots within her albums. She had 12 albums in total and they were accessible to visitors in her home. Ottoline, who was assisted by her young daughter Julian, assembled them, and both annotated the images. The photographs present the self as defined and limited by the frame, and the album pages prescribe the 'narrative' and circumstances of viewing.[50] Patrizia Di Bello writes that whilst some theorists have interpreted women's photography and album-making in negative terms, as compensating for women's relative lack of control in their lives, she believes it might be interpreted in more casual terms; as sociable and flirtatious.[51] It is under this category that I propose Ottoline's practice falls. It is difficult to ascertain a precise 'narrative' in Ottoline's self-portraits, or how much we can read their apparent content as intended but, for historians, Ottoline's photographs emerge as a supplementary or alternative narrative; a clarification of, or counterpoint to, existing texts.

Defining the basic function of biography and autobiography as 'naming', Paul Jay describes a use of language that gives 'shape, scope and significance to some observed or perceived image, act or event'.[52] The action of Ottoline's self-portraiture and the resulting images can be seen to have a similar sort of 'naming' function but, instead of being delineated by language, the object in question is circumscribed by the pictorial limits of the frame. So the *naming* becomes a *framing* function. In Figure 5.3, we saw Ottoline at Garsington: beautifully poised and immaculately dressed. She is framed by two doorways and, once more, in the frame of the photograph on the album page. Though it is especially evident in this image with its multiple frames; *all* of Ottoline's self-portraits delineate Ottoline – her dress and her interiors – as the 'events' being *framed/named* in this self-reflexive effort of representation.

Underlining the role of the domestic interior as a site for the formation and expression of modern identity, John Potvin usefully draws together fashion and space in a discussion of how both impact upon our perception of, response to and memory of the other.[53] Potvin describes 'surfaces', such as cloth, textiles, upholstery, furniture or wallpaper, as 'loci of play and meaning',[54] summoned to 'narrativise the individual's corporeal and spatial identity'.[55] Yet he stops short of considering how this narrative becomes known more widely. I wish to argue that portraiture represents an additional 'surface' that frames expressions of identity in dress and furniture, revealing them in a broader public sphere. Essentially, it allows them to attain social significance.

Whilst the other members of Ottoline's circle, such as Virginia Woolf and Vanessa Bell, were actively engaged in the modernist project as authors or artists, these modes of expression were not within Ottoline's reach. A

patron for countless others,[56] evidence of Ottoline's own artistic or authorial voice is found in her photographic self-portraits. At times they seem to echo extant visual and literary motifs deployed by her contemporaries and biographers, but frequently their rhetoric is challenged. Fundamental to the power of these images to signify though, in a manner that can be seen to approach autobiography, is their composite nature. Body, room and photograph function in tandem and, with each new layer, meaning is compounded and contextualized.

David Cecil described Ottoline as, 'a creative artist of the private life, whose imagination expressed itself in the clothes she wore, the rooms she sat in, the social life that took place there, and more than anything, in herself'.[57] These self-portraits, I would argue, must be understood part of that layered system, and represent a unique body of work that allowed Ottoline to publically negotiate a sense of her own identity, within her own lifetime and since.

Acknowledgements

The National Portrait Gallery, London holds all of Ottoline's albums and additional negatives, which they bought from the Morrell family in 2003 with help from the Friends of the National Libraries and the Dame Helen Gardner Bequest. I would like to thank my colleague Georgia Atienza, Photographs Cataloguer, for sharing her opinions and expertise on the albums and Elaine Uttley at the Fashion Museum, Bath for showing me many wonderful items from the Lady Ottoline Morrell Collection.

Notes

1. *Ritratto Futurista di Lady Ottoline Morrell* by Giacomo Balla. Tempera on board, c.1915. Private Collection.

2. Ottoline's memoirs were edited by her husband following her death, changing the style and quality of Ottoline's prose, and removing much of the defamatory information about both Ottoline and himself. They were then edited by Robert Gathorne-Hardy who, working from Philip's manuscript after Ottoline's original was lost, took out further details that would embarrass or disparage the characters of the still living, or their children and close relatives, resulting in the two volumes of her memoirs published in 1963 and 1974. Sandra Jobson Darroch's 1976 biography was based on the memoirs edited by Gathorne-Hardy, so repeats this edited and incomplete version of Ottoline's life. Miranda Seymour gained access to the original manuscripts, recovered from the Morrell family and now kept at the British Library. The University of Texas at Austin holds the largest collection of Ottoline's correspondence. The University of Maryland holds Ottoline's correspondence with Siegfried Sassoon and two short essays by Ottoline on her life and friends. Additional letters, including her correspondence with Virginia Woolf, are held at various institutions in Britain, listed on the website of the National Register of Archives.

3. The Tate Gallery holds an oil painting by the French artist, Simon Bussy which renders Ottoline's profile as cartoonishly exaggerated [N06015] c.1920.

4. Ottoline was disinherited by her mother and her income was relatively low as a consequence. Miss Brenton was her maid and worked to a strict budget. Inspired by historical figures, one such

influence for Ottoline was her ancestor Margaret, Duchess of Newcastle. See Miranda Seymour, *Ottoline Morrell: Life on the Grand Scale* (London, 1998) p. 98.

5. David Garnett, *The Flowers of the Forest* (London, 1955), pp. 116–17.

6. Siegfried Sassoon, *Siegfried's Journey* (London, 1982), p. 11.

7. Ibid., p. 20.

8. Judith Watt, 'The Lonely Princess of Bohemia', *The Guardian Weekend Magazine* (18 November 2000), p. 29.

9. Items held at The Fashion Museum, Bath, for example, hat: 2005.4M, yellow dress: 2000.184/184A and trousers: 2000.185A.

10. Cecil Beaton, *Lady Ottoline Morrell*, bromide print, 1927: National Portrait Gallery, London [x40291].

11. Baron Adolph de Meyer, *Lady Ottoline Morrell*, c.1907, half-plate autochrome. National Portrait Gallery, London, Lady Ottoline Morrell Collection, 1860–1965 (P1099).

12. See for example the portrait by Cavendish Morton, c.1910. National Portrait Gallery, London, [x45656]. Ottoline's unique style was subsequently caricatured by satirical cartoonist Powys Evans in 1914. See [D33467], National Portrait Gallery, London.

13. The *Illustrated London News*, for instance, describes her as 'a very clever embroideress and designer' reporting one outfit as 'a flame-coloured duvetyn cloak trimmed with kolinsky fur over a dark dress'. *ILN* (19 April 1924), p. 710.

14. Stephen Spender, *World Within World* (London, 1997) p. 156.

15. Ibid., p. 157.

16. Lord David Cecil's description of her as 'a princess of the Renaissance risen to shame our drab age', in Seymour, *Ottoline Morrell* (London, 1998), p. 12.

17. Sandra Jobson Darroch, *Ottoline: The Life of Lady Ottoline Morrell* (London, 1976), p. 15.

18. 'she had red-gold hair in masses, cheeks as soft as cushions with a lovely deep crimson on the crest of them, and a body shaped more after my notion of a mermaid's than I've ever seen …' Virginia Woolf to Vanessa Bell, 22 May 1917, quoted in Seymour, *Ottoline Morrell*, p. 97.

19. Seymour, *Ottoline Morrell*, p. 408.

20. Leonard Woolf, *Beginning Again: An Autobiography of the Years 1911–1918* (London, 1964) p. 199. NB One striking item that could have inspired such descriptions found is an unusual muff, made of small, glinting feathers in tones of green and gold. Lady Ottoline Morrell Collection, Fashion Museum, Bath [2000.376].

21. Kate Roiphe, *Uncommon Arrangements: Seven Portraits of Married Life in London Literary Circles, 1910–1939* (New York, 2007).

22. Rosemary Dinnage, *Alone! Alone! Lives of Some Outsider Women* (New York, 2004).

23. Seymour, *Ottoline Morrell*, p. 465.

24. Constance Holme to Vera Holme, 7 March 1919.

25. Sassoon, *Siegfried's Journey*, p. 24.

26. Bolsover had represented a warm and homely change to the ominous, subterranean world at Welbeck Abbey where Ottoline was brought up. The previous inhabitant, the fifth Duke of Portland had neglected the Welbeck estate and only a few rooms were habitable when the family arrived there. Rather bizarrely, the fifth Duke had engaged in huge underground developments and built miles of tunnel and an underground ballroom at the property. Ottoline came to Bolsover as a child and revisited in 1915 with her lover, Bertrand Russell. In her subsequent homes Ottoline sought to recreate the feel of Bolsover, copying the colour schemes and ideas for the garden. See Seymour, *Ottoline Morrell*, p. 35.

27. Ottoline Morrell in Robert Gathorne-Hardy, *Ottoline: The Early Memoirs* (London, 1963), p. 151. In her notebooks Ottoline often returns to the theme of houses. For instance, upon visiting Winchester, Ottoline was prompted to make a note titled 'against drab houses' in which she noted the 'ideal of learning and religion' found there, which contrasted with Welbeck and

Blenheim, which she described as 'mere mausoleums of our family'. See Ottoline Morrell, *Vol. XLI. Miscellaneous notes and lists*. British Library Manuscripts: MS 88886/3/6.

28. Juliette Huxley, *Leaves of the Tulip Tree* (London, 1986) p. 40.

29. Spender, *World Within World*, p. 156.

30. Sassoon, *Siegfried's Journey*, p. 11.

31. Quoted in Jobson Darroch, *Ottoline*, p. 161.

32. Quoted in Jan Marsh, *Bloomsbury Women: Distinct Figures in Life and Art* (London, 1995) p. 68.

33. Garnett, *The Flowers of the Forest*, pp. 36–9.

34. Walter James Redfern Turner, *The Aesthetes: A Philosophical Dialogue* (London, 1927), p. 39.

35. Ibid., p. 48.

36. Jobson Darroch, *Ottoline*, p. 158.

37. Speaking of Ottoline's death, Woolf writes 'at last, at last, it was time to go from the room which she had made so beautiful'. Virginia Woolf, 'Lady Ottoline Morrell', *The Times* (22 April 1938), p. 16.

38. Lord David Cecil, 'Introduction', in Carolyn G. Heilbrun (ed.), *Lady Ottoline's Album* (New York, 1976), p. 7.

39. Ottoline Morrell, *Garsington*, 1916, p. 1 of 5. *Papers of Ottoline Morrell*, Special Collections Division, University of Maryland at College Park Libraries [LMSS 78–8]. Miranda Seymour also notes her bodily identification with Bolsover. She identified with its 'proud isolation', the intimacy of smaller rooms, romantic colours and personable grounds. Seymour, *Ottoline Morrell*, p. 35.

40. Gaston Bachelard, *The Poetics of Space* (Boston MA, 1994).

41. Lady Ottoline Morrell, *Lady Ottoline Morrell*, early 1926, vintage snapshot print, National Portrait Gallery, London, Lady Ottoline Morrell Album Collection, Album 7, 1925–1926 [Ax142462].

42. Variants of this image were also pasted into her diary at the time. See 19 January entry in Lady Ottoline Morrell, *Vol. lxvii. Journal for 26 October 1925–28 May 1926* British Library Manuscripts [MS 88886/4/17].

43. Lady Ottoline Morrell, *Lady Ottoline Morrell*, 1932, vintage snapshot print, Amerongen, Netherlands, National Portrait Gallery, London Lady Ottoline Morrell Album Collection, Album 10, 1931–1934 [Ax143353].

44. For details of Ottoline's relations with her family see Miranda Seymour, *Ottoline Morrell* (London, 1992) pp. 29–32. Susan Sidlauskas investigates the dislocation of the self in impressionist painting in her essay 'Psyche and Sympathy: Staging Interiority in the Early Modern Home', in Christopher Reed (ed.), *Not At Home* (London, 1996) pp. 65–80.

45. Jean-Paul Sartre, *Being and Nothingness: An Essay on Phenomenological Ontology* (London, 1966), pp. 225–63.

46. Roland Barthes, *Camera Lucida: Reflections on Photography* (London, 2000), pp. 12–14.

47. Gen Doy, *Picturing the Self: Changing Views of the Subject in Visual Culture* (London, 2005), pp. 52–3. Jane Gallop also advocates embracing objectification as a mother through doubling as both subject and object. See Jane Gallop, 'Observations of a Mother', in Marianne Hirsch, *The Familial Gaze* (Hanover, 1999), p. 71.

48. The portrait behind Ottoline is of Elisabeth von Ilsemann (1892–1971), daughter of Count Godard van Aldenburg-Bentinck, possibly by A. Horowitz (private collection).

49. Rosalind Krauss, 'A Note on Photography and the Simulacral', *October*, 31 (Winter 1984): p. 56.

50. Julian's input arguably adds a further level of significance to the albums. For more discussion of photographic albums, see Elizabeth Edwards and Janice Hart, *Photographs Objects Histories: On the Materiality of Images* (London, 2004).

51. Patrizia Di Bello, *Women's Albums and Photography in Victorian England: Ladies, Mothers and Flirts* (Aldershot, 2007) pp. 123–4.

52. Paul Jay, 'Posing: Autobiography and the Subject of Photography', in Kathleen Ashley, Leigh Gilmore and Gerald Peters, *Autobiography and Postmodernism* (Boston, 1994) p. 204.

53. Potvin's reading of spaces of fashion as 'potential sites of and for spectacle, performance, and even transformation [that] people often seek out […] as participants, voyeurs, consumers, spectactors […]' sheds light on the draw that Ottoline must have presented to her contemporaries. Visitors to Ottoline's home would have experienced the 'embodied' spectacle of fashion to which Potvin refers. John Potvin (ed.), *The Places and Spaces of Fashion, 1800–2007* (New York, 2009), p. 9.

54. John Potvin, 'The Velvet Masquerade: fashion, interior design and the furnished body', in Alla Myzelev and John Potvin (eds), *Fashion, Interior Design and the Contours of Modern Identity* (London, 2010) p. 15.

55. Ibid., p. 6.

56. Ottoline was one of the founder members, with Roger Fry, of the Contemporary Art Society formed in 1910 to aid young artists and the collection of their work by established galleries and museums in England.

57. Lord David Cecil, 'Introduction', in Carolyn G. Heilbrun (ed.), *Lady Ottoline's Album* (New York, 1976), p. 10.

Inside Out: Elsa Schiaparelli, Interiors and Autobiography

Tom Tredway

Western society engaged in far-reaching debates about the very nature of civilization, citizenship, culture and identity following the devastating horrors of the First World War. Artists and designers increasingly engaged with the world of political, social and intellectual issues, and some, most notably the Dadaists and later the surrealists, questioned the very notion of civilization itself, rejecting nationalism, materialism and contemporary artistic conventions.

Within this cultural milieu, Elsa Schiaparelli, an Italian woman from an élite intellectual family who rebelled against the strict conventionality of her upbringing, emerged as a champion of the avant-garde in the world of fashion. After a failed marriage to a Swiss-French aristocrat left her penniless and supporting an infant daughter in New York's Greenwich Village in 1920, Schiaparelli preferred to move in artistic, bohemian circles there – 'The Village' was the bohemian centre of the United States in the late 1910s and 1920s – rather than return to the materially comfortable but emotionally stifling world of conservative upper-class Rome.[1] In 1922, she moved to Paris where she supported herself in various ways, including working for an antiques dealer and making dresses for friends. After working as a freelance designer for several seasons, she launched her first collection of sportswear under her own name in 1927 to both critical and commercial acclaim, almost immediately eclipsing her chief rival, Coco Chanel.[2]

Schiaparelli viewed herself first and foremost as an artist whose preferred medium was fashion. While her vast creative output defies a single definition, her designs remain closely associated with the artistic circles in which she travelled. Many of her more memorable designs resulted from close collaborations with surrealist artists, particularly Salvador Dalí. The tear dress and veil from 1938, which used *trompe l'oeil* printing and appliqué to simulate torn animal flesh

where the dress is ripped away, played with contemporary psychoanalytic ideas about feminine masquerade. It showed dress and clothing as a mask, as artifice, as a violent act of deception that, when pulled away, reveals our true animal nature.[3] The shoe hat (1937–38), exemplified Schiaparelli's idea that an outrageous hat protected an insecure woman with an ugly face. It was also, more explicitly, an assault on bourgeois respectability, revelling in the absurd, and the version with a phallic pink heel can be read as an attack on prevalent sexual and gender mores. Her subversive wit, juxtaposition of opposites, and playfulness in these designs became all the rage. Bettina Ballard, the editor of Paris *Vogue* at the time, noted in her autobiography, 'To be shocking was the snobbism of the moment, and she was a leader in this art ... Paris was in the mood for shocks and Elsa Schiaparelli could present hers in well-cut forms and with an elegance that no one could deny.'[4]

Schiaparelli's interiors, much like her couture creations, encompassed many influences, allusions and meanings. Schiaparelli's autobiography, *Shocking Life* (1954), suggests a strong relationship between the modern imagery, particularly the surrealist iconography, used in the decoration of her interiors and her own life experiences and personal creation myths.[5] In 1934 Schiaparelli and interior designer Jean-Michel Frank designed both her apartment on the rue Barbet-de-Jouy and her new couture house on the Place Vendôme, including the boutique on the ground floor. Schiaparelli, then in the process of expanding her business, used references to her life, work and the artistic and social circles in which she moved in her domestic interiors as a way to state her aesthetic point of view and reinforce her role as an artist working in couture. She also used surrealist visual devices, particularly in her boutique, as a way to frame and create desire for her products, reinforce her relationship with avant-garde artists, and make references back to her own personal history.

Identity and the Domestic Interior

When Schiaparelli and Frank began to decorate her new apartment, in an eighteenth-century garden mansion on the rue Barbet-de-Jouy, the pair incorporated many elements from Schiaparelli's boulevard Saint-Germain apartment (1927–28), which they also designed together, resulting in a similar sense of casual comfort and sophistication in a space full of colour, texture and visual stimulation.[6] They punctuated the apartment's white walls with avant-garde paintings and bright pops of orange, yellow, green and lavender, and dedicated several areas to displaying objects, small photographs and works on paper. The furnishings for the living room included the large orange Moroccan leather couch, simple white upholstered chairs, and white Tunisian carpets from Schiaparelli's previous apartment (Figure 6.1). Small chairs covered in quilted canary yellow and milk

white chintz, casually placed in small groupings, created more intimate spaces within the large room, and leopard skins shared the floor with more white wool Tunisian rugs. Schiaparelli's fine art collection, including works by Christian Bérard, Salvador Dalí, Albert and Diego Giacometti, Pablo Picasso, Man Ray, Pierre Roy and Pavel Tchelitchew, formed an important aspect of these interiors and figured prominently in the arrangements of small objects – including busts, figures, plaster vases, and clocks – that rested on virtually every flat surface. The small living room mantel, which held *Bazaar de l'Ocean* (1920), a surrealist painting by Pierre Roy, a large shell, a Frank lamp, and a plaster vase (probably by the Giacometti brothers), gives a sense of the artistic richness of the *objets d'art* carefully arranged throughout the apartment.[7] Large bookcases dominated one corner of the

6.1 Elsa Schiaparelli and Jean-Michel Frank, *Living Room*, Elsa Schiaparelli's apartment, rue Barbet-de-Jouy, Paris, photographed in 1934. Buffotot/Vogue; © Condé Nast.

room, displaying small paintings, works on paper and sculptural figures in addition to books. In the bedroom a white bear skin covered the floor, and they used chicory-blue crinkled rayon crêpe for the bedcover, curtains and upholstery. The furniture, designed by Frank, included small chairs from Schiaparelli's previous apartment, an oak and black-mirrored dressing table and an ashwood and black Japanese lacquer bureau with a Chinese terra cotta figure, Frank lamp and a modern bronze clock on top.[8]

The choice of materials, particularly textiles – chicory-blue crumpled rayon crêpe, yellow and white quilted chintzes, orange leather – reflected Schiaparelli's trademark use of unconventional textiles developed at the time by firms like Colcombet, especially rayon crêpe. This pioneering use of synthetic materials introduced new textures, colours and artistic possibilities to couture with novel and exciting results. Yet untested materials proved disastrous on at least one occasion when used in an interior. The first dinner party Schiaparelli hosted in her apartment on

the boulevard Saint-Germain was an opulent affair. Schiaparelli's chief rival, Chanel, attended, and at the sight of this modern furniture and black plates she shuddered as if she were passing a cemetery.[9] This shocked and visceral response delighted Schiaparelli.[10] Unfortunately, as Schiaparelli recalled:

With the heat of the late spring, however (it was a very warm evening), the white rubber on the chairs had transferred itself, unbeknown to them, to the dresses of the women and the trousers of the men, and when dinner was over and they all got up, they looked like strange caricatures of the sweaters that had paid for their meal![11]

In her zeal to be shocking and original, Schiaparelli could overlook certain practical considerations, much to the chagrin of her guests in this case. This daringness, however, constituted a key element of Schiaparelli's design philosophy, and this willingness to take risks produced some of the most outrageous, inventive and popular designs of the interwar years. Schiaparelli learned from this experience, however, and never upholstered furniture in such an unstable material again.

Schiaparelli also used specific textiles to refer back to particular garments or themes in her recent collections. George Hoyningen-Huene photographed Schiaparelli for the 15 November 1933 issue of American *Vogue* wearing a quilted dinner suit and cape constructed from a taffeta fabric created exclusively for her by the textile firm Bianchini for her winter 1933–34 collection.[12] This interest in quilted fabrics carried over into the textiles used for the small chairs in her living room while the rayon crêpe used in the bedroom first appeared in various forms in 1932 for both day and evening wear. A lacquer portrait by Jean Dunand (c.1933) shows Schiaparelli in an evening dress from her autumn 1933 collection made from a similar synthetic fabric, a Schiaparelli exclusive named rayesca in a light blue-purple shade called pansy.[13]

Schiaparelli also used textiles and floor coverings with more personal associations, particularly the white wool Tunisian carpets and leopard skins in the living room. Even though she grew up in Rome, she spent her childhood surrounded by North African objects. Her father, Celestino Schiaparelli – head of the Lincei Library and an enthusiastic numismatist with extensive contacts in North Africa – devoted his life to the study of Oriental languages and literature, particularly Arabic and Islamic texts. Her Aunt Lillian lived in Egypt when Schiaparelli was young, and her gifts left a lasting impression upon the artist-couturière. As Schiaparelli fondly recalled:

she sent us beautiful materials, wonderful exotic things that brought dreams to my severe surroundings. Perhaps she awakened the love of eastern things which I have retained throughout my life. I used to wait anxiously for her parcels – and nobody in the family guessed what a deep impression they made on the little girl's wild imagination.[14]

Throughout her life Schiaparelli felt a particularly strong attachment to Tunisia, beginning with a trip she made there with her father at the age of 13. Although she complained about being largely relegated to the harems, with their 'ugly modern furniture from European department stores', she told of how a powerful Tunisian man proposed marriage by performing a fantasia with his entourage beneath her window.[15] His display of horsemanship and pageantry impressed Schiaparelli, but her father deemed her too young to accept the proposal. As Schiaparelli recounted, 'Thus I lost an opportunity to lead a life that might have been very happy. Many times, during the great and bitter struggles ahead, I thought back on that moment and regretted that I had not been allowed to take what was a promise of a peaceful existence.'[16] It is doubtful that Schiaparelli would have found life in the harem fulfilling, but this early encounter with Tunisia clearly stayed with her for the rest of her life.

The Tunisian influence in these interiors extended beyond the floor textiles; indeed it is perhaps most apparent in the use of colour. The largely bare, simple geometry of the white walls related not only to broader trends in modernist architecture but also to traditional Tunisian buildings, and her concentrated use of bright 'pops' of colour makes the connection between these interiors and the architecture of the Mediterranean coast of Tunisia more apparent.[17] Schiaparelli's attraction to the area grew stronger later in life; she travelled there again in 1936, incorporated Tunisian designs into her 1939 collections, and bought a small house in Hammamet after the Second World War, where she concludes *Shocking Life* lying on Frank's orange Moroccan leather couch on her mashrabiya.[18]

Schiaparelli's interiors also placed her within the circle of modern artists, particularly surrealists, as a collector, collaborator and important artistic figure in her own right. Through her support of, and work with, these surrealist artists Schiaparelli signalled her allegiance to other creative professionals challenging traditional perceptions of self and society. Schiaparelli's collecting also had gender connotations. Although collecting had long been associated with men, Schiaparelli and a growing number of other 'modern' women – including Marie-Laure de Noailles, who financed important films by Ray, Cocteau, Buñuel and Dalí, among other projects, and beauty tycoon Helena Rubinstein, who frequently lent parts of her collections to the Museum of Modern Art in the 1930s – established public identities for themselves at least in part through art patronage, challenging male prerogatives as they did so.[19] Several pieces in Schiaparelli's collection indicated her direct participation in contemporary aesthetic debates and the importance of collaboration in her own artistic process, reinforcing the fluidity of the boundaries between art, fashion, interior design and commerce. The large bookcase in the living room displayed two photographic portraits of Schiaparelli by Man Ray, the photographer

whose work for *Harper's Bazaar* largely introduced surrealism to fashion photography. He used one of these photographs to illustrate his essay 'L'Âge de la Lumière' (*The Age of Light*, 1933) in the surrealist periodical *Minotaure*, a call for emotion, the subconscious and experience to drive the making of art.[20] He described the photographs accompanying the article as autobiographical images – 'seized in moments of visual detachment during periods of emotional contact, these images are oxidized residues, fixed by light and chemical elements, of living organisms. No plastic expression can ever be more than a residue of an experience'.[21] Other pieces from Schiaparelli's collection drew attention to her work with other artists active in the world of couture. A gouache on the desk by Bérard – another central figure in Schiaparelli's stable of artistic collaborators and a frequent creator of illustrations for the fashion press – showed a young woman in a Schiaparelli quilted dinner jacket made of material not unlike the upholstery used for chairs close by. These images further reinforced the importance of Schiaparelli's personal and professional relationships with leading artistic figures in her work, as well as her place in the intellectual and aesthetic disputes of the day.

Public Persona and the Press

By the 1930s the public role of the top Parisian couturiers expanded to include much more than fashion; it became increasingly de rigueur for couturiers to allow the public glimpses into certain elements of their lives.[22] In addition, the growing influence and proliferation of an international system of fashion journalism and photography increased the exposure of couturiers and their private lives to an extent previously unimaginable.[23] As both a couturier and a member of the social élite strongly associated with the artistic and intellectual avant-garde, Schiaparelli proved irresistible to the press. She recognized this and turned garnering free publicity for herself and her house into an art form, as well as an effective marketing device. As Bettina Ballard later noted, 'Schiaparelli's genius for publicity has been rivalled only by Christian Dior. Her outspokenness during her days of fame was all part of the Schiaparelli shock treatment.'[24] Schiaparelli, together with Hortense MacDonald, her publicity director, fiercely guarded and shaped Schiaparelli's public image while ensuring volumes of press coverage.

Schiaparelli's interactions with the *Life* photographer, John Phillips, convey something of the extent to which she controlled both her personal and commercial image in the press. A label attached to the back of a candid portrait Phillips shot of Schiaparelli in 1937 reads, 'This photo MUST BE RETOUCHED TO REMOVE SPOTS on face; Promised Schiaparelli this

would be done. (John Phillips).'[25] Beyond simple vanity, this request is one example of the careful and determined way in which Schiaparelli approached her relationship with the press, signalling an acute awareness of its power to transmit important non-verbal information about both herself and her commercial ventures to the public. To celebrate the opening of the Place Vendôme atelier, Schiaparelli commissioned the Colcombet company to print fabric of a design which featured a compilation of press clippings from various world newspapers – a physical manifestation of her ability to attract press. The resulting textile design, used for accessories, ties, and even lounge ensembles worn by Jean Dunand and Johan Colcombet on the maiden voyage of the *Normandie* in 1935, playfully alluded to Schiaparelli's domination of the press.[26]

As Schiaparelli clearly controlled her presence in the press the particular insights into her life that she allowed – her hairdresser Antoine attending to her coiffure, images of her costume for Daisy Fellowes' Oriental Ball, her homes in Paris and London – can be viewed as attempts to create and maintain a particular public persona. Taken together, the couture and couturier became cultural capital for the house and its particular brand of chic. Schiaparelli used her domestic interiors, an important arena of aesthetic discrimination, as part of a larger persona presented to the public, including potential and current clients, of a modern woman leading an artistic and intellectual life.

The design press added an additional level of critical success to Schiaparelli's efforts by covering her interiors. Journalists publicized her aesthetic discernment and design judgment in matters outside of couture while reinforcing her connections with the most creative, innovative and daring artists and designers of the day. *Arts and Decoration*, an American decorative arts magazine, described the décor of the Barbet-de-Jouy apartment as 'unusual', 'elegant', 'contemporary', and 'like no one's else'; *Vogue* called the interiors 'fresh', and 'casual'.[27] All these adjectives could also be applied to Schiaparelli's couture designs. The articles noted Frank's involvement in the interior design, crediting him for the design of some furniture. *Arts and Decoration*, however, gave the overwhelming impression that responsibility for these spaces rested with Schiaparelli, describing them as 'highly personal, feminine, unorthodox' spaces and arguing that 'like many other of Schiaparelli's design-inventions, this novel pattern for a room is something which she controls because of the discipline of her taste'.[28] Similarly, *Vogue* credited Frank only for the dressing table in Schiaparelli's bedroom, writing of the interiors in general that 'the casual note is well shown by Madame Schiaparelli's decoration of her own flat'.[29]

While it is difficult to determine the exact nature of the professional relationship and working collaboration between Frank and Schiaparelli, these interiors contain many elements strongly associated with Frank's work,

most notably the furniture forms, many of which appear in various guises in other commissions, the use of luxurious materials like galuchat, and the air of casual sophistication. The display of objects, the bold use of colour and the unusual incorporation of synthetic textiles, however, most likely resulted from Schiaparelli's input. These elements are not generally found in Frank's other work except for commissions in which he collaborated closely with other visual artists, as was the case with the boldly coloured Institut Guerlain, for which he worked closely with Bérard. Her autobiography suggests that Schiaparelli could convince Frank to create effects that he might otherwise have scorned, often winning him over to her ideas in the process. This is especially clear in the decoration of her Parisian mansion on the rue de Berri, which she acquired in 1937. As she recalled in *Shocking Life*:

Jean Franck [sic] and [Maison] Jansen were generous enough to help Schiap with it, though they were sometimes bewildered at the unorthodox setting of her home. As decorators they found their principles seriously disturbed. Jean Franck [sic], for instance, was very shocked when told that some Boucher 'chinoiserie' tapestries had to be used in the library. He hated tapestries and so did Schiap, but these were different, and she insisted on having Chinese-looking bookcases. He suddenly became so enthusiastic that he painted the space between the tapestries to give the impression that they joined up … This room has given Schiap more joy that any she has lived in.[30]

While Frank and Schiaparelli must both be credited with the creation of these interiors, the design press linked these interiors with Schiaparelli's personality and professional work, explicitly connecting her persona, interiors and designs for their readers.

This coverage provided Schiaparelli with opportunities to define herself through a design media that, much like fashion, remained strongly gendered, and therefore attracted the attention of female readers. The *Vogue* article reinforced the synergy between interiors and dress, stating, 'Madame Schiaparelli's salon – as strict, neat and modern as her clothes', and noting, 'blistered fabrics like those in Schiaparelli sports clothes are used in the bedroom'.[31] While many women reading these magazines may not have been able to pinpoint the exact ways in which Schiaparelli presented herself as a daring and ingenious designer, they certainly would have been able to recognize the novelty of these interiors, and the publication of these spaces allowed Schiaparelli to appeal to the public, including potential clients, through a shared language of decorating.

Identity and Commerce: The Perfume Salon

By 1934 Schiaparelli's atelier at 4 rue de la Paix had become too small. Although Poiret offered Schiaparelli his house and couture salon at 1 Rond-

point des Champs-Elysées, she decided to move into the 98-room mansion formerly occupied by the couturière Mme Chéruit, one of Poiret's earliest supporters, located at 21 Place Vendôme. If anyone had missed the fact that she had 'arrived', this building cleared any doubt.

Again Schiaparelli called upon Frank, asking him to refurbish the mansion, which was protected from major alterations due to its designation as a historical monument.[32] The new space opened in January 1935, and the boutique on the ground floor featured less expensive, non-couture items including accessories, cosmetics and ready-to-wear. The financial success of the boutique depended on enticing a relatively large number of consumers, many of whom could not afford the couture modelled on the upper floor, to buy less expensive items that also embodied the Schiaparelli 'shock treatment'. The eclectic, often startling, decoration of the boutique contained many unusual objects used not only to draw attention to the merchandise, but also to make the boutique a destination, and shopping there a cultural experience of its own.

Schiaparelli claimed that her boutique was the first of its kind, and while clothing and fashion boutiques had existed well before 1935 – Sonia Delaunay's *Boutique Simultanée* at the *Exposition Internationale des Arts Décoratifs et Industriels Modernes* in 1925 is but one notable example – Schiaparelli's was certainly selling more diverse merchandise and more diffuse lines than any of her competitors in the world of couture. It is important to note, however, that this expansion of the Parisian couture was not purely Schiaparelli's invention. In the month before Schiaparelli moved to her new location, for example, the 15 December 1934 issue of *Vogue* noted the opening of a new wing of Lucien Lelong's couture house, also decorated by Frank, that was dedicated to *Les Robes d'Edition*. As Lelong claimed, it ushered in 'a new era in the history of *haute couture*' and, as the article states, 'for the first time in history, a famous dressmaking house in the city of lights has opened a department for selling ready-to-wear clothes'.[33] The article also signalled a growing acceptance in 'high fashion' circles of a type of clothing more generally associated with American mass retailing, commenting, 'But in Paris – until now – no woman in a ready-made dress could have the word "chic" applied to her. It was unthinkable for a smart woman not to have every stitch, from hat to shoe, made expressly for her alone.'[34] Lelong's new line, and its coverage in *Vogue*, suggests that diffusion lines were gaining popularity from the mid-1930s on and were also accepted, to a certain extent, as 'chic'. It must be noted, however, that Lelong's venture was limited to dresses, coats and suits, while Schiaparelli's boutique displayed and sold a much wider variety of cosmetics, accessories, hats and clothing.

In the summer of 1937 Frank created a large black lacquer and gilt birdcage for the display of perfume and cosmetics in the boutique, which

6.2 Elsa Schiaparelli and Jean-Michel Frank, *Perfume Salon*, Schiaparelli Boutique, Place Vendôme, Paris, photographed in 1947.

looked out on the Place Vendôme (Figure 6.2).[35] Caged birds were a recurring theme in Schiaparelli's designs around 1937. She designed a series of accessories, including belts and bags, featuring birds in cages painted on cellophane in 1936 – the very types of objects that would have been displayed in the boutique.[36] Her summer 1937 collection included hats and coats made from black or pink horsehair mesh, with *Vogue* noting, 'You can look like a bird in a cage in Schiaparelli's large-meshed horsehair coats.'[37]

In addition to referring to a recurring motif in Schiaparelli's designs Frank's installation closely relates to a painting of two caged birds by Picasso, a cherished item in her personal art collection. Schiaparelli saw it as a portrait of herself and even used it in place of a traditional portrait for the frontispiece of *Shocking Life*, noting in the forward:

Then again there is the famous painting by Picasso. Her friends
(oh, yes, she has many!) say this picture is a portrait of her.

There is a cage. Below it are some playing cards on a green carpet. Inside the cage a poor, half-smothered white dove looks dejectedly at a brilliantly polished pink apple; outside the cage an angry black bird with flapping wings challenges the sky.

She would not part with this painting for a fortune even if she were, through her supreme indifference to material values, reduced one day, as her mother predicted, to a crust of bread and some straw to sleep on in an empty room. The room would not be empty. The Picasso would be hanging on the wall!

Let us hope that her mother's prediction will not come true.

And if it does, she will know that in spite of success, glamour, and despair, the only escape is in oneself, and nobody can take that away – it is stronger than jealousy, hardship, or oppression.[38]

Schiaparelli's description of this portrait provides insights into her views on domesticity and feminine conventions of beauty. For Schiaparelli the white bird, beautiful and dejected, is a representation of traditional femininity, connoting issues of confinement, subjugation and beauty admired in captivity. The black bird, on the other hand, fights against this prison, challenging normative gender roles and femininities. The independence Schiaparelli read through the black bird mirrors her own view of herself. After being deserted by her husband, a key transitional moment in Schiaparelli's life, her mother requested that she to return to Rome and take up her proper position in society. As she described in her autobiography, 'Schiap was by now like a swallow that had tasted the joys of flight. She chose freedom however hard it might prove. She wanted to mold her own way.'[39] Never again, she implied, would she return to the prison of conventional femininity represented by the birdcage, and this symbol remained an important part of her interiors throughout her life.

In addition to being a personal symbol the birdcage became an important symbol in surrealist iconography, and other surrealist artists adapted it to address issues of liberty, captivity and interiority – all key issues for the 'modern' woman. René Magritte's *The Therapeutist* (1937), for example, used the birdcage as a symbol for the interiority of the human psyche and associated it with the psychoanalytical process, though Magritte does not offer any specific interpretations of the inner life of the wandering bird catcher this painting depicts.[40] André Masson's *Mannequin with Bird Cage*, created for the International Exposition of Surrealism in 1938, equated the woman of beauty with a caged bird.[41] The gag over the mouth, the caged head and the open door all contrast liberty with captivity, suggesting that it could also be read as a modern woman engaged in a difficult and complex balance between personal liberty and societal restrictions.

Schiaparelli further explored the relationship between femininity, identity, artifice and surface through Pascaline, a mannequin made from ebony that often appeared in Frank's birdcage with a dress placed on top of it, rather than around it. Schiaparelli recognized the masking role of fashion in the creation of self, writing in *Shocking Life*, 'When you take off your clothes, your

personality also undresses and you become quite a different person – more true to yourself and to your real character, more conscious, sometimes more cruel.'[42] This articulation of the artificial, particularly through the explicit masking of the self to conform to social expectations, played an important role in Schiaparelli's exploration of the role of clothing and accessories in women's lives. Caroline Evans has challenged the idea that Schiaparelli's wittiness, gags and use of surrealist iconography were mere publicity stunts or attempts to capitalize on the avant-garde artistic movement of the moment, arguing instead that they challenged contemporary constructions of identity using the psychoanalytic ideas of femininity and masquerade, as proposed by the psychoanalysts Joan Rivière and Jacques Lacan.[43] She notes that Schiaparelli's designs, particularly after 1935, explored issues of identity and femininity by highlighting the artifice and superficiality of the feminine through an elaboration of surface as the site of displacement between the inside and outside of the body.[44] Pascaline's dress, floating on the surface of the mannequin's body, reinforces these ideas.

The window display for Schiaparelli's signature scent, Shocking, introduced in 1937, also used surrealist devices to great effect, again blurring the line between surrealist iconography and personal history. The bottle's designer, the artist Léonor Fini, based its form on a dressmaker's dummy modelled on Mae West's famous hourglass figure.[45] This clever mix of references to glamour and the basic trade of garment making alluded not only to Schiaparelli's role as a couturier, even specifically her work for Mae West, but also to the disembodiment and fracturing of the human form frequently associated with the surrealists.

In the window, designed by Bettina Bergery, a real dressmaker's dummy placed alongside displays of the perfume bottles produced an interesting juxtaposition of scale of a type favoured by modernist inter-war graphic designers such as the Bauhaus instructor Herbert Bayer. Like the bottle, the dummy was fitted with a surrealist bouquet of flowers in place of a human head, which may have appealed to Schiaparelli due to an event in Schiaparelli's youth. Schiaparelli's mother, widely recognized as a very beautiful woman, often criticized Schiaparelli's appearance as a child. To rectify the situation Schiaparelli planted flower seeds in her mouth, nose and ears to make what she perceived as her ugly face more beautiful and unique, with predictably disastrous results.[46] Much like the birdcage in the perfume salon, the bouquet of flowers also related to contemporary surrealist imagery – in 1936 alone Dalí's figures in *Necrophiliac Springtime*, which Schiaparelli owned, the figure in his *She Was a Surrealist Woman – She Was Like a Figure in a Dream* window for Bonwit Teller in New York, and the 'Surrealist Phantom' in Sheila Legge's photograph for the cover of the *International Surrealist Bulletin* all appeared with bouquets of flowers in place of heads. One of the print advertisements for Shocking featured

an illustrated version of the window display, indicating the importance of surrealist representational devices in the wider marketing of products displayed in the boutique. Two bottles of Shocking could also be purchased nestled together in a bird cage, further reinforcing the relationship between the perfume, the boutique and Schiaparelli's art collection.[47]

The Issue of Legibility: Surrealism as Chic

Schiaparelli, in part, used surrealist ideas in her interiors to explore notions of femininity, artifice and surface, challenging, or at least drawing into question, traditional notions of gender, respectability and beauty. While these concerns proved central to Schiaparelli's creative production and how she positioned herself in the marketplace, their implications likely remained accessible to only a very small élite with strong intellectual and artistic inclinations. Schiaparelli fulfilled a need for novelty in the fashion world with intelligent, witty, humorous designs. This novelty, together with her élite clientèle, created desire for her products in the marketplace, but many women wearing her designs had little or no knowledge of, or interest in, the way Schiaparelli challenged expectations of femininity. The fact that surface decoration formed the basis of this challenge often allowed Schiaparelli's critique of society to go relatively unacknowledged.

A Cecil Beaton photograph of Wallis Simpson before her wedding to the Duke of Windsor for *Vogue*, in 1937, is instructive on this point. Simpson appears in the park of the Château de Candé wearing Schiaparelli's famous lobster dress from the summer 1937 collection. One purpose of the extended photo spread in *Vogue* was to present Simpson in a more flattering, romantic and feminine light, and, while the silhouette of this dress seems suitable for that purpose, the imagery on the dress works against those goals.[48] Schiaparelli collaborated with Dalí in designing this dress, and the lobster formed an important and well-publicized aspect of his iconography. A highly sexualized symbol, Dalí often used the lobster to cover female genitalia, and there is a direct correlation between his photographs and drawings depicting naked women, often in various forms of implied bondage with their genitalia covered by a lobster, and this garment.[49] As a result, this dress makes direct reference to the naked female form while simultaneously suggesting an oversized phallus, owing to the scale and placement of the lobster. As Dilys Blum has noted, to those familiar with surrealist art and contemporary psychoanalytical ideas the surrealist implications of the design negate the goals of the photograph.[50] Schiaparelli's designs may have been novel, desirable and chic, but the ideas behind their novelty often remained inaccessible to her clients. As a result Schiaparelli's artistic output, including her interiors, was simultaneously widely popular and covertly subversive.

Notes

1. Dilys Blum, *Shocking! The Art and Fashion of Elsa Schiaparelli* (Philadelphia PA, 2003), p. 11.

2. Ibid., p. 13.

3. Caroline Evans, 'Masks, Mirrors and Mannequins: Elsa Schiaparelli and the Decentered Subject', *Fashion Theory*, 3/1 (March 1999): p. 14.

4. Bettina Ballard, *In My Fashion* (New York, 1960), p. 61.

5. Elsa Schiaparelli, *Shocking Life* (New York, 1954).

6. Blum, *Shocking!*, pp. 36, 62; Pierre-Emmanuel Martin-Vivier, *Jean-Michel Frank: L'Étrange Luxe du Rien* (Paris, 2006), pp. 105–6.

7. Blum, *Shocking!*, p. 62. Blum also notes the possible relationship between the Roy painting and a Schiaparelli bathing suit from 1928.

8. Ibid.; 'A Designer Makes her Home in Paris – in London', *Arts and Decoration* (May 1934): p. 38.

9. Schiaparelli, p. 67.

10. Palmer White, *Elsa Schiaparelli: Empress of Paris Fashion* (London, 1995), p. 92.

11. Schiaparelli, p. 67.

12. Blum, *Shocking!*, p. 65.

13. Ibid., pp. 32, 34.

14. Schiaparelli, p. 25.

15. Ibid., p. 27.

16. Ibid., p. 28.

17. Others perceived a connection between modernism and North Africa as well, often in a negative light, perhaps most forcefully found in criticism of the Weissenhofsiedlung in Stuttgart, including a post card of the housing estate as an Arab village. See Richard Pommer and Christian Otto, *Weissenhof 1927 and the Modern Movement in Architecture* (Chicago, 1991), p. 51.

18. Schiaparelli, p. 253.

19. Leora Auslander, 'The Gendering of Consumer Practices in Nineteenth-Century France', in Victoria de Grazia and Ellen Furlough (eds), *The Sex of Things: Gender and Consumption in Historical Perspective* (Berkeley, 1996), pp. 85–90, 99; Marie J. Clifford, 'Helena Rubinstein's Beauty Salons, Fashion and Modernist Display', *Winterthur Portfolio*, 38/2–3 (Summer/Autumn 2003): pp. 83–108.

20. Man Ray, '*L'Âge de la Lumière*', *Minotaure*, 3/4 (1933): p. 1.

21. Man Ray, 'The Age of Light', short preface to *Photographs by Man Ray: 105 Works, 1920–1934* (New York, 1979), n.p.

22. For more on the interiors and collections of Worth, Doucet and Poiret see Nancy Troy, *Couture Culture: A Study in Modern Art and Fashion* (Cambridge, 2003). Poiret's example is particularly important as Schiaparelli can be considered Poiret's successor in the world of fashion. His early encouragement was crucial to her development as a couturier and their close friendship certainly influenced her thereafter.

23. Stephen Calloway, *Baroque Baroque: The Culture of Excess* (London, 1994), p. 79.

24. Ballard, pp. 61–2.

25. John Phillips, Elsa Schiaparelli, photographed 1937, Time Inc. Picture Collection, 001114357. Phillips' autobiography presents a view of Schiaparelli's couture house, including its interiors, from outside the world of fashion. See John Phillips, *Free Spirit in a Troubled World* (Zurich and New York, 1996).

26. Blum, *Shocking!*, p. 76.

27. 'A Designer Makes her Home', p. 38; 'Decorator's Preview', *Vogue* (15 September 1934): pp. 76–7.

28. 'A Designer Makes her Home', p. 38.

29. 'Decorator's Preview', pp. 76–7.

30. Schiaparelli, pp. 118–19.

31. Ibid.

32. Blum, *Shocking!*, p. 71.

33. 'Lelong Branches Out', *Vogue* (15 December 1934): p. 59.

34. Ibid.

35. Martin-Vivier, p. 174.

36. 'French Flair', *Vogue* (1 July 1936): p. 72.

37. 'Sparks from the Paris Openings', *Vogue* (1 March 1937): p. 59.

38. Schiaparelli, p. 10.

39. Ibid., p. 54.

40. Richard Martin, *Fashion and Surrealism* (New York, 1987), p. 192.

41. Ibid., p. 193.

42. Schiaparelli, p. 72.

43. Evans, pp. 3–32.

44. Ibid., p. 7.

45. Dilys Blum, 'Fashion and Surrealism', in Ghislaine Wood (ed.), *Surreal Things* (London, 2007), p. 154.

46. Schiaparelli, p. 17.

47. 'Display Ad 32 – no Title [Saks Fifth Avenue]', *New York Times* (7 December 1941): p. 33.

48. Blum, *Shocking!*, p. 135.

49. Nancy Frazier, 'Salvador Dalí's Lobsters: Feast, Phobia, and Freudian Slip', *Gastronomica*, 9/4 (Fall 2009): pp. 16–20.

50. Blum, *Shocking!*, p. 135.

Illusion and Delusion:
Validating the Artificial Interior

Gene Bawden

Since its inception in 1839 photography has played a pivotal role in the documentation of time and place. People, objects, locations, fashion and events – grand and intimate – have been sealed within two-dimensional time capsules that readily disclose detailed information to the viewer decades beyond their creation. Photography's rapid ascension from an experimental chemistry to a popular and familiar technology has freed the vanity of portraiture from the clutches of the moneyed classes. By the 1880s all levels of society had at their disposal a means of forever securing their image. However, by that time the process once valued for its capacity to capture truth and fact, had begun to blur the edges of reality with illusionary mastery. Photography could at once capture an indisputable physical likeness, and at the same time displace sitters from their true and at times unfortunate circumstances: no longer poor, no longer lonely, no longer abused. 'Photography celebrates the details while it obscures the ironies, ambiguities and contradictions of life.'[1]

Most ordinary archival photographs have long since lost their immediacy. They have faded into generic representations of history or romanticized visual narratives rather than remaining diligent recordings of specific events. We read meaning into the images, guided towards a narrative conclusion simply by their visual content, our own presumptions and the atmospheric effects induced by the photographer. On one level the four photographs discussed in this chapter possess the same narrative veneer of a polite, anglo-centric Australian family. They perpetuate a myth of wholesome family relationships within homes of idealized domesticity in a country culturally aligned to a benevolent, guiding motherland. However, the lived realities suggested in these images challenge their imagined truths and, consequently, our reading of them.

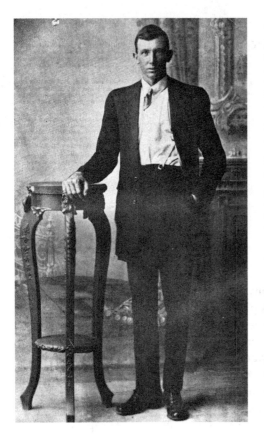

7.1a　*John Bawden, 1925.*

An Untimely Death

On 7 January 1926 my grandfather, John Bawden, was murdered. Time and an unbridled curiosity have unshackled this story from a closeted family secret to reveal a narrative that intrigues me like no other. A single photograph exists of him, taken in 1925 (Figure 7.1a) at the same sitting as that of his two sons Jack and Leslie, then aged 5 and 3 (Figure 7.1b).

As images they are as aesthetically unremarkable as any collection of domestic ancestral photographs. They are just like any that languish at the bottom of forgotten boxes, or are uncaringly discarded in secondhand stores and charity shops; their value lessened further by anonymity.

They are ordinary images of unremarkable people. Their stories are deeply personal but historically inconsequential. Within each photograph though, lies a richer narrative played out against a backdrop of artificial interiors that imbue the images with meaning that extends far beyond our first impulse to dismiss them. As Stephen Pinson argues, 'to effect a more complete understanding (of a photograph) we must get beyond superficial detail. Otherwise we remain servants to illusion and susceptible to its lies.'[2]

In the photograph my grandfather is depicted as the moral sobriety of his time demanded: a man empowered by a suit within a genteel room of commanding architecture and distinction. The room is defined by a heavily carved fireplace, an ornate staircase and a single, bauble-encrusted curtain falling upon a checkerboard floor. His interior is obviously an artifice; a painted photographer's prop common to studio photography across the globe since the 1880s. The only tactile object within the interior is the denuded jardinière stand. It too holds little more provenance than the painted canvas. Nothing of this interior replicated the reality of my grandfather's life, yet he is represented as though belonging to it; owner of this gracious delusion; a man of substance and means.

The image is a mediated truth, hovering somewhere between reality and fantasy. It is an objective likeness of a real man, but one blurred by illusion and supposition. My grandfather undoubtedly *looked* like this. His facial features are accurate and a close examination of his hand reveals something of his occupation. It is the hand of a labourer: clenched, gnarled and sinewy, not refined or elegantly poised like those of a man of another class. However, these tiny 'truths' are overwhelmed within a vision of culturally specific, but entirely delusional, formality. He stands clothed in a suit he would never have owned, in an opulent, anglo-centric interior he could never hope to occupy. He is stiffly posed, possibly directed to be so by the photographer, but more likely as a result of the exposure time of the camera. 'Stern' was a far easier pose to hold for any length of time, and its prevalence in studio photography up to this period suggests it was a normal and expected practice. 'Natural' poses

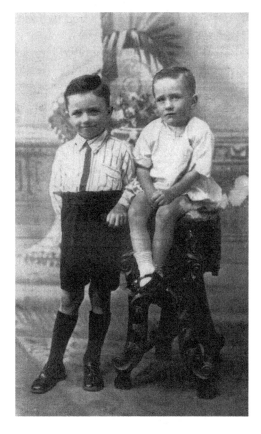

7.1b *Jack and Leslie Bawden*, 1925.

and smiles belong to much later photographic convention. This righteous, formal pose dislocates my grandfather further from his lived reality. As Roland Barthes has observed, 'the photograph is the advent of myself as other: a cunning dislocation of consciousness from identity'.[3]

Less than a year from the moment captured in this portrait my grandfather lay dead in his front yard, shot point blank in the chest by his boarder, best friend, and – unknown to him – the lover of his young wife, my grandmother.

Amid the lengthy and at times brutal forensic details of the shooting is buried a brief description of my grandparent's house: 'the house had an iron roof and bag sides and consisted of two rooms, one being the bedroom and the rest of the house was the sitting and dining room and kitchen.'[4] The 'truth' of the formal family portrait is immediately discredited by this sentence. My grandfather was a poor and itinerant worker in an isolated sugar-cane town on the coast of Queensland, Australia. His makeshift house was constructed of materials gathered from the industry of the town:

hessian sugar bags wired to iron uprights that were simply hammered into the earth. Its structural integrity was little better than that of a tent.

This was not unfamiliar in isolated Australian communities. Houses were often frail and temporary. As Phillip Drew explains, makeshift materials made for a 'portable architecture that served well the needs of an expanding colony'.[5] But it was not one to be celebrated or immortalized in portrait photography. On the contrary it was a domestic situation better left unspoken and unseen. It represented a fragile, half-built and unfinished culture; one that needed to be disguised behind a painted canvas backdrop.

The artificial space evident in my grandfather's photograph evokes a reassuringly familiar architectural reference that denies the tenuous grasp his small isolated community held over its environment. Large heavy building symbolized population, permanency and achievement – a stoic victory of civility over barbarianism, if not in reality at least metaphorically. It is interesting too, that a 1925 photograph should conjure up a hazy vision of Victorian excess. Outdated though it may appear, even for its time, this historical reference is symbolically important. Laying claim to a history denies a community's newness and its subsequent rawness. The heavy Victorian architectural reference opposes the 'anti-culture of the frontier'[6] and presents us with signs of permanency in a fickle, transient and dangerous space.

This photograph offered my grandfather a refuge from the shortcomings of his own history by situating him in another. The painted Victorian opulence provided him with the opportunity to deny the evidence of his own material failure – that made clear by his own ramshackle abode – and repositioned his provenance in an imagined reality far beyond his actual reach. As explained by Julia Hirsch, 'portraiture was no longer proof of pedigree'.[7]

The imagined space is decidedly domestic rather than public. It references a resolute English interior of another age. It had ceased to belong to the present, but had enshrined forever lasting values of sobriety, proper order and home: a place of refuge and protection in a largely inhospitable location. The implied room has the ability to infer positive experience and construct believable narratives of survival, belonging and refinement despite the tyranny of isolation and the reality of unfortunate circumstance. Albeit a generic pastiche of middle-class interiority, the room is an allegorical sign that the subject understands and is seen to conform to 'the acknowledged goals of civilization'.[8] It implies that everyday domestic protocols and accepted familial rituals have guided this young man towards a life of reassuring, middle-class ordinariness. Had the unfortunate events of 7 January 1926, and their subsequent reporting not precisely recorded an alternative reality, this inferred existence would have protected my grandfather's provenance. His impoverishment and his disastrous marriage may well have been censored from family memories, hidden forever within an idealized, alternate version of *truth*.

Like Father, Like Sons

In an essay to mark the tenth anniversary of Franz Kafka's death, Walter Benjamin wrote, 'there is a childhood photograph of Kafka, a rarely touching portrayal of the "poor, brief childhood". It was probably made in one of those nineteenth-century studios whose draperies and palm trees, tapestries and easels placed them somewhere between a torture chamber and a throne room.'[9] The practice of photographing children in this situation was widespread. Benjamin's description of a young Kafka in Prague in the late 1880s closely resonates with the photograph of my father and uncle taken more than 35 years later in an Australian mill town (Figure 7.1b). The image of the latter subscribed to a globally understood reference to 'family' and precisely aligned them, culturally and aesthetically, with a much-coveted sense of European belonging.

Anne Stoler argues that inhabitants of settler colonies were 'often viewed disparagingly from the metropolis as parvenus cultural incompetents, morally suspect and indeed "fictive" Europeans, somehow distinct from the real thing'.[10] The photograph is a means of proffering a counter opinion, and indeed, recording a counter reality. The image is a protective cover, enveloping the children in the semiotics of European civility. To identify oneself as European, suggests Anne Maxwell, 'implied more than an identification with a particular race and culture. It also implied that one adhered to middle-class principles of behaviour.'[11]

This photograph is a potent mix of metaphors and signs. In it, an opulent backdrop is positioned behind and under the children. A strange perspective betrays the artifice of the rug, painted on the same canvas plane that rises behind the children culminating in a confection of obscure floral ornament, a single palm leaf, ornamental drapery and carved dado. The result is a family unit cast in an obvious fiction of place, but one that explores a powerful narrative. Dressed in awkward Sunday-best the children are the wholesome sons of Empire, safe within the security of a good Anglo-Christian home.

The abundant ornament, the exotica of the potted palms, and the heavily carved furniture constitute steadfast signs of Victorian middle-class propriety and moral rigour. Although the photograph postdates Victoria's death by 24 years, the language of the interior tells of a family the substance of which is bound in property and spiritual correctness. Victorian virtue remained well preserved in the isolated communities of Australia, and the accoutrements of the Victorian parlour were often viewed as positive signs of conquered adversity. In 1892 teacher and social observer, John Fewings, wrote of the English-style interiors in the unruly settlements of Queensland that they left one with 'a joyous conviction that the house is blessed with a husband of sobriety and industry supplemented by the efforts of a busy,

thrifty and tidy wife'.[12] While a piece of visual fiction, the backdrop behind the children emphatically declares a stoic adherence to moral order, despite the infidelities of one parent and the imminent, untimely and brutal death of the other.

Embedded in the sober and unimpassioned reporting of my grandfather's murder is a description of the location of his children at the time of his death: 'The children were down in the scrub playing.'[13] 'Scrub' is un-European, specifically un-English, but very much a part of the Australian colonial vernacular. The township of Giru, the site of the shooting, was entirely surrounded by scrub. It was not a pretty woodland with darting butterflies and playful wildlife, but instead a terrifying thicket rife with all kinds of deadly threats: snakes, crocodiles, heat exhaustion and disorientation. Yet the encroaching menace of the town's surrounding environment is dutifully ignored in the photograph. The generic domestic interior, an enduring symbol of English civility, has been draped over this unfortunate geography, and in so doing aligned the children to a more acceptable 'British' site of refuge and protection.

'No Place for a Woman'[14]

My grandfather, father and uncle were resident along the coastline, the relatively safe and secure edge of the country to which most Australians still adamantly cling. The interior of the country, its vast and mythologized outback was – and remains – far less inhabited. It is the land Henry Lawson describes as exhibiting, 'the everlasting, maddening sameness of the stunted trees – that monotony which makes a man long to break away and travel as far as trains can go, and sail as far as ship can sail – and farther'.[15] It required a particularly stoic character to survive extreme isolation, relentless heat and endless desert. After the events of January 1926, my grandmother fled deep into the outback, and in so doing escaped her reputation as the wanton wife of a murdered husband. She was by no means alone. Within the Queensland interior dwelt many Australians haunted by the ghosts of previous lives. Its isolation brought with it anxiety and hardship, but equally it provided a longed-for anonymity and sufficient distance from a less than respectable past.

No photographs exist of my grandmother from this period. They were either carelessly lost, or more probably abandoned in her hasty flight from the circumstances of her husband's death. However, archival images of outback women are important to the prevailing construct of early European Australian identity. They confirm that, although isolated and lonely, this peculiarly Australian space subscribed to the gender-coded demarcations of Victorian sociality.

Women in the Queensland outback were rare. The outback was a place to be feared by them; it was 'dangerous, non-nurturing and not to be trusted'.[16] The idealized values of British femininity – the 'angel of the hearth'; devoted wife and benevolent mother – would surely wither in the Australian desert. Lawson wrote of one outback mother in *The Drover's Wife* (1892): 'She loves her children, but has no time to show it. She seems harsh to them. Her surroundings are not favourable to the development of the "womanly" or sentimental side of nature.'[17]

Women did live in the outback. Indeed their presence, although scarce and pitied, was highly valued. They identified their isolated settler communities as ones of 'normalized sexuality',[18] regardless of their suspect backgrounds or imperfect upbringings. Married women and their formal wedding portraits went further in this normalization. They attested to the existence of middle-class morality and Christian rituals in locations not naturally disposed to nurturing such civilized, bourgeois values. As Sara Mills explains, 'the characteristics of conventionality and morality commonly attributed to wives were virtues useful to colonialism'.[19] Wedding photographs provided the necessary proof that nothing strange or unusual festers in the isolation of Australia. The outback was at once a terrifying otherness and, at the same time, a place of ordinary normative acts.

The image of Minnie Kriesel, captured on her wedding day circa 1900, is richly endowed with the prevailing construct of middle-class British womanhood (Figure 7.2). She is elegant, delicate, fragile and cultured. She is a woman surely unattainable in the 'God-forgotten holes'[20] of Lawson's outback.

Yet Minnie hailed from Winton, a desperately isolated, central Queensland desert town. Her interior, a magnificent painted confection of Victorian ornament, was in complete contrast to the dusty plains that surrounded her actual geography. Winton is the rough outpost used in Nick Cave's 2005 film *The Proposition*, a symbolic end-of-the-earth settlement cursed by lawlessness and human brutality. Minnie's image speaks powerfully of stoic defiance with a seemingly pointless adherence to social protocols, class demarcation and religious symbolism. Her long, white and corseted wedding attire, worn in a location of stifling temperatures and plains of dust, is both meaningless and essential. Sweat and filth would surely mar her elegant poise and virginal grace, but the image refuses to yield anything of this reality. Minnie is a traditional bride, participating in a traditional ritual, within a traditionally elegant space, just as any middle-class woman anywhere in the Empire would aspire to do. Her social position within the oddly placed, but nonetheless conspicuous outback gentry, is also dutifully captured. Minnie belonged to Queensland's 'squatter aristocracy'; the wealthy landowners who laid

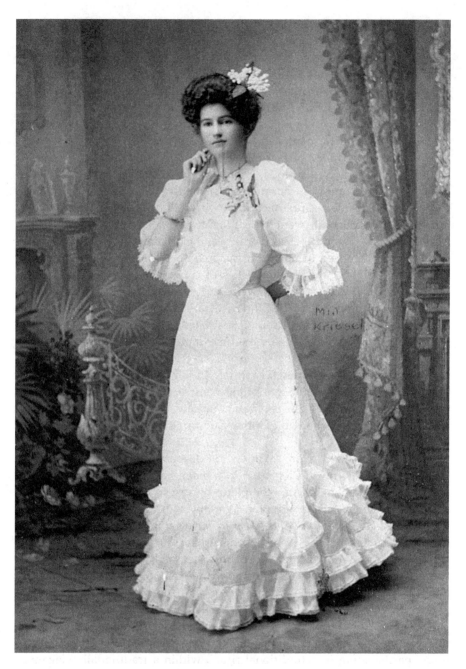

7.2 *Minnie Kriesel, of Prairie, in her wedding dress, c.1900.*

claim to enormous sections of land for the grazing of sheep and cattle. Such wealth was widely distributed throughout the colonies and did not limit itself to city domains. Unlike my grandfather and his children, Minnie is far more at ease in her situation. She is relaxed and adept at posing, suggesting a familiarity with the practice. Her photograph within a grand, though artificial, room captures her class-conscious aspirations to both spiritual correctness and material self-improvement.

In *The Coast Dwellers*, Phillip Drew attributes Australia's long devotion to English social practices as a way of aligning itself to a distant but familiar cultural identity. 'Life' he wrote, 'could only be centred by falsification and denial, by the cultivation of English ways of doing things, of English customs and architecture. This resulted in a damaging dislocation within the culture, a feeling that certitude could only be bought at the price of falsifying experience.'[21]

Drew continues to dissect the English attitude to Australian space: 'infinite and empty space is the ultimate hell and to be kept at bay.'[22] Minnie's photographic attachment to a splendid formal interior, albeit two-dimensional and temporary, does exactly this. Her likeness is assigned to a fictional space that for the narrative requirements of the photograph, becomes hers. The vast expanse of Australian nothingness that epitomizes the outback, her actuality of place, is ignored. That was an inconvenient reality that would not be permitted to deny Minnie's right to contribute as other women of the Empire did 'as living representations of home and portable packets of morality'.[23] Minnie's image as a radiant bride within an interior of imaginary luxury aligns her sense of belonging not to a hostile and unforgiving outback, but to an extensive body of settler communities and established cities that understood and complied with the rituals of good behaviour, and their representation within the spatial traditions of the English interior. Her anonymous painted backdrop takes no account of geography. Rather it suggests a homogenized interior of prosperity and demeanor that had become one of the most defining symbols of nationhood and empire.

A Sign of Their Time

As Hilary Callan observes, in 'a colonial or settler society, a properly managed home is more than a precondition of a civilizing mission; it is part of it'.[24] The representation of home, no matter how artificial, was essential to a community of Australians who relied on domestic familiarity to elevate their status above those of hicks and bumpkins.

The image of August and Annie Stallman (Figure 7.3) was taken circa 1887 in Clifton, another small, isolated township the architectural claims of which ran to a pub, a train station and a coalmine.

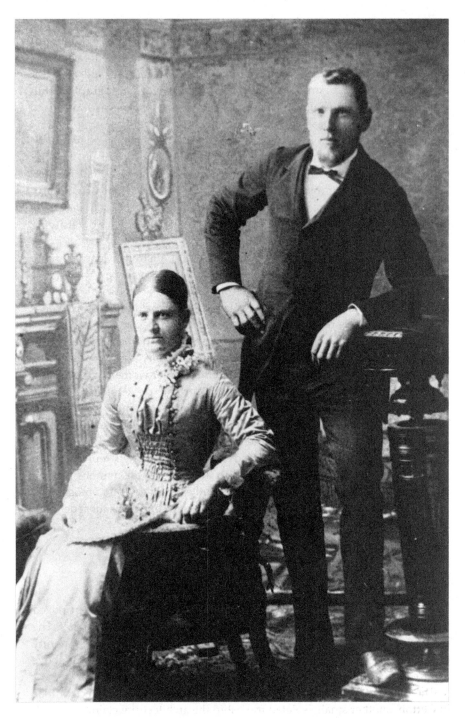

7.3 *August and Annie Stallman*, c.1887.

So much of the Stallman's image encapsulates the Victorian values so stoically adhered to in terms of gender, space and Empire. Their room, like the others discussed here, was artificial. However, it appears more appropriate to their 'real' time than any of the other backdrops examined. It is not an outdated relic, but a sign of aspirational modernity. It references the abundant Victorian drawing-room of the 1880s, the realm of female taste that glorified the sanctity of parlour: sentimental ornament, elaborate furnishings and decorative surfaces, all painted into an illusion of spatial grandeur. Annie sits as her English contemporaries would, in a middle-class representation of social value and personal worth. That hers is artificial is of no consequence. The potency of the image lies not in the actuality of objects but that virtue and order, as represented through the middle-class home, are seen to be understood and adhered to, even in the most isolated provinces of the Empire. The room was a symbolic enclosure for English values, defined not by the solidity of actual walls but through a carefully constructed composition of signs that defy the tyranny of distance and the actuality of place. The Stallmans were entrenched in the comfort of *knowing* that this room is a sign of their colonial aspiration if not their actual reality.

For August Stallman, his representation in this artificial roomscape is as potent a symbol as it is for Annie. This is a man whose place in the Empire was one of heroic masculine endeavour. He is represented as the confident patriarch, capable of providing a wife with the necessary distractions of home. In turn, the brutality of the outback is seen to be tamed; the overwhelming emptiness has been obliterated; good management, dignity and order reign as they ought.

Annie's success as a colonial wife depended upon her prized feminine disposition remaining intact. As already discussed, femininity imposed a civilizing moral probity upon the harshest colonial settlements. In this image it appears safe, ably secured in the representation of the room. Her unrecorded reality was undoubtedly tormented by dirt, flies and coal dust, but for posterity she sits in a small parlour chair before a range of appropriate feminine distractions by which, ironically, she was not actually distracted. A petit-point banner hangs from the mantelpiece, a framed painting sits upon a decorative easel, the cluster of pictures and ornaments could only be arranged by a woman of means with the time to occupy herself with the endeavours of home-making. The enormous decorated hat is undoubtedly hers, but together these signs present a picture of ideal middle-class Victorian femininity. The room heaves with what John Ruskin (1819–1900) referred to as 'an obsession with little things'[25] and 'the art of the nest'.[26] Though not of her making, Annie is nonetheless perceived as author of this domestic tableau. It is the perfect fiction: untrue, but infinitely believable.

The Stallman's imagined home is rich in meaning and significance. Its artifice does not lessen its meaning, but rather intensifies it. The immensity of

their isolation, through which they could be so easily consumed by feelings of loneliness and exile, was fended off via an anonymously composed interior that supposes the residents of a colonial backwater deserved the same representation as those living in grander parts of the Empire. They belong, as their image attests, to a community whose identity harbours within the spatial patterns of Victorian domesticity. The room's artificial gentility was part of an established language of taste in which the Stallman's claimed fluency. 'The system of gentility', argues Linda Young, 'could be seen as a common currency of an international English-speaking middle class, that shared a transnational identity as inhabitants of "greater" Britain'.[27]

In 1885, an English visitor to the colonies, J.A. Froude, remarked that Australia had evolved into a settlement suitable 'for all sorts and conditions of men'.[28] He discovered, to his delight, 'English life all over again: nothing strange, nothing exotic, nothing new or original.'[29] The suppression of any independent identity was pivotal to Australia's sense of inclusion within the Empire. 'Most Britons saw their empire as an extension of their own social world rather than in contradistinction to it. They exported social perceptions on the presumption of sameness',[30] writes David Cannadine. Within the colony most Australians were happy to have their identities so clearly defined. The alternative was far too awful to contemplate: exclusion, exile and anarchy. The country's peculiar landscapes, flora and fauna and the realities of isolation were clearly subordinate to a vastly more important visual and mental alignment with England. 'They saw what they were conditioned, what they wanted, and what they expected, to see.'[31]

As Clear as Black and White

Each of these photographs situates its subject within a widely understood and homogenized system of representation. More specifically, they locate them firmly within a 'built' European culture. As Anne Maxwell explains, native or indigenous people were represented, even scientifically, as 'non-interiorised "others" who existed outside the common bonds of humanity and the flow of history'.[32] The grand but artificial domestic interiors, laden with historical reference and symbols of cultural capital, represented a clear and spacious divide between a ruling white 'civility' and a subservient black indigeneity. 'Colonial photography', explains Maxwell, 'was in the business of confirming and reproducing the racial theories and stereotypes that assisted European expansion.'[33]

To this end, the representation of white Australians within European interiors was vital. The Australian aboriginal culture was a nomadic one, and one largely deplored and dismissed because it lacked permanent structures. Ironically, my grandfather's house was equally as temporary, and has long since

disappeared from the landscape. The fragile painted canvas that implied his greater domestic situation has undoubtedly also gone, disintegrated through constant rolling and unfurling. However, their physical impermanence is of no consequence. Photography has recorded their place *inside* the architectural bonds of white civilization: a commanding language of pillars, swags and ornamentation drawn from a long history of European aesthetics and cultural endeavour. The semiotics embedded within these thin, flat, canvas fakes was sufficient evidence that the colonizing culture should preside as the dominant and governing one.

The artificial interiors present in these images, and the many like them, are the imagined longings of a displaced population. They are the visualization of anonymous amateur painters, who drew reference from no real structure – the interiors are too oddly composed and out of scale to be the representation of actual rooms. They are imagined hybrids that contain the material luxuries and architectural symbols that identify their sitters as belonging to a culture that is civilized, established, permanent and English.

The context of these images elevates them above an easy dismissal of simply belonging to the prevailing photographic convention of their day. They are rich in meaning and geographically significant. The supposed *terra nullius* of the outback and the rawness that characterizes new settlement are disguised behind a thin canvas veil of refuge – eternal, familiar and safe. According to David Malouf, the 'truth in history, as we commonly conceive of it, is not what happened, but what gets saved, recorded and told … The history that is in objects may need to be excavated and made visible before we can experience the richness it represents.'[34]

These photographs, and in particular their imagined interiors, allow the sitters to construct their own history as they wished it to be recorded; with an air of homogenized propriety and obscured reality. All stories untoward – those of misconduct, loneliness, insecurity, murder, fear and danger – remain on the whole unexcavated, wrapped and disguised in a thin sheet of canvas fiction.

All is well and as it should be … or at least it is seen to be so.

Notes

1. Julia Hirsch, *Family Photographs: Content, Meaning and Effect* (Oxford, 1981), p. 45.

2. Stephen Pinson, 'Trompe l'oeil: Photography's Illusion Reconsidered', *Nineteenth-Century Art Worldwide: A Journal of Nineteenth-Century Visual Culture*, 1/1 (2003): p. 1.

3. Roland Barthes, *Camera Lucida: Reflections on Photography* (New York, 1981), p. 12.

4. 'Giru Shooting Case', *North Queensland Register* (Townsville, 25 January, 1926), p. 1.

5. Phillip Drew, *The Coast Dwellers: A Radical Reappraisal of Australian Identity* (Ringwood, Victoria, 1994), p. 51.

6. Ibid., p. 59.

7. Hirsch, p. 70.

8. Bede Morris, *Images: Illusion and Reality* (Canberra, 1986), p. 64.

9. Walter Benjamin, *Illuminations* (New York, 1969), p. 118.

10. Anne Stoler, *Race and the Education of Desire: Foucault's History of Sexuality and the Colonial Order of Things* (Durham, 1995), p. 102.

11. Anne Maxwell, *Colonial Photography and Exhibitions: Representations of the 'Native' People and the Making of European Identities* (London, 1999), p. 7.

12. John B. Fewings, 'Arcadian simplicity: J.B. Fewings memoirs of Toowong', in Rod Fisher and Brian Crozier (eds), *The Queensland House: A Roof Over Our Heads* (Brisbane, 1994), p. 9.

13. *'Giru Shooting Case'*, p. 1.

14. 'No Place for a Woman' is the title of a short story published in 1900 by renowned Australian author, Henry Lawson.

15. Henry Lawson, 'The Drovers Wife', in *Australian Classics: While the Billy Boils. 87 Stories from the Prose Work of Henry Lawson* (Windsor, 1979), p. 112.

16. Kay Schaffer, *Women and the Bush: Forces of Desire in the Australian Cultural Tradition* (Cambridge, 1988), p. 62.

17. Lawson, p. 112.

18. Stoler, p. 105.

19. Sara Mills, *Gender and Colonial Space* (Manchester, 2005), p. 122.

20. Henry Lawson, 'No Place for a Woman', in *Australian Classics: While the Billy Boils. 87 Stories from the Prose Work of Henry Lawson* (Windsor, 1979), p. 248.

21. Drew, p. 5.

22. Ibid., p. 159.

23. Mills, p. 45.

24. Hilary Callan and Shirley Ardener, *The Incorporated Wife* (London, 1984), p. 9.

25. Quoted in Hirsch, p. 56. From Ruskin's essay 'On the Present State of Modern Art', *Works*, XIX (London, 1905), p. 200.

26. Ibid.

27. Linda Young, *Middle-Class Culture in Nineteenth Century America, Australia and Britain* (New York, 2003), p. 32.

28. J.A. Froude quoted in David Cannadine, *Ornamentalism: How the British Saw Their Empire* (London, 2001), p. 34.

29. Ibid.

30. Cannadine, p. 134.

31. Ibid.

32. Maxwell, p. 3.

33. Ibid., p. 9.

34. David Malouf, 'The Making of Australian Consciousness', in *The Boyer Lectures* (Sydney, 1988). First broadcast November 22, 1988. http://www.abc.net.au/radionational/programs/boyerlectures/lecture-2-a-complex-fate/3460262

Jean Genet, or the Interiors of Marginality in 1930s Europe

Cristóbal Amunátegui

When existence has been circumnavigated, it will be manifest whether one has the courage to understand that life is a repetition and has the desire to rejoice in it. The person who has not circumnavigated life before beginning to live will never live; the person who circumnavigated it but became satiated had a poor constitution; the person who chose repetition – he lives.

Kierkegaard

Before he was 15 years old, Jean Genet had already been in prison twice, escaped four times from the authorities, and dwelled in a number of places spread over six different towns, let alone the time spent in streets, trains, police stations, hospices and psychiatric units. These facts were no accident in the light of what he was going to live through in the years to come. 'I was born in Paris', wrote Genet, 'on December 19, 1910. As a ward of the *Assistance Publique*, it was impossible for me to know anything about my background. When I was twenty-one, I obtained a birth certificate. My mother's name was Gabrielle Genet. My father remains unknown. I came to the world at 22 Rue d'Assas.'[1] Mother and child left the hospital the night before New Year. Seven months later, however, on 28 July 1911, Genet was welcomed at the Hospice for Welfare Children. Abandoned in the *Assistance Publique*, from that day on he became a ward of the state and was put in the care of a family of artisans in the village of Alligny-en-Morvan. The Regniers, Eugénie and Charles, were to raise the child until the age of 13, by which time he had received the highest grades in the primary school examinations and put an end to his formal education.

During the next two years, Genet was involved in a series of escapes from both his occasional guardians and the police. From the Hospice for Welfare Children, to Nice, to the Saint Anne Clinic; from the Childhood and

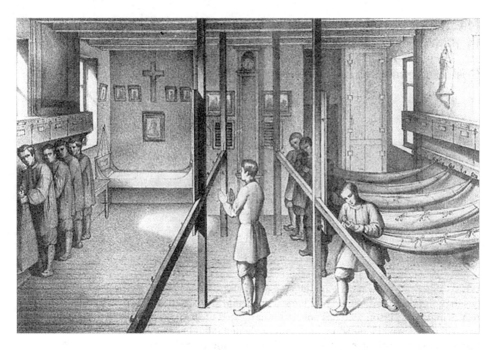

8.1 *Mettray*. Lithographie, A. Thierry, 1844.

Adolescence Patronage to Marseilles; from a train to Bordeaux to the Petite-Roquette Prison; this wandering only ended upon his fourth capture at the hands of the police. Finally confined to jail, the court decided to change his sentence and send him to the agricultural colony of Mettray, a children's prison he entered at the age of 15 (Figure 8.1).[2]

Thus surrounded by orphans and young petty criminals, during his adolescence, the places where the foundling Genet dwelled were no other than the collective interiors of the welfare. Genet's life was signalled by the mark of repetition, and at this point he could rightly say he had circumnavigated existence for the first time.

Property and Privacy in the Life of an Outlaw

We know that one of the effects of the Enlightenment was the consolidation of the secular. A reasonable explanation of the world could ever since be found outside the realm of the sacred. Hence, a new fondness for what was real, tangible and immediate emerged throughout modernity. This new understanding of the world and of worldly things was both the outcome and the cause of capitalism's success. From clothes to furniture,

everything became a sign of something else, the evidence of one's own status and personality. The common notion of the bourgeois family was also one which emerged in this period. The pressures of modern capitalism led people to find protection in the family, which became a sort of shelter against the uncertainties of the modern world. If the opposition between the private realm of the household and the public realm of the city had existed at least since the days of the ancient city-state, it was during the advent of industrialization that the family acquired the unequivocal status of a protected refuge. The domestic interior became the epitome of familiar stability, and objects, the physical manifestation of such certainty. Objects, '*our* property and our friendship, co-knowers of our distress and gladness, as they have already been the familiars of our forbears',[3] a longing Rilke wrote in 1925, but his was also a complaint against the effects of capitalism over the things of the world. 'The private individual, who in the office has to deal with reality, needs the domestic interior to sustain him in his illusions', wrote Benjamin, and he was right in that, for the private man, the interior 'represents the universe'.[4] Privacy and ownership, the two main aspirations of the modern bourgeois, were thus fully achieved in the interior of the home.

Well into the twentieth century, the universe of Jean Genet was not to be found in the interior of the household. Introduced into the world of burglary and petty crime at an early age, he never quite opposed 'the place of dwelling' to 'the place of work', for he neither dwelled nor worked under any modern conventions.

The private realm of an outlaw cannot be found in the interior of the household. A dweller in transit, the outlaw knows no fixed residence, and makes every place a room of his rather endless home. One of Genet's dearest writers, Baudelaire was said to have had more than 14 addresses by the time he was hunted by creditors.[5] The hunted life of the outlaw prompts the multiplication of living spaces. Condemned to a perpetual escape, every interior he enters becomes his temporary dwelling. The interior of the prison, then, was the only place which could provide Genet with a certain sense of safety and stability. 'Prison is that fortress, the ideal cave, the bandit's retreat against which the forces of the world beat in vain',[6] he wrote in *The Thief's Journal*. 'I am in danger not only when I steal, but every moment of my life, because I have stolen.'[7] His access credential was the anthropometric card, which bore his physical features, and the no less eloquent record of his crimes. Derived from Bertillon's methods, the card was issued 'to all tramps, and stamped in every police station'.[8] It made the outlaw become the redundant evidence of himself. Altogether, Genet's cave, his ideal refuge, sheltered no other family than the one of the outcasts, and was reached through opposite means than those of the middle-class dweller: Genet knew that only through the abjection of crime could he reach

his safe hut. 'Nothing will demolish it, not blasts of wind, nor storms, nor bankruptcies. The prison remains sure of itself, and you in the midst of it sure of yourself',[9] he said. In opposition, the domestic realm of the modern bourgeois – 'the private citizen's universe'[10] – became the antithetical rival of the outlaw, the very image of the unattainable, and its secret blaze surely lingered in the burglar's mind as the object of both his contempt and desire. Thus fascinated by the idea of conquering a world to which he didn't belong, Genet wasn't willing to perpetuate his life under the severe protection of prison:

When I walked miserably along in the rain and wind, the tiniest crag, the most meager shelter became habitable. I would sometimes adorn it with an artful comfort drawn from what was peculiar to it: a box in the theater, the chapel of a cemetery, a cave, an abandoned quarry, a freight car and so on. Obsessed by the idea of a home, I would embellish, in thought, and in keeping with its own architecture, the one I had just chosen. While everything was being denied me, I would wish I were meant to for the fluting of the fake columns that ornament facades, for the caryatids, the balconies, the stone, for the heavy bourgeois assurance which these things express.[11]

The mystified interior of the prison may well become the outlaw's emblem of safety, but yet it remains an incomplete refuge: unlike the domestic interior of the bourgeois, prison doesn't 'sustain' the outlaw 'in his illusions'. Benjamin's dictum, that 'the crowd is not only the newest asylum of outlaws; it is also the latest narcotic for people who have been abandoned',[12] finds its epitome in Genet, who conjures up the two features at once: he is the abandoned outlaw, and his private realm will be defined by a life lived among the crowds.

The Journal

During the years 1932–36 Genet wandered through a number of cities, towns and villages spread throughout Europe – more than 30, as we learn from *The Thief's Journal*. His journey was prompted by numerous arrests and subsequent escapes, from both prison and the army. As a fugitive, he made travelling his alternative refuge. First published in 1949 by Gallimard, the book is the literary account of what Genet experienced during the 1930s, and becomes a legitimate record of his own subjective memories.[13] From Paris, to Barcelona, to the region of Andalucía, hunted for a number of thefts, he headed back to France. 'I did not wander along the roads at random. My path was that of all beggars',[14] he wrote about his Spanish period. After a brief sojourn in Paris he moved to Rome, to which followed Napoli and Brindisi. Then came Tirana, Corfu, and the northern cities of Belgrade, Vienna, Prague, Brno, Katowice, Warsaw, Berlin and Antwerp. It was in those years that the young,

self-cultivated burglar and prostitute spent his nights between the walls of cheap hotel rooms, looted apartments, cellars, bars and brothels, but also in parks, churches, prison cells, market halls and police stations. Barcelona has a central place in Genet's book. The Raval district, otherwise called Barrio Chino, gave Genet the settings for most of the *Journal's* accounts, and provided him with a number of acquaintances that were to reemerge time and again throughout the journey (Figures 8.2 and 8.3).

By the time he arrived in the Raval, the area housed the poorest segments of the working class and had a long-standing tradition of strong, well-organized labour movements. While the former provided the neighbour-hood with an air of proletarian bohemia, it is

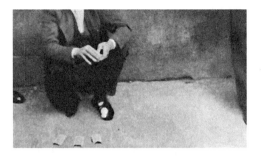

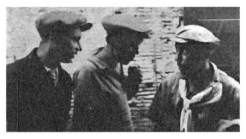

8.2 (*top*) and 8.3 (*bottom*) *Scenes from the Barrio Chino in Barcelona*, c.1930.

chiefly due to the latter that the district had a social and cultural order of its own. However overcrowded, insalubrious and often bound to illegality and crime, the Barrio Chino did not lack a strong sense of local identity.[15]

At the turn of the century, a unique characteristic of the area was the emergence of numerous doss-houses, which, placed in former factories, became the only affordable space for 'single, male, unskilled migrant labourers'.[16] Although in *The Thief's Journal* there is no account of Genet's living in these proletarian versions of the rooms of Mettray, he may well have spent several nights there. In turn, a typical Raval tenement varied from four to six stories high. Until the middle years of the nineteenth century, one family would occupy each floor, and the entire block would share a single toilet and a water tap placed underground. Nearing the turn of the century, the informal extension of the dwellings resulted in even scarcer lighting conditions for the narrow streets of the Raval. As the pressure for housing increased, so did the rents, prompting the subdivision of the existing housing stock. By the beginning of the twentieth century several families were living in a flat conceived for no more than four or five dwellers. If in each tenement the bathroom was communal, most often so was the kitchen, where the lodgers would gather to cook, eat and drink.[17] It is no wonder then that most of the places where Genet stayed during his time in the Raval are often described as small crowded rooms, sometimes without even a window for light or ventilation:

In Barcelona we hung around the Calle Mediodia and the Calle Carmen.
We sometimes slept six in a bed without sheets, and at dawn we would
go begging in the markets. We would leave the Barrio Chino in a
group and scatter over the Parallelo, carrying shopping baskets, for the
housewives would give us a leek or turnip rather than a coin. At noon we
would return, and with the gleanings we would make our soup.[18]

Having often being brought up in the collective rooms of the welfare, burglars
were not uncomfortable among peers, and a peculiar sense of conviviality
emerged from this interaction.[19] 'We mounted', wrote Genet in the *Journal*,
'narrowly limited by a fragile wall which must have contained the sleep of
the whores, thieves, pimps and beggars of the hotel ... At the fourth landing,
I entered his grubby little room'.[20] After some days sharing a bed with his
mentor-in-crime, Genet describes a typical night in the room of yet another
hotel: 'Then Stilitano would fall asleep', he writes:

He would manage so that his body did not touch mine. The bed was very
narrow ... Our room was very tiny. It was dirty. The wash basin was filthy.
No one in the Barrio Chino would have dreamed of cleaning his room, his
belongings or his linen – except his shirt and, most often, only the collar.[21]

Clothes were the burglar's only belongings, his property and home, and for
Genet, the collar seems to become the most visible manifestation of such sense
of ownership.

The crime culture at the time was eminently masculine. The most frequent
reference Genet made to women was to the prostitutes with whom he hung
out at the bars, and who were his fellow beggars at the Ramblas – the avenues
across the Barrio Chino. In turn, the homosexual culture among the burglars
and criminals was strong. Prostitution was another way to earn a living in
the life of the homosexual outlaw, and thus his rooms, which were suddenly
turned into houses of meetings:

Generally Robert and I would go upstairs with the queer. While he was
asleep, we would throw the money down to Stilitano, who was posted
beneath the window. In the morning the client would accuse us. We
would let him search us, but he dared not lodge a complaint.[22]

Little tactics of robbery were unfolded in minute rooms where burglars lived
and prostituted themselves. In the neighbourhood, some beggars dwelled in a
cheap hotel room, which once was the living room of a working-class family.
One of Genet's favourite joints, a cabaret and restaurant called La Criolla,
occupied the spot of a former textile factory. The owner charged 30 cents for
any of the 16 bedrooms available for prostitution. In the upper floor he hosted
recently arrived immigrants for equally cheap prices. Small workshops were
stuffed inside former industrial buildings, so much for workers' doss-houses,
now occupying entire floors of deserted factories. Meanwhile, Theresa the

Great waited for clients in a pissoir. 'At twilight, she brings a camp chair to one of the circular urinals near the harbour and sits down inside and does her knitting or crocheting. She stops to eat a sandwich. She is at home.'[23] These places were part of a more ample domestic realm, whose interiors were not unlike those of the Baudelerian character of the flâneur. With Genet, too, the city became a playground in which spaces triggered a number of social encounters: streets as passages, brothels as living rooms, hotel rooms as brothels, and so on. Altogether, they conjured up different moments in time, making the Raval an actual palimpsest whose most hidden layers date from as early as the Middle Ages.

During this time, each of the cities, towns and villages Genet went through would reveal to him a peculiarity of its own. In Barcelona, the crime culture among beggars allowed them small thefts and occasional prostitution. Food was somehow guaranteed by neighbours' generosity, and the gregarious culture of the Barrio Chino made the smallest, darkest room a likely place to dwell in. His time in Paris was different. There everyday life acquired a certain degree of formality. As a native Parisian, the boundaries within which Genet moved were far broader than the ones of the Raval. His living conditions were more stable and, to some extent, conventional. Genet shared a room with his lover, and enjoyed the simple pleasures of domesticity:

Our room is darkened by wet clothes drying on ropes which
zigzag from wall to wall. These washing-shirts, underpants,
handkerchiefs, socks, towels – softens the bodies and souls of the
two fellows who share the room. We go to sleep fraternally.[24]

Genet and Java cleaned their clothes and furnished their interiors with them. Out on the streets, wearing those shirts, underpants and socks, they may well have felt at home. Later, while wandering through the aisles of a flea market in Saint-Ouen, Genet was even struck by the condition in which he found his old friend Guy: 'He was dirty, ragged, covered with filth. And alone, in a group of purchasers poorer and dirtier than the tradesmen. He was trying to sell a pair of sheets, probably stolen from a hotel room.'[25]

The scope of his burglary also changed during his Parisian days. No longer prostituting himself, no longer simply begging in the streets or performing small robberies, he now looted apartments, and even took the time to rest in their interiors for a while. 'I am steeped in an idea of property while I loot property', he writes, and 'the decision (of leaving) is born when the apartment contains no more secret spots, when I have taken the proprietor's place.'[26] Only when Genet unveiled and seized the domestic universe of his rival could he leave the place holding the flag of victory. Once away and with the booty at his disposal, the phantasmagoria of the bourgeois' domestic belongings flooded the spirit of the burglar, who was well aware of the world contained

in such objects: 'Sure – or not – of never being discovered, he walks on his rugs and lolls in his armchairs with an authority he did not hitherto have',[27] wrote Genet about his fellow looter.

After leaving the cities of southern Europe, Genet gives a snapshot of his days in Poland. In the *Journal*, he recalls the awakening in a park outside the city of Katowice. It was during summer, and at dawn, the beggars would slowly start to awake in all different manners:

Other tramps came there to sleep on the lawns in the shelter of the shadow and the low branches of the cedars ... a thief would rise up from a clump of flowers, a young beggar would yawn in the first rays of the sun, others would be delousing themselves on the steps of a pseudo-Greek temple.[28]

The description of a summer morning in a park is quickly replaced by visions of a street in Brno, where Genet joined some beggars who sang and collected the money given by passersby. At the end of the day they rested and cooked their meals in a cellar.

Genet's memories of his time in Brno do not refer, however, to a series of events in which he took part, and which have little to do with the general tone he conveys throughout the book. In his biography of the French writer, Edmund White describes the way Genet arrived in a Czechoslovakia that was already tense in the face of German threats and the rise to power of Nazism: 'Dressed in rags and covered with lice, he was quickly arrested by the police, to whom he readily admitted that he was a deserter of the French army.'[29] Not knowing how to treat his case, the police transferred him to the League of Human Rights. Lily Pringsheim, a German politician and journalist who had fled Germany after Hitler's accession took him under her care. She and her family – her husband and their daughter – allowed Genet to sleep in the balcony of their minute apartment:

(Genet would) sleep in the very narrow projecting ledge of a balcony. He was glad to have the stars to look at, and was wholly unaccustomed to a bed, or to any of the 'normal' comforts of life, which indeed never failed to astonish him.[30]

Not unlike other sections of the *Journal*, here Genet's accounts only include the events that serve the overall purpose of the book, which is the construction of a character built dialectically upon the modern middle-class individual. In his carefully displayed array of memories and experiences, the formal acquaintance with a woman who belonged to the world of institutions does not suit the consciously marginal flair of the *Journal*. By the same token, the various passages which comprise the book scarcely deal with the tragic events brewing in 1930s Europe, something that may well astonish the reader who is unaware of the *Journal's* ambition. Nevertheless, more than the accurate diary of Genet's days as a wandering burglar, *The Thief's Journal* is altogether

a memoir, a work that fixes a presence in the multiplicity of times, without necessarily restraining itself to the past: 'Let the reader therefore understand that the facts were what I say they were, but the interpretation that I give them is what I am – now',[31] Genet wrote. The following paragraph suffices for us to see this montage of anachronistic experiences at work:

Some negroes are giving me food on the Bordeaux docks; a distinguished poet raises my hands to his foreheads; a German soldier is killed in the Russian snows and his brother writes to inform me; a boy from Toulouse helps me ransack the rooms of the commissioned and non-commissioned officers of my regiment in Brest: he dies in prison; I am talking of someone – and while doing so, the time to smell roses, to hear one evening in prison the gang bound for the penal colony singing, to fall in love with a white-gloved acrobat – dead since the beginning of time, that is, fixed, for I refuse to live for any other end than the very one which I found to contain the first misfortune: that my life must be a legend, in other words, legible, and the reading of it must give birth to a certain new emotion which I call poetry. I am no longer anything, only a pretext.[32]

Genet's wandering was above all defined by that other realm towards which he was oriented: the construction of his own self. His travelling was thus signalled not so much by a series of events whose meaning was self-contained, but by the exploration of both his own limits and those of the world. 'The crossing of borders and the excitement it arouses in me were to enable me to apprehend directly the essence of the nation I was entering. I would penetrate less into a country than to the interior of an image',[33] he wrote, to then add: 'yet I was not going through Europe but through the world of objects and circumstances.'[34] With the same joy the bourgeois entered his dwelling, Genet opened the door of a country to discover its secrets.

Postscript

'Not all who would be are Narcissus', wrote Sartre in the foreword to *The Thief's Journal*. 'Many who lean over the water see only a vague human figure. Genet sees himself everywhere.'[35] Prisons, parks, hotel rooms, brothels, streets, churches: they all became mirrors in whose reflections Genet found the various pieces of the legendary character he sought to build. Hunted and hunter at once, Genet's restless wandering bears the features of perpetual repetition, and in this, the resemblances with the ancient character of the cosmopolitan are many. The cosmopolitan, the individual par excellence, the errant subject who has no other limits than those of the world, and whose figure Jakob Burckhardt epitomized in Dante's dictum, 'My country is the whole world.'[36] In Genet home is above all a state of mind, and its physical manifestations are to be found everywhere. Wherever he fixes his seat, there is home, and according to the Swiss historian, this may well be the definition

of the true cosmopolitan. Countless cities define the ground wherein his movements unfold and, in so doing, they spring one of repetition's constitutive elements, which is difference. If Genet's fate is not to indulge in the pleasures of civilization, he builds a complex order in which dispossession and wandering amount to the modern values of ownership and privacy. By reversing such moral order, what Genet achieves to establish is the difference between an age signalled by an unprecedented process of alienation, and an age of his own, constituted of various times and various places, and rooted in the very notion of experience.

Notes

1. Jean Genet, *The Thief's Journal* (Paris, 1949), p. 44.

2. See Edmund White, *Genet: A Biography* (New York, 1993).

3. Rainer Maria Rilke, *Letters of Rainer Maria Rilke* (vol. 2, 1910–1926) (New York, 1947), p. 374.

4. Walter Benjamin, *The Writer of Modern Life* (Cambridge MA, 2006), p. 38.

5. Benjamin, p. 79.

6. Genet, p. 98.

7. Ibid., p. 211.

8. Ibid., p. 91.

9. Ibid., p. 88.

10. Benjamin, p. 38.

11. Ibid., p. 169.

12. Benjamin, p. 85.

13. 'I shall therefore make clear that it (the journal) is meant to indicate what I am today, as I write it. It is not a quest of time gone by, but a work of art whose pretext-subject is my former life. It will be a present fixed in the past, and not vice versa. Let the reader therefore understand that the facts were what I say they were, but the interpretation that I give them is what I am – now.' Genet, p. 71.

14. Ibid., p. 79.

15. See Chris Ealham 'An Imagined Geography: Ideology, Urban Space, and Protest in the Creation of Barcelona's "Chinatown", c.1835–1936', *International Review of Social History*, 50 (2005): pp. 373–97.

16. Ibid., p. 383.

17. Ibid., pp. 382–3.

18. Genet, p. 18.

19. It would be wrong to give an impression of total despair in the living conditions of people in the 1930s' Raval. From our current point of view, it seems indeed difficult to understand such degree of coexistence, particularly in places that modernity had designated with the unequivocal role of sleeping and, furthermore, individual sleeping. As early as 1939, Norbert Elias wrote in *The Civilizing Process*: 'Children are trained early in this distancing, this isolation from others, with all the habits and experiences that this brings with it. Only if we see how natural it seemed in the Middle Ages for strangers and for children and adults to share a bed can we appreciate what a fundamental change in interpersonal relationships and behaviours is expressed in our manner of living. And we recognize how far from self-evident it is that bed and body should form such psychological danger zones as they do in the most recent phase of civilization.' Norbert Elias, *The Civilizing Process: Sociogenetic and Psychogenetic Investigations* (Malden MA, 2000), p. 142.

20. Genet, p. 42.

21. Ibid., p. 64.

22. Ibid., p. 141.

23. Ibid., p. 100.

24. Ibid., p. 250.

25. Ibid., p. 244.

26. Ibid., pp. 155–6.

27. Ibid., p. 153.

28. Ibid., p. 99.

29. White, p. 116.

30. Ibid., pp. 116–17.

31. Genet, p. 71.

32. Ibid., p. 118.

33. Ibid., p. 56.

34. Ibid., p. 113.

35. Ibid., p. 7.

36. Jakob Burckhardt, *The Civilization of the Renaissance in Italy* (New York, 1954), p. 103.

Mario Praz: Autobiography and the Object(s) of Memory

Shax Riegler

The roles of collector, historian, decorator and writer are in constant dialogue, if not outright conflict, in the writings of Mario Praz (1896–1982), the seminal literary critic, art historian and essayist. Praz's books on romanticism, emblem books, domestic interiors, neoclassicism and group portraiture, among others, are foundational studies in their various fields.[1] He was also a passionate collector of books, furniture, art and other objects, and even his most academic texts were rooted in very personal experience, often springing from his intense engagement with the particular objects he owned. This commitment to thinking with and through things culminates in Praz's fascinating, eccentric autobiography, *The House of Life*. Organized as a tour of the rooms of his home, the book narrates his curriculum vitae in explicit relation to his possessions, combined to form a material digest of his personal and professional aspirations. Towards the end of this object-centred memoir, Praz declared his preference for turning his back on the modern world and looking inward, delving into the visions there:

I myself do not care to stand looking out of the window that gives on to the
noisy street ... I prefer to go to the window of the boudoir that looks out
at the back of the house, over the solitary courtyard from whence rises the
sound of the perpetual drip of a fountain singing the song of the past.[2]

Praz's preferred view – to the courtyard of the sixteenth-century palace in which he then lived – symbolizes the interior focus of many a collector, in which things and the intimate, sensory perception of them can unlock personal memories and historic associations. Praz's life's work was to share this experience and ability with readers, so that they too could hear the song of the past (Figure 9.1).[3]

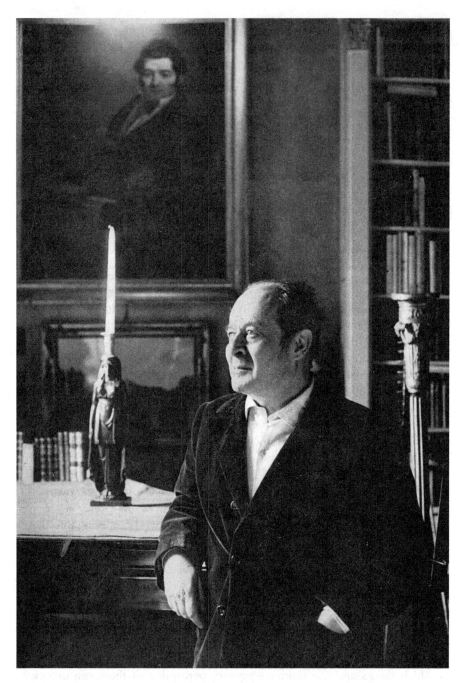

9.1 Author portrait of *Mario Praz* for the American edition of
The House of Life, New York, 1964. Photographer: Jerry Bauer.

In the summer of 1934, after nearly 12 years in England and just recently married, Praz and his English wife, Vivyan, moved to Rome, where they rented an apartment in the sixteenth-century Palazzo Ricci on the sleepy, palace-lined Via Giulia. Praz had first encountered the street while a student at the University of Rome two decades earlier and had never forgotten the serenity of the old thoroughfare in those days:

> it was quiet like some noble street in a provincial town; quiet like a corridor
> between rooms which were the courtyards of palaces, or like the nave of a
> church with chapels on either hand: and when one went into these courtyards
> one was filled with astonished reverence on account of their secret silence
> broken only by the gentle sound of a fountain. Of all these courtyards
> that of the Palazzo Ricci remained impressed upon my memory.[4]

In 1934, he found the street still peaceful, though 'perhaps not as quiet as it had been'. Seeing a 'To Let' sign on the door of the Ricci palace, the couple were seduced by the grand Renaissance scale of the rooms and rented the apartment in it.

'By a subtle and inevitable process, the man who cares for his house can easily become a collector', Praz declared years later.[5] By 1934 Praz had already long been a collector of books as well as objects and furniture of the late-neoclassical period. Until his death in 1982, Praz would work on the masterpiece that was his home, first in the apartment on the *piano nobile* of the Palazzo Ricci, then from 1969 at another on the third floor of the seventeenth-century Palazzo Primoli on the Via Zanardelli (now home to the Museo Praz, created after his death).[6] Praz filled both with the Regency and Empire-style objects he loved. In his homes, he created a world far removed from twentieth-century Rome (Figure 9.2).

In doing so, Praz took inspiration from the nineteenth-century watercolour pictures of interiors that he collected and which form the heart of *An Illustrated History of Furnishing*. In this book, Praz utilized such views of rooms to chronicle the development of furniture types and changing fashions in interior decoration. The *Illustrated History* established the modern study of the domestic interior. Praz was one of the first to see that these paintings could be interpreted as primary documents of the taste and mores of previous generations, not just as sentimental objects with meaning only for the families whose homes they depicted. Even so, he was not interested in using them only to trace the evolution of furnishing types and arrangements, nor did he just use them as visual inventories of great houses. In addition to these purposes, he looked at them to understand the bourgeois domestic *Stimmung* ('mood') – a German word that appears often throughout his writings – of the nineteenth century.

For, while Praz is widely credited with being the first to recognize the evidentiary value of these pictures, he felt that they did more than document

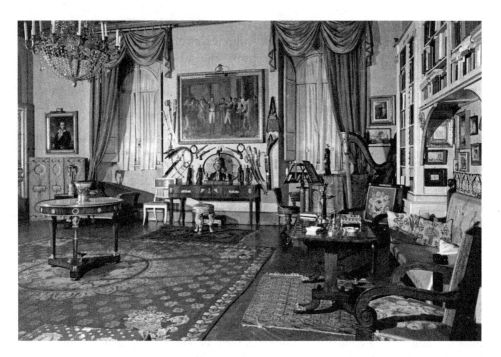

9.2 *Drawing Room in the Palazzo Ricci.* Image from *The House of Life*, New York, 1964.

spaces. They were able to bring palaces and rooms 'to life in the mind of the beholder, thanks to the diligence with which they reproduce every piece of furniture and every household object, every minute detail of carpets and curtains, and the feeling of light and shade in a room'.[7] He saw them as epistles dispatched more or less directly from the past, and he brought these eloquent messages to light for the modern world. As architectural historian David Watkin wrote in an essay that accompanied a 2000 exhibition of interior views, when it comes to 'the study of watercolours of domestic interiors, Mario Praz … is the father of us all. A literary historian rather than an art critic, he used his study of psychology and poetry to explain the extraordinary hold which these drawings have over us.'[8]

For Praz the historian, they were a treasure trove. For Praz the collector and decorator, they were keys to unlocking a lost world. In fact, his idiosyncratic and personal approach can make the *Illustrated History* a frustrating reference book for students of historic interiors today, but in bringing the objects' and rooms' stories alive for readers, he was rescuing a form of the past and blazing trails. Later scholars may have become more empirical in their use of these images as evidence, but they all pay homage to the territory Praz first mapped.[9] The relationship between Praz the collector and Praz the historian is most clearly evidenced in the ways he looked at paintings in the *Illustrated*

History and in his personal life. Praz had a self-described 'weakness' for nineteenth-century watercolours (usually done by amateur young ladies and other unsung artists) that so exactingly depicted spaces.[10] The fastidious depictions in these works make them excellent documents and Praz often made a game of tracing the movements of items of furniture around Europe through existing pictures of the different homes of a person or a family. For example, in analyzing a series of paintings of the various dwellings inhabited by Queen Hortense (the daughter of Josephine Bonaparte, who married Louis Bonaparte and became queen of Holland, and the mother of Napoleon III) he noted how various pieces – a round table, a bookcase, a harp, a particular painting – that could be recognized in pictures of her apartments at the Tuileries also showed up in pictures of her home in Augsburg, after she was expelled from France in 1817.[11] Praz tracked the travels of pieces depicted in these paintings, especially masterpieces in his beloved Empire style. For example, in an 1811 watercolor of *Queen Hortense in her Boudoir* Praz noted that 'The two cabinets, or *serre-bijoux*, eventually found their way to Saint-Cloud, under Napoleon III. The *jardinière* seen at left is now in Malmaison, and the bookcase reflected in the mirror can be seen today at the castle of Arenenberg, Thurgau, Switzerland.'[12] Meanwhile in another 'little' watercolour, *Queen Hortense in her Drawing Room*, also by Garnerey, the walls are 'almost hidden behind an array of small pictures, so scrupulously rendered that it is possible to identify them'.[13]

Praz's excitement about identifying objects became especially personal on at least one occasion when he examined an 1850 watercolour showing the *Living Room of the Palazzo Policastro in Naples*. After describing the decoration and general appearance of this room, Praz noted that 'the most curious pieces of furniture are the two bookcases against the left wall, completely similar to a bookcase in my possession except that mine only has two doors'.[14] He included a picture of his bookcase alongside a reproduction of the watercolour on a page of the *Illustrated History*.

These paintings also provide evidence of what palaces looked like in a specific year or at a particular hour of the day before renovation, redecoration, addition and subtraction of objects, change of ownership, or destruction by fire or in war. Praz began writing *La Filosofia dell'Arredamento*, the extended essay that became the introduction to the 1964 book, in October 1944. As the Second World War came to an end, he was wondering which of the houses of 'Old Europe' that he had visited in his life were still standing. For him, one goal was that the images assembled together in the *Illustrated History* would form a record of life as it once was lived in the 'richly-decorated salons', 'calm rooms' and 'rustic kitchens' of palaces, bourgeois houses and humbler dwellings; and amongst beautiful furniture 'with its time-stained patina' and 'objects lovingly worked by generations of cabinet-makers, potters, and goldsmiths'.[15] By gathering such pictures

in word and paint, Praz was not only reflecting on the qualities he associated with a lost way of life, he also aimed to preserve 'the aroma of that vanished Europe'.[16]

Praz showed how these paintings had the power to transport viewers back into the spaces they depict and the events which occurred therein. One of his own pictures depicted a room in the palace at Naples at the time it was inhabited by Caroline and Joachim Murat, two more members of the far-flung Bonaparte clan. Praz was seduced by the details that made the painting seem 'like an eternal Elysian scene', frozen at an ideal moment before history intervened tragically in the lives of the room's inhabitants, who:

have long ago gone to their deaths; one of them to a violent death, beneath the volley of a firing-squad. Beside the door of the room the key still hangs, as though the master of the house had left it there a moment ago, and the bell-cord awaits a hand to pull it. But it is as when a ray reaches the Earth from a star already extinct.[17]

Continuing this melancholy train of thought, Praz chronicled the dispersal of some of the objects depicted in the painting, but confessed 'I do not know the fate of the other, less illustrious, *objets d'art*; but such was the precision of the miniaturist in portraying them that, if they were met with today in some museum, or in the possession of a family or a dealer, it would be possible to recognize them.'[18] Especially possible, one thinks, for Praz.

Praz continually gave the impression of losing himself in the contemplation of all these pictures. In his imagination, these 'crystalline' rooms seemed forever 'to be waiting for human inhabitants'.[19] He cannot help but almost hear the instruments about to be played, or the faint receding echo of a footstep far down a hallway glimpsed through an open door.[20] Of another painting that captures sunlight beaming through the windows, he wrote that 'you cannot help gazing at this shaft of sunlight as though it were bound to change its position, little by little, on the wall in company with the gradual movement of the hands of the clock as it chimes beneath its glass bell on the dressing-table'.[21] Praz was interested in the experiential and emotional ellipses in these portraits of rooms – the sounds, smells, textures and experiences of space – which the visual cues, such as precisely rendered objects, inspire the viewer to fill in on his or her own.

Praz also put his paintings to use as inspiration in decoration and shopping. For example, the so-called gallery, or main room, of the apartment in the Primoli Palace (now the Museo Praz) took its inspiration from *The Queen Mother Isabella of Naples at Capodimonte*, a painting from 1840 in Praz's collection, which was featured on the cover of the first edition of the *Illustrated History*. The gold-and-white colour scheme echoes that in the painting, which hangs at one end of the long narrow room. Praz even bought the chandelier and a chair that are depicted in the picture, as well as

copying the gold picture hangers.[22] One room over, in the study, an Erard harp stands in front of an 1830 painting entitled *Young Woman with Harp in an Interior* by Ulisse Griffon, which shows a similar harp.[23]

In such choices and juxtapositions, Praz acted like a curator creating suitably authentic period rooms in a museum. The charm, however, is that Praz was creating a space to actually inhabit, not just exhibit, and so was creating personal spaces filled with the things he himself treasured. Over the past two decades many scholars have been looking to collectors for insights into how the act of forming and displaying a collection can shape the gathering and transmission of knowledge. Yet, as early as 1965, the American writer Edmund Wilson had already identified Praz as an artist, for *both* his writings *and* his activities as a collector. In a profile of Praz for *The New Yorker* magazine Wilson wrote that:

to think of Mario Praz as primarily an English expert and a literary critic is largely to misconceive his role. He should be considered as primarily an artist – and I do not even say literary artist, for the results of his activities as a collector of furniture, pictures, and *objets d'art* are as much a part of his *œuvre* as his books.[24]

In his 1989 book, *The Romantic Interior*, Clive Wainwright looked at the growing trade in 'antiques' and used case studies of figures like Horace Walpole, William Beckford and Walter Scott, among others, to explore the design of special interiors to house collections of old things at the end of the eighteenth and beginning of the nineteenth centuries. Wainwright noted that while some patrons had visions of complete interiors from the start others simply collected pieces 'ad hoc' until the accumulation of so many objects of a certain period or style suggested that an appropriate setting be devised for them. Wainwright emphasized the central role of the patron who selected and the broker who supplied the objects, rather than professional architect-designers, in creating these 'singular' interiors. He also pointed out that such interiors were mostly created over years, or even decades, rather than in the few months in which it would take a professional to deliver a completely designed space.[25]

Praz and the home he designed can easily be seen as a later manifestation of this romantic spirit in collecting and presenting antiques. An ardent Anglophile, he strongly identified with this first generation of self-conscious 'antiques' collectors in England and the so-called 'romantic interiors' they created from about 1750 until 1850. Praz himself wrote sympathetically and colourfully about Horace Walpole, William Beckford, Thomas Hope and Sir John Soane. He was fascinated by the houses they built to show off their huge, and continuously growing, collections of old things. And he was deeply inspired by the creative, often playful, interactions between these collectors and their objects – and the sometimes fantastic stories they often told about their assembled things.

In his own collecting, Praz certainly started out picking up things to which he felt a visceral connection on an ad hoc basis, but soon developed the desire to create a complete décor around the objects he was buying. He was smitten as early as his childhood when an 'old chest-of-drawers with pillars' made him want 'to repair the lack of harmony between this piece of furniture and the others' in his bedroom.[26] In a 1937 issue of *Decoration* magazine, Praz wrote that the apartment in the Palazzo Ricci was 'particularly suited, with its spacious rooms and wonderful lacunaria, to the Empire furniture I had started collecting in my Florence days'.[27]

Praz wrote of visiting the home of Paul Marmottan (now the Musée Marmottan) in Paris. Praz was not sure what to make of the *faux* bits and pieces that he saw in the house. Marmottan 'believed in the possibility of copying, provided that the models of the period were respected and that one avoided "all innovatory fantasy"', Praz wrote. Although he was at first dismayed by the fakery, on a later visit, after Marmottan's death, Praz was disappointed that the curator of the newly formed museum had purged it of these interjections noting that 'he had done well, no doubt, to abolish imitations and additions, but had he done well as the friend of Paul Marmottan?'[28] In creating his own home, Praz came to understand the compromises a collector-decorator would have to make in order to create the total feeling he was after. By the time Praz was an old collector himself, such actions had become merely part of the whole ensemble. Unlike Marmottan's, Praz's decorative innovations have been maintained now that his home has become a museum. Though perhaps a bit embarrassing to its curators, these pieces still sit in the rooms where Praz placed them adding their voices to the other more historical objects he so loved.

In his own quest for 'authentic décor' (to borrow the title of Peter Thornton's magisterial 1984 history of interior decoration inspired by the *Illustrated History*), Praz eventually had no qualms about introducing changes 'according to the Empire taste'[29] whenever he felt it would benefit the display of his collection. And he was not afraid to create things anew, often from antique parts, when he needed to. Unable to find the brightly coloured silks he wanted to create appropriately Pompeiian curtains in one room, he eventually sourced them from a shop that sold ecclesiastical vestments and furnishings. 'For true violet and golden yellow are positively not to be found in modern shops that sell furnishing materials', he wrote.[30] He also related how he used antique curtains in the drawing room at the Palazzo Ricci. He had only four panels for three windows, but his knowledge of Empire period decoration, and decorative sources, saved the day. 'I solved the problem by adapting a single curtain to each window (as in Plate 81 in La Mésangère, *croisées drapées*), those of the two windows on the same wall being arranged symmetrically, and the fourth curtain being used as a cover for the modern grand piano' (Figure 9.2).[31]

To fill a niche under a white-and-gold bookcase, he had to design an Empire-style sofa because he was unable to find one in antiques shops. 'This will seem an unexpected heresy', he wrote, but he had no choice. After having a frame made by a joiner, he copied a cross-stitch embroidered cover from a wall panel at the Hôtel Beauharnais in Paris. At the time of copying this embroidery Praz had only seen a black-and-white photograph of the design so, some time later, 'when I visited this Parisian palace in person, I discovered, to my joyful surprise, that in almost every case I had indicated the colours of the original'. (This sofa can be seen all the way to the right in Figure 9.2). After working with his wife on completing this particular embroidery he continued the craft. '[T]he art of Arachne pleased me so much that, besides the back of the sofa, I made covers for three stools, from designs taken from Ernest Dumonthier's book on the stuffs of the Napoleonic period.'[32]

Praz also pined for an Empire bathroom, 'even if I could not expect to rival those at the Palazzo Pitti and Rambouillet and the Hôtel Beauharnais'. He purchased a bronze faucet shaped like a swan's head and neck – 'just like the ones in the Hôtel Beauharnais' – in the hope that it would encourage him to 'transform' the bathroom at the Palazzo Ricci.[33] Years earlier he had taken note of an advertisement in the June 1928 issue of *International Studio* for 'a "splendid Directoire bathroom" called after Madame Récamier [in which] even the towel-rail is in the form of a lyre' (Figure 9.3).[34]

The bathroom proved too awkwardly shaped to change, but just as Walpole and Hope recast ancient tombs into chimneypieces, so Praz performed modern versions of such transformations in his own home. When he wanted a radio in the 1950s, Praz took old gilt-bronze mounts and commissioned a cabinetmaker to produce a case that would not look out of place in his rooms (Figure 9.4).[35] Such imaginative hybrids reminded Praz of what the original generation of Empire designers did. To make modern objects for which there were no antique precedents, they 'adapted ancient forms to functions different from their original ones. For the French cabinet-makers, the moulding of an antique stele could become the cornice of a bookcase or the back of a chair'.[36] As a collector, Praz took personal and connoisseurial delight in such transmissions; as a historian, he looked for what such adaptations might say about those who created them and the passing of time.

One of the most moving aspects of Praz's object-centred autobiography is his ability to show how any object can come to represent far more than itself in the mind of a collector. In a five-page aside entitled 'Neapolitan Porcelain'[37] he recounts how, one day, he impulsively bought a set of Neapolitan porcelain dishes bearing paintings of the great stars and composers of the *bel canto*. What possessed him to commit this 'folly' he could not say, but possessed he was as he 'found' himself, despite feeling

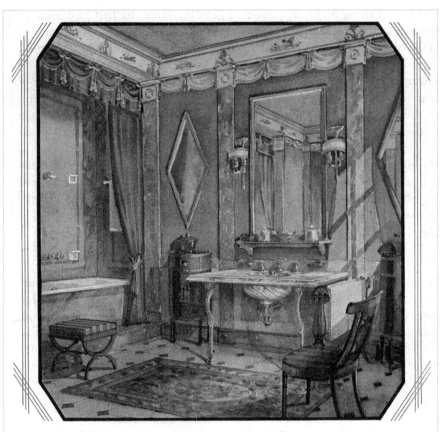

SOMETHING of the bright, brave spirit of Madame Recamier has been infused in this splendid Directoire bathroom, named for her. Matching the fleur de peche marble of the *Neumar* lavatory and of the front and recess of the *Tarnia* bath, the pilasters are cleverly marbleized in paint. Even the drapery indicated under the frieze is merely skillful brush-work. Many other inspiring suggestions, you will find in *New Ideas for Bathrooms*. Beautifully printed and full of illustrations, this compact book contains miniature blue prints of floor plans, color schemes, fixture placement, details of decoration, and vital plumbing information. It is sent gladly on request. . . . Consult a responsible plumbing contractor and learn how moderate is the price of a complete Crane installation.

≪ CRANE ≫

EVERYTHING FOR ANY PLUMBING INSTALLATION ANYWHERE

Crane Co., General Offices, 836 S. Michigan Ave., Chicago • Branches and sales offices in one hundred and sixty-six cities

9.3 Crane Plumbing, *Advertisement for a Directoire-Style Bathroom*, 1928. *International Studio*, vol. XC, no. 373 (June 1928), inside front cover.

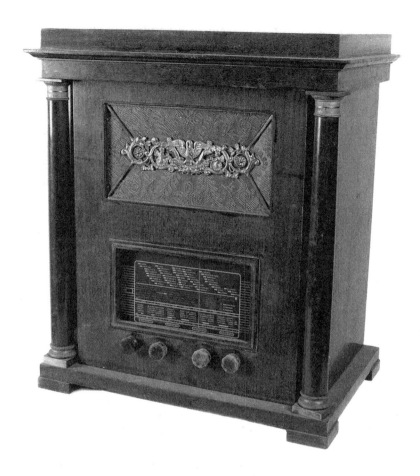

9.4 *Empire-Style Radio Cabinet Commissioned by Mario Praz*, c.1953.
Rome, Mario Praz Museum–National Gallery of Modern Art.

qualms, 'enquiring the price of the set, haggling over it, hesitating, and finally throwing myself blindly into what very few people would have described otherwise than as a mad expense'. Such out-of-body experiences, in which Praz almost seemed to observe himself in the act of making an irrational purchase, recur throughout the story of his life. And yet, his remorse almost never lasted long. Instead, he enjoyed probing deeply to discover what might lie at the base of his overwhelming desire to own an object. 'I will not speak of my wife's long face, or of the restless night which this acquisition of a dinner-service for twelve cost me', he wrote of the unplanned purchase, but this initial guilt gave way to rapture over the purchase and the associations it brought forth in his mind. As the celebrities on these dozen plates 'became endued with light and life, the

air seemed to be filled with a humming sound like that of a musical-box'. Old tunes came to his mind and his thoughts turned to his grandfather and the lost world he (and the plates) symbolized.[38]

It may not be possible to fully comprehend the impulse that drove him to the purchase, but the story quickly moved beyond that specific impetus to become about the associations such objects take on in the mind. Many people have fond memories of grandparents and can relate to the power of objects – whether inherited directly or not – to bring such memories out of the shadows. In making the plates and his recollections of his grandfather's physical presence emblematic of a vanished era, Praz shows how the personal realm of memory can enhance the value of a thing in the mind of its beholder. The nineteenth-century objects and spaces which Praz loved were created only a generation or two before he was born. He grew up with similar objects and knew many places like those depicted in the pictures he collected. They struck a deep, resonant, nostalgic chord in him. He did not just want to study them; he often wanted to possess them, too.

Throughout his home Praz encountered objects that he acknowledged might not be masterpieces but which nevertheless held a spark of life that inspired him to loyalty. For example, he recognized that a pastel portrait group did not hold its own in comparison with others in his collection, but he could not bring himself to part with it because of the associations it held for him. In October 1957 Praz stopped in Florence 'in order to see a friend and also, naturally, to pay another visit to Bruscoli's antique shop in Borgognissanti'.[39] During his visit, he experienced a sense of 'foreboding' walking down Via dei Fossi and when he arrived at the shop learned that it was going out of business. Praz recounted his memories of visiting the shop on previous occasions, always in eager anticipation of what he might find. He told of things he did buy and of things he passed up or could not afford. That October day, he bought 'the little picture painted by Anna Tonelli in 1812' although 'it seemed something I could do without' because 'it would be the last purchase I should make from Bruscoli, a modest acquisition, but charged with sentimental value'.[40] Praz transformed this personal loss into a symbol of so much that had been lost in the post-war world. Another picture also failed to live up to the level of the best objects in his house, yet he could not bear to part with it because it reminded him of the Christmas in 1933 that he spent with his soon-to-be wife in a cold apartment in Florence. The heat of the fire caused this painting to bend, and 'the slight curvature of the board that has persisted reminds me of the evenings of a happy winter'.[41]

Over the course of the book many objects in the apartment inspire such transporting memories and thoughts. And Praz often narrated tales as though he were unable to resist the spells cast by his things.[42] A blue Bristol glass witch-ball held memories of 'Doris' a woman he once loved

in England.[43] A *poudreuse* 'still holds a faint and ghostly reminiscence' of 'the fragrance of scents and powders and creams' that had been stored in the compartments alongside the mirror, and which always called to mind the image of his now former wife in the glass.[44] A chandelier that hung in a hallway was a 'degenerative derivative' found in a Paris antiques shop in 1934 of a much nobler one with which he 'fell so deeply in love … that, if it had been for sale, I would have done anything in the world to acquire it'.[45] Yet, while his chandelier may have been a poor substitute for the true love, for Praz, it had over the ensuing decades absorbed the power of many 'happy and sad moments', making it difficult to let go.[46] An Aubusson carpet evoked the memory of a night in June 1942 when he sat with a friend in the darkened drawing room, fearing air raids, with moonlight falling through a window onto the carpet, discussing the uncertain fate of the world at that time.[47]

In Praz's world, and that of many other collectors, objects are both passive and active. The possessor impresses the moments of his or her life into them, but then they acquire the power to call forth memories, to make them more physically palpable. As he wrote, flowers and old photographs often 'share the common fate of being kept hidden away, the flowers often between the pages of books, for years and years, until one day you rediscover them and they make your heart ache'.[48] In Praz's writings not just dried flowers and faded photographs but all the objects he owned – furniture, curtains, paintings, old china and much more – held that power, too. In his eloquent writings and composed home, Praz orchestrated their many voices into a chorus of songs of the past.

Notes

1. English titles and original publication years: *The Romantic Agony* (1930), *Studies in Seventeenth-Century Imagery*, vol. 1 (1939) and vol. 2 (1947), *An Illustrated History of Furnishing* (1964, reissued as *An Illustrated History of Interior Decoration* in 1982 and 2008), *On Neoclassicism* (1969), *Conversation Pieces: A Survey of the Informal Group Portrait in Europe and America* (1971).

2. Mario Praz, *The House of Life*, trans. Angus Davidson (New York, 1964), p. 346.

3. Writer Edward Hollis has likened Praz's literary conflation of autobiography and space to a 'memory palace', the classical rhetorical method by which orators committed stories to memory by constructing elaborate mental images of architectural spaces populated by objects meant to evoke various parts of what they were trying to remember. See Edward Hollis, '*The House of Life* and the Memory Palace: Some Thoughts on the Historiography of Interiors', *Interiors: Design Architecture Culture*, 1/1–2 (July 2010): pp. 105–17.

4. Praz, *House*, pp. 17–18.

5. Mario Praz, *An Illustrated History of Interior Decoration: From Pompeii to Art Nouveau*, trans. William Weaver (New York, 1982), p. 26. A note on the publication history of this work: In 1945, Praz published an essay, *La Filosofia dell'Arredamento*, which was revised and expanded into a longer book of the same title in 1964. This expanded version appeared in the United States as *An Illustrated History of Furnishing from the Renaissance to the Twentieth Century* (New York, 1964) that same year. The book was re-issued in 1982 and again in 2008 as *An Illustrated History of Interior Decoration from Pompeii to Art Nouveau*.

6. Under the ownership of Count Giuseppe Primoli, the building underwent a massive renovation from 1904 to 1911.

7. Praz, *House*, p. 287.

8. David Watkin, 'The Psychology of the Interior View', in *Inside Out: Historic Watercolour Drawings, Oil Sketches, and Paintings of Interiors and Exteriors, 1770–1870* (London, 2000), p. 4.

9. See, for example, Peter Thornton, *Authentic Décor: The Domestic Interior, 1620–1920* (New York, 1984); Charlotte Gere, *Nineteenth-Century Decoration: The Art of the Interior* (New York, 1989); Jeremy Aynsley and Charlotte Grant (eds), *Imagined Interiors: Representing the Domestic Interior since the Renaissance* (London, 2006). In his wide-ranging *Structures of Everyday Life* (New York, 1981) no less a historian than Fernand Braudel called the *Illustrated History* a 'splendid book' and acknowledged his debt to the work, going on to say, 'However characteristic it may be, one piece of furniture does not reveal a whole picture; and the whole picture is what matters most. Museums, with their isolated objects, generally only teach the basic elements of a complex history. The essential is not contained within these pieces of furniture themselves but is in their arrangement, whether free or formal, in an atmosphere' (p. 590, note 127).

10. Praz, *Illustrated History*, p. 36.

11. Ibid., p. 212.

12. Ibid., p. 196.

13. Ibid., p. 196.

14. Ibid., pp. 342–3.

15. Ibid., p. 67.

16. Ibid.

17. Praz, *House*, p. 286.

18. Ibid., pp. 286–7.

19. Ibid., p. 285.

20. Mario Praz, 'Genre Painting and the Novel' (Introduction), in Mario Praz, *The Hero in Eclipse in Victorian Fiction*, trans. Angus Davidson (London and New York, 1969), pp. 4–5.

21. Praz, *House*, p. 290.

22. Rachel Kaplan, *Little-known Museums in and around Rome* (New York, 2000), p. 134.

23. Praz had written an essay, 'The Lady with a Lyre', in Mario Praz, *On Neoclassicism*, trans. Angus Davidson (Evanston, IL, 1969), pp. 255–67, which examined the convention in portraiture of portraying young women with musical instruments.

24. Edmund Wilson, 'The Genie of the Via Giulia', *The New Yorker*, 41 (20 February 1965): p. 152.

25. Clive Wainwright, *The Romantic Interior* (New Haven CT and London, 1989).

26. Mario Praz, 'Two Old Collectors', in Praz, *On Neoclassicism*, p. 282.

27. Mario Praz, 'An Empire Flat in a Roman Palace', *Decoration*, no. 25, new series (June 1937): pp. 11–15.

28. Praz, 'Two Old Collectors', p. 290.

29. Ibid.

30. Praz, *House*, p. 66.

31. Ibid., p. 265.

32. Ibid., pp. 271–3.

33. Ibid., pp. 57–8.

34. Mario Praz, 'Resurrection of the Empire Style', in Praz, *On Neoclassicism*, p. 312.

35. Patrizia Rosazza-Ferraris (ed.), *Museo Mario Praz: Inventario Topografico delle Opera Esposte* (Rome, 2008), p. 71.

36. Praz, *Illustrated History*, p. 151.

37. Praz, *House*, pp. 67–72.

38. Ibid., pp. 68–70.

39. Ibid., p. 200.

40. Ibid., pp. 200–203.

41. Ibid., p. 180.

42. It can seem as if, as Imma Forino has written, 'the interior belongs to the things, rather than to the man who has chosen and loved them'. Imma Forino, 'Living in "The Sense of the Past:" Solipsistic Impulses in the Domesticscapes of Edmond de Goncourt and Mario Praz', *Interiors: Design, Architecture, Culture*, 2/1 (March 2011): p. 14.

43. Praz, *House*, p. 102.

44. Ibid., pp. 103–4.

45. Ibid., p. 63.

46. Ibid.

47. Ibid., p. 303.

48. Ibid., p. 275.

Art, Architecture and Life: The Interior of *Casa de Vidro*, the House of Lina Bo Bardi and Pietro Maria Bardi

Aline Coelho Sanches Corato

This chapter discusses the interior of *Casa de Vidro* (Glass House) the private house in São Paulo, Brazil, designed by Italian-born architect Lina Bo Bardi in 1951. It explores Bo Bardi's understanding of the relationship between art and architecture and the ways in which that understanding informed the original conception for Casa de Vidro's interior and its transformation during the years in which Bo Bardi lived there with her husband, art critic and director of the Museu de Arte de *São Paulo* Pietro Maria Bardi.

As an architect, Lina Bo Bardi contributed to interior design in a non-specialized way and without detaching it from more general architectural issues. Although good examples of Brazilian modernist interiors exist, in that country interiors were not the main focus for the discussion and dissemination of a new architectural language. In contrast, Italian interiors designed for exhibitions, such as the Triennales and trade fairs in Milan, and for stores and museums during the inter-war period and after the Second World War, were laboratories for architectural experimentation that offered opportunities to debate the development of a modern architectural and design language. Throughout her career Bo Bardi's work, which was transformed by Brazilian culture, created opportunities for discussion in this field, be it through executed designs, articles or exhibitions that positioned interior design as an important topic for architecture.

Lina's life and designs evidence a central concern with the relationship between art and architecture.[1] One of the values of her architecture is precisely the connection with art and *Casa de Vidro* must be read together with her ideas about art and life and those of her husband, Pietro Maria Bardi.

Lina Bo was born in Rome in 1914. Drawing and painting were part of her education. Her father, Enrico Bo, an important figure in her drawing education, was an engineer who later became a painter. Bo attended an art

school and was awarded her degree at the Rome Architecture School in 1939. After receiving her degree Bo moved to Milan where she was welcomed by Carlo Pagani, a former classmate at the Architecture School in Rome. In 1940 they opened 'Studio Pagani Bo'. During her time in Milan Bo also worked occasionally for Gio Ponti and published articles and illustrations in several magazines.[2]

The Second World War and the trauma it caused had a defining impact on Bo Bardi before she left Italy. In 1946 she married Pietro Maria Bardi, who had an important influence on her artistic ideas. Born in La Spezia in 1900, Bardi was an eminent journalist, art critic, gallery expert and an important cultural figure in Italy during the 1930s. In the same year they travelled to Brazil by sea, along with Bardi's great art collection, without planning to stay in the country in which they would spend the rest of their lives. It is not yet completely clear why the Bardis travelled to Brazil. One possibility is that Bardi, as an art dealer in a poor post-war Europe, saw opportunities in South America, which was at the time attracting many European immigrants.[3]

Soon after arriving in Brazil Bardi was invited by politician and businessman, Assis Chateaubriand, to create an art museum, the *Museu de Arte de São Paulo* (MASP), which was established in 1947.[4] The Bardis moved to the city and Pietro Maria took up the position of museum director, with responsibility for organizing and acquiring the collection, an endeavour in which he was supported by Chateaubriand and other artistic patrons. Lina took charge of organizing the design of the galleries and exhibitions, teaching the museum courses[5] and later on designing the museum's new building (1957–1969). The period in which the Bardis established MASP was one of rapid urban growth in which São Paulo developed into a metropolis of new buildings and new cultural institutions. It was also a period of industrial development, part of a process that was initially triggered by the coffee market and then stimulated by government actions.

In 1951, four years after the foundation of MASP, Lina Bo Bardi designed and built *Casa de Vidro* as a home for herself and her husband. The house was situated in the Morumbi borough of São Paulo, a sparsely urbanized area of the city at that time. Soon after its completion, the Bardis installed their art collection, which consisted of ancient and modern paintings, objects, sculptures and items of furniture.

The juxtaposition of modern and ancient art was important for Pietro Maria Bardi, who defended and diffused this idea through his work at the *Studio di Arte Palma* galleries, in Rome and São Paulo, and at MASP. Bardi also disseminated his ideas through articles, such as 'L'Antico e Noi' (The Ancient World and Us)[6] published in *Stile* magazine in 1941, in which he stated that the meaning of the past is not linear, but is something related to modern art, something that still lives, as a witness of man's creativity. Lina Bo Bardi and and Carlo Pagani also collaborated with *Stile* magazine, which was created

and directed by Gio Ponti. In the first issue of the magazine they published an interior design based on modern and ancient artwork,[7] a strategy that was also used in *mediterraneità*[8] poetics. The presence of the past in the work of some modern Italian artists and architects expresses the different cultural positions that they adopted, which is a feature of modernist Italian architecture of the inter-war and post-war periods.

The earliest published photographs of *Casa de Vidro* show the initial location of works from the Bardi's collection. Over time works moved around the house and new elements were added to the interior: industrial objects without any economic value and Brazilian handcrafts and folk objects that had been collected by Bo Bardi over the years. These became a source of inspiration for her architectural practice as well as shaping a part of her private, imaginary world.[9] Recent photographs of the house show some wooden animals made by a folk artist – a mason at *Sesc Pompéia*[10] construction yard, São Paulo, nicknamed 'Paulista' – for the *Entreato para crianças* exhibition, organized by Bo Bardi in 1985; a piece of folk patchwork fabric on a Franco Albini *Margherita* chair; some folk furniture; and some small plastic toys.[11]

Within the *Casa de Vidro* household objects, furniture and works of art represent episodes in the couple's life, as well as their cultural choices. They include pictures by artists supported by Pietro Maria Bardi that were exhibited in the galleries that he ran in Italy and in the Brazilian museum; furniture designed by Bo Bardi and architects she admired; works of the ancient world, the European past and the modern avant-garde; Brazilian folk objects, pictures and natural elements like rocks and roots that reveal their encounters with Brazil; and elements that recalled the great design experience of a total work of art, as was the *SESC-Pompéia* and its exhibitions, by Bo Bardi and her collaborators between late 1970s and early 1980s. These pieces make up a chorus of many voices and many times, a personal and trans-cultural museum.

The Bardis' interest in folk culture began in Italy.[12] In Brazil it was directed at local folk culture, which had a strong presence in the magazine *Habitat*, edited by the couple from the end of 1950 to 1954 in São Paulo, as well as in the MASP initiatives. At that time rural architecture, craftsmanship and folk objects were seen as bearers of a sort of authenticity, bringing such topics closer to modernist ideals of simplification and economy. Folk culture represented a close bond to nature and spontaneity, themes that were at the same time local and international.

Bo Bardi's personal rediscovery of this folk world occurred during her first years in Salvador, Bahia between 1958 and 1964, when she was initially invited to teach at the University of Bahia. While she was there, Bo Bardi made contact with a large group of foreign and Brazilian artists and intellectuals and was responsible for writing a newspaper column[13] and for directing two linked museums, the *Museu de Arte Moderna da Bahia* (MAMB),

for modern art (which at Lina's decision also included ancient and popular art), and the *Museu de Arte Popular* (MAP), for folk art. She also contributed to the cultural formation of a number of young Bahia intellectuals and artists in this period, including Glauber Rocha and Caetano Veloso. During her time in Bahia, Bo Bardi studied folk culture from a specifically political point of view, influenced by Antonio Gramsci's ideas, and she created opportunities to develop the Brazilian manufacture of objects based on folk objects.

In response to her experience of Bahia, folk objects became even more important to Bo Bardi in her work, as can be seen in her designs for later projects, for example the *Sesc Pompéia* complex. A collection of Brazilian folk objects formed part of the *Casa de Vidro* bringing to life its interior spaces. The objects told the stories of the way they had been made by their creators and the way they had been selected by their collectors. These objects also reflected the life experiences that had occurred in the house.

The first sketches that Bo Bardi made for the *Casa de Vidro* do not show the presence of folk art or folk objects (although a small number of Brazilian wooden folk sculptures appear on a piece of furniture in the first photographs of the house), but they already show her interest in both modern and ancient art, as well as her wish to make objects appear to float in space. In these sketches, sculptures and furniture items expand through space, and paintings are suspended on delicate, slender structures that were also used for illumination.

These structures resemble the designs of Franco Albini, an architect who Bo Bardi certainly admired. Similar structures can be seen in his apartments in via De Alessandri (1938) and via De Togni (1940) in Milan, as well as the Scipione and Black and White exhibition that he designed at the Brera Painting Gallery in Milan, in 1941. Earlier examples can be found in the work of Ignazio Gardella, in his house/studio of 1937 in piazza Aquileia in Milan. Albini and Gardella were part of a constellation of references that belonged to Bo Bardi's imaginative world, which had been strongly influenced by her experience of Italian exhibitions both before and after the Second World War. As we know, she had not undergone that Italian post-war experience directly, but she kept herself informed of it through trips, magazines and constant contact with Italian artists and architects.

Bo Bardi pursued the idea of paintings floating in space in various projects, for example by using slender structures in the original MASP gallery in 1947, rather differently in the 1950 MASP extension and again, in a unique way, using a glass and concrete structure for the paintings in the gallery on Avenida Paulista. However, as the design for *Casa de Vidro* progressed, the paintings were placed on the walls rather than suspended in space.

In *Casa de Vidro* most of the works of art were located in the living room, on the furniture, or on the floor. They occupied all spatial levels and represented the absence of gravity, amidst a natural landscape seen through the windows,

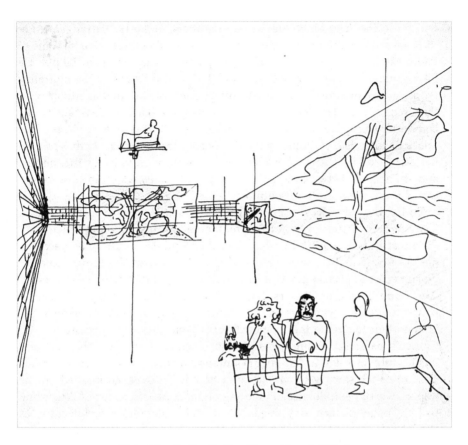

10.1 Lina Bo Bardi, *Glass House (Casa de Vidro)*,
São Paulo, 1951. Sketch – perspective of the inside,
coloured pencil and Chinese ink.

which became increasingly dense over the years. In the 1953 arrangement of the *Casa de Vidro* dining room, the majority of the paintings were by some of Pietro Maria's favourite modern Italian painters – among them Filippo De Pisis, Ottone Rosai, Giorgio Morandi and Ferruccio Ferrazzi. The figurative works of art provided a contrast with the abstraction and modularity of the architecture. This choice communicated Bo Bardi's ideas about the composition of space as a collage of contrasting elements. In the images of the house the objects communicate an idea of suspension similar to that present in De Chirico's paintings. They create an atmosphere provided by the contrast and strangeness between added elements and voids, which in turn offer a model for a sort of ideal museum.

Bo Bardi used works of art as the base material for the construction of space and, as a starting point for thinking about it, positioning them in a theatrical and communicative way. This is exemplified by the only piece that has been continually present: a De Chirico mosaic made by Enrico Galassi[14] that occupies a special place in the house. Although authors, including Renato Anelli and Olivia de Oliveira, have discussed the relationship between Bo Bardi's work and paintings by De Chirico,[15] whom she knew personally, it is important to situate the relationship between Lina's architecture and De Chirico's painting within the context of twentieth-century Italian art and architecture. In a 1935 article about Gardella's renovation of the Busto Arsizio Theatre of the same year, the great critic Edoardo Persico insisted on the importance of the influence of painting on modern architecture.[16] According to him, neoplasticism was the basis of Walter Gropius's architecture, as was cubism for Le Corbusier's and metaphysical art for the work of some Italian architects. Persico believed that the relationship with metaphysical painting could be seen as an important starting point for the creation of an original language for Italian architecture. Persico's ideas and designs had influenced the work of a number of Milan rationalists, Gardella and Albini in particular. As in De Chirico's paintings, the work of these architects exuded an atmosphere created by the strangeness between the objects and the void surrounding them. The forms and atmosphere of Italian cities were transferred to De Chirico's paintings,[17] and aspects of the latter were transferred to Bo Bardi's architecture.

Bo Bardi gave De Chirico's mosaic an important role in her architectural approach, similar to the way in which Brazilian architects had learnt from Le Corbusier in 1936, evidenced in the *Ministry of Education and Health* in Rio de Janeiro, a masterpiece of modern Brazilian architecture designed by Lucio Costa, Affonso Eduardo Reidy, Jorge Moreira, Carlos Leão, Ernani Vasconcellos and Oscar Niemeyer, with Le Corbusier as an initial consultant.

The role of murals in architecture had been discussed in Italy during the 1930s, in articles by Mario Sironi, Gio Ponti and Gino Severini.[18] Some of Le Corbusier's ideas about the relationship between art and architecture

are expressed in an article that he wrote for a conference in Rome in 1936, published one year later.[19] These ideas influenced several Brazilian architects, among them Costa, Niemeyer, Reidy and Roberto Burle Marx.[20] It is, however, worth noting that Costa's ideas were also discussed and absorbed by Le Corbusier, as there was an exchange of ideas around this theme.[21]

According to Le Corbusier a painter should only work with an architect in two cases: to dematerialize a wall or to communicate ideas by painting in accordance with the architecture of the building. On the other hand, the role of the sculptor in architecture is to place his work at a point in the building where its own meaning can resonate; a point Le Corbusier called a 'speaker place'.[22] It is important to remember that, in those years, the relationship between art and architecture was crucial for Brazilian architects and was an issue that had frequently appeared in designs, texts, discussions and conventions.

The mosaic panel in *Casa de Vidro* occupies such a 'speaker place'. It is hung on the wall at the top of the entrance stairs, anticipating the space that will be revealed inside. The choice of a De Chirico's mosaic seems to confirm the hypothesis that the space is closely related to metaphysical art and Italian culture.

Even though the way in which Bo Bardi chose to display the mosaic reminds one of Le Corbusier's and other Brazilian architects' ideas about communication, her general approach towards the positioning of works of art within the *Casa de Vidro* interior is different. The distinctiveness of her approach can be explained through a comparison of *Casa de Vidro* with another important Brazilian architect's house of the same period, Oscar Niemeyer's *Casa das Canoas* in Rio de Janeiro, of 1953. In this building Niemeyer chose sculptures created by his friend Alfredo Ceschiatti and placed them in specific locations around the swimming pool and inside the house. There is a correspondence between the curves of the house, those of the sculptures and of the surrounding landscape. The sculptures in Niemeyer's house communicate a sense of gravity and are placed at special echoing points, in the manner suggested by Le Corbusier. In Niemeyer's buildings, the connection between architecture and works of art is established through a sense of similarity, not of strangeness: the architect and the sculptor had similar intentions. Sacred art of the Brazilian baroque could also be found inside *Casa das Canoas,* but its presence was in accordance with Niemeyer's architectural ideas and with Lucio Costa's theories. In order to demonstrate that modern Brazilian architecture had an authentic Brazilian identity, Costa related it to the baroque art of the Minas Gerais region.

The position of the mosaic in *Casa de Vidro* also suggests that Bo Bardi planned the interior space with the observer's point of view in mind, to create a *mise en scène* in which the work of art communicated with the viewer.

In *Casa de Vidro* there is also another piece that receives the guests and introduces them to the house: a first-century BC Roman sculpture of the

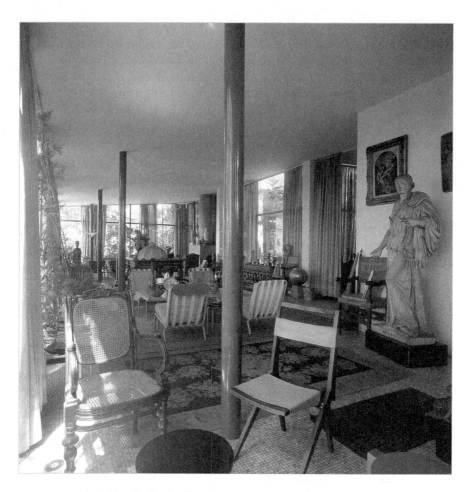

10.2 Lina Bo Bardi, *Glass House (Casa de Vidro)*, São Paulo, 1951.
View of the living room, 1998.

goddess Diana. Photographs show how the sculpture moved around the house over the years. In the oldest photographs of the house it can be seen between the *pilotis* on the ground floor, in a sort of sculpture garden. In later years it was relocated to the interior, in front of a wall parallel to the De Chirico mosaic.

Before the sculpture was moved into this position, the wall had some paintings hung on it. At that time, another work entered into a dialogue with the observer: a sculpture of a girl's head by the Italian sculptor Pericle Fazzini, which was placed over a sixteenth century Italian marble table. This relationship was recognized and explored by Peter Scheier in his photographs of *Casa de Vidro*, taken in the early 1950s.

At MASP's second building on Avenida Paulista, also designed by Bo Bardi, another sculpture of Diana welcomed spectators to the picture gallery for some time. This sculpture, Giuseppe Mazzuoli's *Sleeping Diana* (1690–1700),[23] could have been situated anywhere in the gallery. Nevertheless it was placed on the right side of the gallery entrance, creating a point of entry for visitors to the exhibition. In some photos another sculpture, Valerio Villareale's *Sleeping Bacante* (1833), can be seen on the left side of the entrance, receiving the visitors. In other photographs, this role was taken over by *Igea*, a fourth-century BC sculpture. It is not known whether these locations were chosen by Bo Bardi or her husband. Further indication of the former's habit of placing art objects to welcome the visitor can be seen elsewhere. For example, in the case of the *Exu* deity sculpture in the *Bahia no Ibirapuera* Exhibition (1959) in São Paulo, and of the *Polochon*, an imaginary animal, a pig with two heads, that was meant to welcome the theatre audience for the 1985 performance of Alfred Jarry's *UBU Roi*, in São Paulo, for which Bo Bardi designed the scenery.

The construction of *Casa de Vidro* was completed in the same year that Gio Ponti published an article about Milan's *Casa al Parco*, designed by Gardella.[24] Angelo Lorenzi claims that the interior design of the *Tremi apartment* in *Casa al Parco* was based on a contrast of elements and a variety of pictures from different times.[25] This contributed to an effect of strangeness similar to that in the *Casa de Vidro*.

The objects and the figurative paintings that Bo Bardi and Gardella placed in their interiors performed a theatrical role. Another common characteristic of their interior design is the close relationship between the collection and the house: the living space and the exhibition space. As a result, *Casa de Vidro* and the MASP Picture Gallery are similar in character and works of art were moved from the house to the museum, either temporarily or permanently. One example is an Egyptian sculpture, allegedly from the twentieth dynasty, that initially appears on the first site of the MASP picture gallery in 1950 (on loan from Pietro Maria)[26] and later in the garden of *Casa de Vidro*.[27]

The creation of a relationship between the house, the museum and the collection is a practice that can also be recognized in Albini's designs.[28]

Like Bo Bardi and Gardella, Albini made no distinction between pieces of ancient and modern art and combined figurative paintings and sculptures by means of contrast, detaching them from the walls and giving them an aerial character. Federico Bucci used the term 'spatial narration' to describe the architecture of Albini's exhibition spaces and pointed out the tension that existed between abstraction and figuration in those spaces.[29] For Albini it was important to create something he called 'atmospheric vibrations'. He stated that architectural space must be planned by using air, light and the distance between the work of art and the viewer, an approach that can also be seen in Bo Bardi's architecture.[30]

The same relationship that is present in Bo Bardi's house, between the works of art and the viewer, can be seen in the apartment that Franco Albini designed for himself in via De Togni in Milan (1940). In some of the photographs, the photographer emphasized a piece in the foreground that welcomed the guests; the same effect is achieved in the S. Lorenzo Treasure Museum in Genoa, also designed by Albini between 1952 and 1956, where it looks as if the sculptures were performing a role on a stage.

There is a difference between the way in which Bo Bardi arranged the two Diana statues and that in which she arranged Mario Cravo's Exu sculpture in the Bahia no Ibirapuera exhibition. While the statue of Diana at MASP, or that at Casa de Vidro, were taken from their original locations (an operation typical of museums), Bo Bardi placed Mario Cravo's Exu in a way that recreated the deity's position in the sacred space of the Candomblé religion.[31] In the Bahia no Ibirapuera exhibition Bo Bardi and Martim Gonçalves (an important Brazilian theatre director who designed the exhibition with her) created a special arrangement for this and other pieces in an attempt to evoke their original settings. In some of her exhibitions and museum designs she chose a means of display used for all works of art in the collection, as she did at the MASP Picture Gallery. In others, like the aforementioned Bahia no Ibirapuera and The hand of Brazilian people (1969 at MASP) exhibitions, Bo Bardi created a number of different special exhibition displays that commented on the original context for a piece, or group of pieces, in a way similar to that employed in some post-war Italian museums, for example Albini's Genoa museums (Palazzo Bianco, 1949–1951; Palazzo Rosso, 1952–1962; and S. Lorenzo treasure museum, 1952–1956), BBPR's Castello Sforzesco museum in Milan, 1954–1956, or Carlo Scarpa's Castelvecchio museum in Verona, 1956–1964.[32]

Rather than searching for a genealogy of Bo Bardi's work, it is important to set it within the context of her architectural background which was later to be transformed by Brazilian culture. Bo Bardi's original conception for Casa de Vidro, which was not implemented, was that it should be used both as a personal home and as a studio for the MASP School of Art. Maybe her desire for works of art in space to stimulate artists' creativity and provoke

an active public reaction derived from this idea, as her museums aspired to stimulate and educate the viewer. This idea would become important in her later designs, such as the one for *Sesc Pompéia*.

The interior of *Casa de Vidro* reveals an experience of correspondences and cultural exchanges: between Italian and Brazilian cultures and architecture and between art and architecture. In Lina's work, art and folk objects are a source of inspiration; they are the basis of her architecture, a means of achieving poetry, an element of the continuous transformation of space, a didactic resource, something that she felt could stimulate those who lived in, or visited, the space and, finally, something that fills that space with life.

Casa de Vidro was transformed along with the lives of its architect and her husband. Bo Bardi absorbed Brazilian culture and used it as the basis of her creative output. Beyond that she added a tradition that came from the world of relationships between modernist art and architecture in the Modern Movement. The house is also part of the biography of its inhabitants. It was an experience of displacement and migration, of the transformation of forms in which we cannot separate art, architecture and life.

Notes

1. In *The Architecture of Lina Bo Bardi: Subtle Substances* (São Paulo/Barcelona, 2006), Olivia de Oliveira suggests that there is a special dialogue with certain artists in Lina's designs, and she develops the thesis that air, light, nature, works of art and time are the *subtle substances of architecture*. Cathrine Veikos, 'To Enter the Work: Ambient Art', *Journal of Architectural Education*, 59/4 (2006): pp. 71–80. According to Veikos, the MASP Picture Gallery is an art installation that includes the presence of people. Renato Luiz Sobral Anelli, 'O Museu de Arte de São Paulo: O Museu Transparente e a Dessacralização da Arte', in *Arquitextos*, 10.112 (2009). http://www.vitruvius.com.br/revistas/read/arquitextos/10.112/22, accessed January 2012; Renato Luiz Sobral Anelli, 'Da Integração à Autonomia: Arte, Arquitetura e Cultura no Brasil, 1950–1980', *8ᵗʰ DOCOMOMO Brazil Conference: Cidade Moderna e Contemporânea: Síntese e Paradoxo das Artes*, Rio de Janeiro, 1–4 September, 2009. http://www.docomomo.org.br/seminario%208%20pdfs/086.pdf, accessed January 2012. According to Anelli, Lina's work reveals an articulated and complex life experience that includes politics and a didactic value in every action. Also according to him, there is a sense of desacralization of the work of art, a discussion between design and folk art problems; Lina's designs do not integrate art, since they are works of art per se.

2. Lina Bo Bardi (Rome, 1914–São Paulo, 1992). Some works about Lina Bo Bardi's life are listed in the bibliography.

3. Francesco Tentori, *P.M. Bardi: Con le Cronache Artistiche de 'L'Ambrosiano', 1930–1933* (Milan, 1990); Francesco Tentori, *Pietro Maria Bardi: Primo Attore del Razionalismo* (Torino, 2002).

4. Pietro Maria Bardi (La Spezia, 1900– São Paulo, 1999). Some works about Pietro Maria Bardi's life are also listed in the bibliography.

5. Throughout its existence, MASP has developed courses and conferences, including one dedicated to industrial design (1951–1954), which was directed by Bo Bardi and took place at the Museum's Instituto de Arte Contemporânea (IAC, Contemporary Art Institute).

6. Pietro Maria Bardi, 'L'Antico e Noi', *Stile*, 3 (March 1941): pp. 57–8. The title is a direct reference to Tadeusz Stefan Zienliński's (1859–1944) book published in English as *Our Debt to Antiquity* (Port Washington NY, 1909), and in Italian as *L'antico e noi: otto letture* (Florence, 1910, 1915), which was an inspiration to Pietro Maria.

7. Lina Bo Bardi and Carlo Pagani, 'Tre Arredamenti degli Architetti Lina Bo e Carlo Pagani', *Stile*, 1 (January 1941): pp. 88–103.

8. A propos of *mediterraneità* see Michelangelo Sabatino, 'Spaces of Criticism: Exhibitions and the Vernacular in Italian Modernism', *Journal of Architectural Education*, 3 (2009): pp. 35–52.

9. Concerning the transformation of the house see also Oliveira, *Architecture*, pp. 41–79.

10. *Sesc Pompéia* is an important project to renovate an old factory in the Pompéia neighbourhood of São Paulo, as a leisure centre with sports, cultural and educational programmes. The project by Bo Bardi and her collaborators Marcelo Ferraz and André Vainer was sponsored by the Brazilian institution Serviço Social do Comércio (SESC, Trade Social Service). The design was begun in 1977 and the renovation of the existing factory was completed in 1982 and the new towers in 1986.

11. On the objects in the house it is useful to refer to some of Lina's collaborators: Marcelo Ferraz, 'Casa de Vidro', in Lina Bo Bardi (texts) and Marcelo Ferraz (ed.), *Casa de Vidro, São Paulo, Brasil, 1950–1951* (Lisbon/São Paulo, 1999); and Marcelo Suzuki, *Lina e Lucio*, PhD Diss., University of São Paulo (São Carlos, 2010). http://www.teses.usp.br/teses/disponiveis/18/18142/tde-05012011-151425/pt-br.php, accessed 1 August 2011.

12. In Pietro Maria Bardi's specific case, it must be remembered that the so called 'primitive' or 'naïve' was already one of his main interests in Italy, an interest reflected in his article of 1933 dedicated to the *'pittori della domenica'* (Sunday painters), as he called them. See, Pietro Maria Bardi, 'I "Pittori della Domenica"', *Il Secolo Illustrato* (5 August 1933), from Paolo Rusconi, 'Le Riviste Popolari Illustrate di Rizzoli (1931–1934)', in Raffaele Berti e Irene Piazzoni (eds), *Forme e Modelli del Rotocalco Italiano tra Fascismo e Guerra, Quaderni di Acme*, 115 (2009): pp. 527–73.

13. The Sunday column was called 'Crônicas de Arte, de História, de Costume, de Cultura da Vida' (Chronicles of Art, History, Customs and Life Culture) and ran from September to November 1958 for the *Diários de notícias de Salvador*, a newspaper belonging to the Assis Chateaubriand's group.

14. As stated by Lina in Lina Bo Bardi, 'Residência no Morumbi', *Habitat*, 10 (1953): p. 35.

15. Olivia de Oliveira, 'Quarto do Arquiteto: Lina Bo Bardi e a História', *Óculum*, 5–6 (1995): pp. 82–7; Anelli, *Museu de Arte*.

16. Edoardo Persico, 'Un Teatro a Busto Arsizio', *Casabella* (June 1935): pp. 36–43.

17. Guido Canella, 'La Pittura del "Novecento" e l'Architettura', in Guido Canella (texts) and Enrico Bordogna, Enrico Prandi and Elvio Manganaro (eds), *Architetti Italiani del Novecento* (Milan, 2010), pp. 33–43.

18. Two examples are Mario Sironi, 'Pittura murale', *Il Popolo d'Italia*, 1 January 1932 and Gio Ponti, 'Considerazioni sulla pittura murale', *Domus*, 134 (1939), p. 37.

19. Le Corbusier, 'Le Tendenze dell'Architettura Razionalista', in Fondazione Alessandro Volta, *Convegno di Arti: Rapporti dell'Architettura con le Arti Figurative* (Rome, 1937), pp. 119–29.

20. On this influence see also Fernanda Fernandes, 'Arquitetura no Brasil no Segunda pós-Guerra: A Síntese das Artes', *6th DOCOMOMO Brazil Conference*, Niterói 16–19 November, 2005. http://www.docomomo.org.br/seminario%206%20pdfs/Fernanda%20Fernandes.pdf, accessed January 2012. Although his principles were personally taught by Le Corbusier, the text was only translated into Portuguese in 1984, as: Le Corbusier, 'A Arquitetura e as Belas-Artes', trans. Lucio Costa, *Revista do Patrimônio Histórico e Artístico Nacional*, 19 (1984), pp. 53–68.

21. Cecília Rodrigues dos Santos, 'A Arquitetura e as Artes Menores', *8th DOCOMOMO Brazil Conference: Cidade Moderna e Contemporânea: Síntese e Paradoxo das Artes*, Rio de Janeiro, 1–4 September, 2009. http://www.docomomo.org.br/seminario%208%20pdfs/003.pdf, accessed January 2012.

22. See Le Corbusier, 'Le Tendenze dell'Architettura Razionalista', p. 127.

23. The author and date of this sculpture were discovered by art historian Cristiane Nascimento Rebello. Cristiane Maria Nascimento Rebello, *A Diana Adormecida do Museu de Arte de São Paulo: Um Caso da Estatuária Barroca*, MA Diss., Universidade Estadual de Campinas (Campinas, 1994). http://www.bibliotecadigital.unicamp.br/document/?code=000082039&fd=y, accessed January 2012.

24. Gio Ponti, 'Casa al parco', *Domus*, 263 (1951): pp. 28–33.

25. Angelo Lorenzi, 'Tre Interni Milanesi di Ignazio Gardella', in Maria Cristina Loi and Raffaella Neri (eds), *Anatomia di un Edificio* (Naples, forthcoming).

26. 'Museu de Arte: Esculturas', *Habitat*, 1 (1950): p. 31.

27. Bardi and Ferraz, *Casa de Vidro*, n.p.

28. Daniele Vitale, *'La Ciudad, el Museo, la Colección'*, in Aa.Vv., *El Museo* (Sevilla, Colegio Oficial de Arquitectos de Andalucía Occidental, 1990): pp. 330–47.

29. Federico Bucci, 'Spazi Atmosferici: L'Architettura delle Mostre', in Federico Bucci and Augusto Rossari (eds), *I Musei e gli Allestimenti di Franco Albini* (Milan, 2005), p. 20.

30. Franco Albini, 'Le mie Esperienze di Architetto nelle Esposizioni in Italia e all'Estero' (Venezia, 1957), republished in Federico Bucci and Fulvio Irace (eds), *Zero Gravity, Franco Albini: Costruire le Modernità* (Milan, 2006), pp. 75–7.

31. Juliano Pereira states that this sculpture protected the entrance of the exhibition in the same way the deity did in sacred spaces. Juliano Aparecido Pereira, *Lina Bo Bardi: Bahia, 1958–1964* (Uberlândia, 2008), p. 104.

32. In these museums the relationship between the architect and the museum director was important. An example of this is the dialogue between Franco Albini and Caterina Marcenaro in the Genoa museums; between BBPR and Costantino Baroni in the *Castello Sforzesco* museum in Milan; and between Carlo Scarpa and Licisco Magagnato in the *Castelvecchio* museum in Verona.

Negotiating Interiority: Displacement and Belonging in the 'Autoportraits' of Lydia Maria Julien

Harriet Riches

In attempting to grasp the exact nature of autobiography Timothy Dow Adams asks us to consider the question: 'if it's not nonfiction, and not exactly fiction, then what is autobiography's referential status?'[1] Hotly debated in the era in which post-structuralism proposed the 'death of the author', in the expanded field of life-writing the traditional autobiographer's claims to truth-telling have not only been questioned, but deliberately deconstructed to reveal their basis in performative acts in which fact and fiction merge.[2]

But by pointing to the instability of the enduring belief in its referential status, Dow Adams situates his discussion of that act within the parallel discourse of photography, a medium whose claim to indexical truth has since its earliest days been contested.[3] Yet, similarly, its own promise of intimate proximity with the world it represents persists as a seductive promise even in the digital era in which those links have been severed once and for all.

If the traditional painted self-portrait can be interpreted as a kind of visual equivalent to the textual autobiography, in which the necessary introspection of the genre is symbolized by the act of painting in front of the mirror, is it possible that a photograph, with its historical associations of automaticity and apparently neutral or cool observation really serve projects of solipsistic self-reflection? As Linda Haverty Rugg asks when considering the role played by photography in life-writing itself, does the inclusion of these images within the text work to shore up the destabilized belief in that text's referentiality through the self-image's 'presentation of the author's body in the world', or, conversely, 'undermine the integrity of referentiality through multiple or posed presentations'?[4]

When considered in isolation, a photographic autobiography independent of any textual equivalent further complicates the issue. When produced and mediated via the camera in an act in which the imaged subject must, for the

snapshot moment in which the shutter is clicked and the negative exposed, evacuate the authorial position behind the lens, it is perhaps difficult to consider the photographic self-portrait as an autobiographical act at all.

The unstable positioning of the photographic self-image between the potential of performative fiction and the integrity of reference has certainly troubled its theorization as a space of self-representation since the expansion of the practice in the nineteenth century. At a time when photography was appropriated as a useful prop in the construction of bourgeois subjectivity through the production and widespread mediation of ideas of normalcy and deviance through which certain ideals of identity were produced and stereotypes of less desirable ones constructed, the photographic portrait also contributed to new understandings of subjectivity produced within the strictly gendered spaces of Victorian society.[5] Unlike the institutional portraits littering the walls of the police department's Rogue Gallery, in which criminal identity was produced on the surface of the body, the middle-class portrait's 'auratic' composure lent its sitter a depth that emanated from a newly configured understanding of the subject's interiority.[6] Both a cause and effect of the portrait's affect, that 'aura' was inscribed in the temporal registration of the image – an effect that Walter Benjamin later celebrated in his nostalgic look back to the then obsolete early 'time exposure', whose temporal pause offered a moment of reflection that contrasted with the brevity of the industrialized form of the snapshot that superseded it.[7] For him, the quiet composure of the early photograph framed a moment in which, as he put it, the sitter was not excised 'out of the instant, but into it; during the long exposure they grew, as it were, into the image'.[8]

But it seems that when in a woman's hands, the camera often worked to disrupt these distinctions between surface identity and interior depth, and it was through the self-portrait in particular that the format's dual claims to referentiality and fiction became inextricably entwined. Photography's relative simplicity, ease of use and increasing mobility offered women (of a certain class and means) a tool of self-representation, one that could be practised within the home. At a time when the gendering of public and private spaces confined women's lives to the feminized domain of the privatized domestic interior as the stage-setting for the construction of self and attendant expectations of contemporary femininity, it provided the means to explore both.[9] From the fleeting materiality of the behind-camera presence of Clementina Hawarden's self-portraits (both actual and, as Carol Mavor suggests, projected through the desiring gaze upon her own daughters) to the fictional narratives cut-and-pasted together in Lady Filmer's montaged albums, the photographic 'self' emerges as the product of both depth and surface, both referential trace and artfully constructed fiction.[10]

It is a relationship that has endured; while self-portraiture as a genre has traditionally occupied a lowly position within the hierarchy of artistic

formats it remains both popular and compelling as a practice for women and for female artists. Particularly attractive to those disenfranchised by the masculine tenets of modernism and traditionally denied the voice and means to articulate a different 'self', the format continues to offer the means to tell previously untold stories of lives and identities on the margins. As such it is not only valuable as a form of expression, but as an object of study. Because, as feminist art historian Marsha Meskimmon suggests, it not only reveals the particularities of overlooked lives and marginalized identities, but also exposes the everyday 'mediation of the "self" in social signification' through which we might understand the 'very nature of subjectivity' and its production – and perhaps elision – in the act of representation itself.[11]

It is perhaps through photography more specifically that light can be focused on to that question. As a practice whose potential for multiple exposure and fractured quick-fire results has been interpreted as coincident with contemporary notions of subjectivity produced in multiplicity and through performance, photographic self-representation frames a space of alterity in which the very autobiographical act itself comes under pressure. How can photographic autobiography (or autobiographical photography) work to reveal the relationships between interiority and identity on which the genre depends?

This questioning of the relationship between the self and the camera, and the negotiation of interiorities – both physical and psychical – through which it is produced is a persistent issue in the performative photography of contemporary artist Lydia Maria Julien. A young Londoner of Afro-Caribbean descent, Julien draws upon her own life throughout her work, but in often obscure ways, offering only partial glimpses of that life's story. Although largely focused on the representation of her own body and image, Julien expressed surprise at hearing her photographs described as self-portraits; instead, she offered up the term 'autoportrait' to describe them. In a sense distancing her project from the conventional art historical genre of self-portraiture and instead relocating it within the literary tradition of written autobiography, it is an interesting term. Articulating a critical distance from the assumptions and tenets of the conventional 'self-portrait', the prefix 'auto' points both to subjectivity of the authorial subject, at the same time as invoking the 'automaticity' of the process of photography itself. In this linguistic naming, something of the problematic relationship at the heart of photographic self-representation is revealed. Conjuring both subjectivity and objectivity, fiction and referential truth, Julien's project of 'autoportraiture' suggests both connection and displacement to the self behind the camera.

A desire to exploit the camera's automaticity is revealed in Julien's working method's exploitation of the unpredictability of analogue film – what she describes as a 'nervous, anticipatory' process of blind performance and subsequent anxious development as she waits to see what her camera

11.1 Lydia Maria Julien, *Crossing*, 2006.

has captured.[12] That almost nostalgic attachment to a now all-but outmoded photographic technology is echoed in her continuing belief in its indexical status. While in a number of contemporary photographic practices there is emerging a desire to return to a pre-digital era in which something of the medium's early 'magic' might be re-found, Julien seems almost wilfully technophobic in her resistance to digital production in a way that reveals an unshakeable belief in its autobiographical potential. What is more, by often printing up just a single image from each of her series, Julien expresses a desire to hold on to the precious quality of the unique, hand-crafted image that somehow traces her touch, her own self. When asked why she refused to print up more, she said that to produce multiple editions would be to produce mere facsimiles in which she suggests there is 'nothing of myself left'.[13]

But throughout her work, the photograph's ability to give something *of* that self is repeatedly questioned. At times, an autobiographical narrative seems to appear, only later to unwind and unravel. For example, the thread of a conventionally linear autobiography appears central to Julien's exploration of identity in an early project entitled *Crossing* (Figure 11.1), produced as part of the group show 'Dream Landings' supported by Arts and Business East and the John Lewis Partnership Watford in 2006.

For this project, a number of contemporary artists interested in themes of belonging and national identifications were invited to reflect on the dreams and aspirations shared by immigrant families coming to Britain from all over

the world over the past century or so.[14] Originally conceived as part of Black History Month's celebrations, curator Jolanta Jagiello broadened its scope to include wider experiences of immigration and movement, and contributors from Poland, China, Bangladesh, African states and Afro-Caribbean origins were asked to narrate their personal experiences using pillowcases as their space of expression.

For her contribution, Julien chose to represent the story of her mother's journey from St Vincent to England in the early 1960s, a two-week sea voyage that ended on arrival into a bitterly cold Southampton one Christmas Eve – a journey that to the artist's twenty-first century sensibility in which the space and time of long distance travel has collapsed seemed almost archaic, a tale of endurance that she could only experience vicariously as it was handed down. Keen not to create 'just another diaspora story', or indeed to reclaim it as her own, Julien emphasized that vicariousness, displacing the narrative from the reality of the facts or 'truth' of her mother's memories and biography.[15] By combining her own words with photographs taken of a contemporary Southampton, herself, and her own London home, the story is re-imagined by the artist, and retold as a fragmented sequence of text and image – a sequence that reflects her imagining of her mother's voyage as a suspended temporality. Caught up in its duration, the journey framed a period of time in which fear and anticipation of the future fluctuated with a yearning for the just-distant past, in which time was endured 'oscillating between conscious verbalized expectations, aspirations of what would be once landed, to snapshots of the unconscious'.[16] Taking the form of small photographs stitched on to the surface of the pillow slips as if pages from the memory's own photograph album, the format of the work conjures the spaces of dreaming and unconscious desires – the places that, as curator Jagiello put it, 'you rest your head when you dream'.[17] Invoking a relationship between the spaces of the home, the 'not yet home', and the visual unfoldings of the unconscious, Julien's dream-scapes present a journey as snapshots of memory in which the past erupts in the visual screening of the present.

Read alone, the photographs cannot tell an autobiographical story, and if anything, seem to disrupt its flow and obscure its meaning, in so doing illustrating what for Walter Benjamin represented the powerful affect of the autobiography imagined not as a linear text, but as if a series of photographic snapshots.[18] His celebration of the political potential of the new visual medium to undercover the repressed underside of modernity's own 'optical unconscious' grew up alongside Freud's mapping of the topography of the psychic unconscious.[19] This too was dependent upon the contemporary currency of photographic metaphors, used to describe the spatiality, as well as the registration of temporality, through which subjectivity was imagined as another interiority defined in relationship to the exterior world of objects and others.[20]

For Benjamin, the photograph's ability to disrupt the present with the referential detail of the past through its absolute location both in time *and* space proved more adept to the telling of stories of selfhood forged in the past than a textual counterpart. In his own autobiographical texts the interplay of photography, memory and the spaces of his childhood are narrated through the photographic metaphors that constitute a visually remembered autobiography as dependent on the evocation of space as much as time's chronological unfolding. Not a linear sequence of events, but instead a series of fragments in which time and space collide in the meeting of interior and exterior worlds, Benjamin's identification of the superior impact of the 'reminiscence' over the fluidity of autobiography lends it a particular power. Mediated by acts of remembering imagined as images on the sensate surface of a photographic plate, the act of reminiscing ignites a series 'of spaces, of moments, of discontinuities' that are experienced in the 'moment of recollection', in the fleeting irruption of flashes of the past in the present.[21]

Julien makes use of a similarly fragmented format here in her own photographic autobiography; the threads of her autobiography are multiple and far from linear, made up of a series of almost abstract photographic recordings of a city nearly 50 years after her mother's arrival, interspersed with images of her own body in her own home. The origins and endings of the story remain unresolved, reflected in her focus not on the ever-receding horizon of the sea, but on the ropes and cables of the port's dockside, the grid-like geometry of the tower blocks' grey façades that add up to a tangled web of crossed lines leading nowhere. In fact, there is little attempt to tell her mother's 'real' story at all. Through the artist's re-telling in her own words, her mother's story is claimed as part of her own autobiography, but displaced, altered, and re-imagined: echoing the displacement of the immigrant's journey that displacement points to a dead end or the impossibility of tracing roots to a lost homeland. Embodying here Stuart Hall's assertion that for each successive diasporic generation there is scarce possibility of a return to 'origin' – as lived 'placed', rather than geographical space – because it does not and can never exist, Julien's fragmented autobiography works to place that imaginary place out of reach.[22] Instead, identity can only be produced in the points of intersection and crossing – a contingency that is echoed here in the photographs' emphasis on the abstracted dynamism of intersecting vectors and juxtapositions of unspecified interior and exterior space, rather than on the unvisualized places and invisible absences to which these lines once promised to connect. Rather than a neat linear thread reaching back in time then, Julien's 'autobiography' is presented here as a series of lateral loose ends caught up in a complex nexus of transient relationships.

What emerges here, then, is not a narrative of not belonging, but of being out of place, the various immigrant artists' stories of displacement surely heightened by the project's domestic siting on the pillows and beds of

John Lewis Watford's linen department – *the* cosy womb in which middle-England's identity is forged and played out everyday.

It is that 'not belonging' that reappears in later work, in which Julien explores the relationship of identity to the interior by investigating 'society and its spaces' as the sites in which subjectivity is formed and re-formed throughout life.[23]

At times, those spaces are markedly domestic, although rarely comfortable. In the large-scale untitled photographs that made up her Masters degree show at Central St Martins in 2007, the artist appeared as just one material object amongst a host of others, her body threatening to merge with the myriad surfaces and things that made up the interior of her own home. More uncomfortable still was her contribution to the Market Estate Project, Islington in 2010 in which artists were invited to occupy the evacuated flats of a soon to be demolished housing block.[24] In her allocated spaces – some of which were left pristine as if ready to be occupied once again, while others retained the detritus of the building's hastily abandoned life – Julien performed for her camera before photocopying the resultant prints and pasting them to create a ghostly wallpaper decorating the flat's now empty walls. Each shot more faded than the last, her gradual disappearance traces a narrative of erasure that echoes the ongoing physical disconnection of each home from its previous inhabitant and eulogizes its loss.

But far from evoking the cosy comfort we associate with the domestic interior, the close juxtaposition of the artist's skin against its uncomfortable bared surfaces adds to the sense of discomfort. And although it is not her own story told here, by exploring with her own body the limits of this defamiliarized space, Julien's performative acts emphasize the intimate dependence of the body on its environment through which the self is defined – and de-formed. As Sidonie Smith suggests, although autobiography might seem to rely on memory and time, it is just as dependent on its production in space; 'subjectivity', she points out, 'is not, after all, an out-of-body experience'.[25] The body's relationship to the world outside its own borders is integral to the creation and maintenance of any notion of interiority; here, Julien's performative photographs frame a sense of displacement and alienation that evokes a conflation of the *unheimlich* in which the familiar and the unfamiliar become turned in upon each other.

But it is in Julien's use of institutional spaces that the interior's role in the inscription of identity and production of subjectivity becomes most apparent. Central to two projects staged within the back rooms and usually hidden spaces of London's National Portrait Gallery and the Courtauld Institute of Art, the institutional interior is revealed as a powerful one in which identifications based on class, race and gender are revealed in the many parallel lives lived out within its walls.

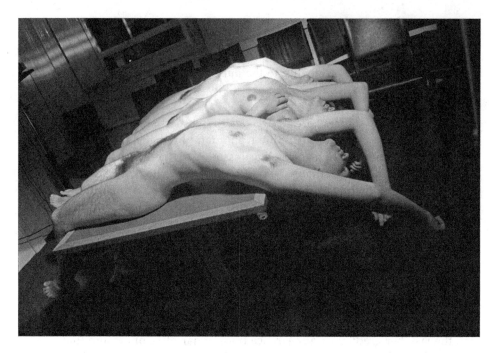

11.2 Lydia Maria Julien, *En Stasis*, 2007.

In one, so integral was the interior's relationship to the self felt to be, Julien could not appear at all within its space. Installed as part of the Courtauld Institute's 'East Wing 08', a biennial group show whose origins lie in attempts to introduce living, breathing contemporary practice into the daily life of an institution more usually associated with the study and preservation of its history, Julien's response spoke more of its deadening weight. With the title *En Stasis* (Figure 11.2) Julien chose to photograph a group of young models within the darkened interiors of the Institute's teaching rooms, posed naked in the poses found in police photographs of murder scenes. More dead than alive, by striking poses unnatural in life their awkwardness contrasted with the carefully contrived grace of art historical convention on display in the public galleries next door.

The models' discomfort was intentional, a punishment even, provoked by Julien's personal discomfort within the space. She felt alienated: on meeting the commissioning panel, she felt an acute sense of 'not belonging', with no shared history or intimate connection to the space in which she planned to perform. In sharp contrast to the panel's own sense of ownership of the interior as they led her through its warren-like rooms and up its ceremonial staircase, Julien's unease provoked a deviation from her own usual practice. So, by using the panel as her models instead of herself, Julien attempted to

disrupt their self-possession. Shooting them at night, their easy occupation of space was quickly destabilized in the interiors so familiar during daylight hours; and drawing on her own experience of the physical endurance of life-modelling, Julien asked her models to hold their pose for quite some time. Not quite long enough to feel pain, but long enough to experience their bodies, they became hyper-aware of its relationship to the interior – the disproportionate heat of limb as it seemed to dislocate itself from the totality of the body, the pressure of a corner digging into flesh, the almost unbearable nylon scratch of the office-grade carpet's static fuzz against bared skin.

Lifeless and mannequin-like, the bodies were subjected to the institutional gaze bearing down upon them – a gaze that mediates not only the disciplinary power of the historical and educational institution in which the work was performed, but also the weight of the art historical discourse purveyed within its walls. As an institutional critique, Julien's victims were fixed and subjugated by her camera, a performance of the internalization of the disciplinary eye of power through which, as Foucault has described, we are all remade as docile bodies.[26] Her own inability to perform within its spaces is testament to its power; through her absence Julien's performative photography projected the alienating gaze on to her models – substitute selves who retained the trace of that power, and the artist's experience of difference provoked by the institutional space.[27]

Condemning them to undergo the uncomfortable process of photographic objectification she more usually experienced herself, the black, female artist's absence contrasts with the insistent visceral experience of what she described as the well-spoken, thin, tall white bodies that she photographed here – body-subjects whose difference from herself represented, as she put it, 'everything I am not'.[28]

But in *WNPG06* (Figure 11.3), Julien reappears as a marginal yet persistent presence that seems to linger in the interior, on its margins and between its thresholds. As another project of institutional critique, this project differed from *En Stasis*, as it was staged in a space with which Julien was familiar, having worked for years in the National Portrait Gallery – in its shop. As a worker employed in the institution's commercial function rather than a professional involved in the preservation or curating of its cultural heritage, Julien described an ambivalent relationship with the space as she negotiated daily the shifting borderlines between its outward-looking public face and the inner workings of its privatized bureaucratic and academic interiors.

To work within the retail arm of such an institution is almost to experience a public space within the private space of the interior, a duality that Julien experienced through the parallel lives of the congruent spaces as they were played out at different times. She described feeling at times utterly invisible,

11.3 Lydia Maria Julien, *WNPG06*, 2008.

like an overlooked servant standing aside so as to remain unseen by the eyes of royalty; at others, more at ease and intimate with the empty corridors she was privileged to wander along out of hours.

In photographing herself, she attempted to reconcile these diverse relationships to the same interior, reclaiming spaces out of bounds to the visitor, the back room offices and studies upstairs that contrasted with the public spaces of the metaphorical 'below stairs' areas that formed the usual limits of her domain. Stripping off and performing for the camera, Julien attempted to become visible in the spaces – the offices of curators and picture researchers – in which she felt her presence (and that of others like her) was overlooked. Defying invisibility, her half-naked, working, artist's body is a transgressive presence.

But, captured with a long lens, that presence is ambiguous, one that appears throughout the series of 16 photographs as a persistent but somehow floating trace that both disrupts the recession of the interior's *enfilade* organization, while also threatening to become 'part of the furniture' of the institution's daily life. Little of the autobiographical 'self' is revealed. The photographic subject remains unclear, in that through a strategic negotiation of the camera's gaze it eludes being pinned down, and so defends against the institution's role in inscribing stereotypes of identity upon the working body moving through its spaces in daily life. Julien emerges and recedes, stands out and is re-absorbed, difficult to see at first and just as easy to miss.

It is in these moments of disappearance and re-emergence that Julien's project of autoportraiture might reveal something about the nature of photographic self-representation, and its relationship to subjectivity itself. All photographic self-portraiture (unaided by a mirror) registers the momentary evacuation of the authorial position behind the camera in order to take up position within its visual field: here, Julien's performative act is no different, although the relatively lengthy distance from the lens speaks of a hurried shuttling back and forth that dramatizes the transition from subject to object under its gaze. Illustrative of the splitting of the self engendered

in the photographic logic of Benjamin's own autobiographical acts in which the subject remembering in the moment of the present can only ever access the past self as an objectified image seen from the outside rather than felt or remembered from within, Julien's autoportraits articulate a similar gap into which any promise of referentiality can only disappear.

Dependent upon a necessary absence, the act of photographic self-representation can only refer to a displaced subject. Always split and alienated, both seeing subject and seen object experienced as if from the outside of the self, this autobiographical referent cannot be pinned down. Julien remains a slippery subject, her acts of autobiography refusing to add up to form a seamless narrative. There is no authorial voice, no master narrative, no historical unfolding. As such, her 'autoportraiture' might be interpreted within a historical trajectory of women's self-representation that Estelle Jelinek argues has often defied modernism's teleological narrative through practices of life-writing that are not 'chronological and progressive but disconnected [and] fragmentary'.[29] In its fractured and repetitive form with no sense of conclusion, the elements of the Juliens's series resist such a linearity, instead evoking Benjamin's construction of a self only ever revealed in the flashes and fragments produced in spaces of memory in which self and other, and past and present converge. As she transgresses its thresholds and explores the liminal borders in which the institutional interior's own parallel lives converge, Julien's 'self' emerges as only the trace of that spatial encounter. Defying the photograph's claims to both autobiographical reference and fiction, the act of autoportraiture instead frames the impossibility of its representation, of ever capturing the fleeting flashes in which interior and exterior collide and from which interior life begins to emerge.

Notes

1. Timothy Dow Adams, 'Introduction: Life Writing and Light Writing: Autobiography and Photography', *Modern Fiction Studies*, 40/3 (1994): p. 460.

2. See for example, Roland Barthes, 'The Death of the Author', in Roland Barthes, *Image – Music – Text*, ed. and trans. Stephen Heath (New York, 1977).

3. Dow Adams, 'Introduction', pp. 459–92. See also his subsequent book *Light Writing & Life Writing: Photography in Autobiography* (Chapel Hill NC and London, 2000). A key critique of photographic indexicality is Joel Snyder, who argues that all photographs should be read as pictorially conventional. See his argument in James Elkins (ed.), *Photography Theory* (London, 2007).

4. Linda Haverty Rugg, *Picturing Ourselves: Photography and Autobiography* (Chicago, 1997), p. 1.

5. The relationship of photography to the construction of bourgeois identity is central to Allan Sekula's argument mapping of the 'honorific' and 'repressive' functions of photographic portraiture during this period. See 'The Body and the Archive', *October*, 39 (Winter 1986): pp. 3–64.

6. A compelling discussion of issues of surface and depth are developed in relation to Benjaminian auratic aesthetics by Shawn Michelle Smith, in her *American Archives: Gender, Race and Class in Visual Culture* (Princeton NJ, 1999).

7. Walter Benjamin, 'A Short History of Photography' (1931), reproduced in Alan Trachtenberg (ed.), *Classic Essays on Photography* (Stony Creek, 1980), pp. 199–215.

8. Benjamin, 'A Short History', p. 204.

9. See Carol Mavor's poetic reflection on Hawarden's photography *Becoming: The Photographs of Clementina, Viscountess Hawarden* (Durham, NC, 1999). The relationship between femininity, women's photography, and the domestic interior has been explored by a number of art historians informed by feminism, most notably by Carol Armstrong in 'From Clementina to Käsebier: The Photographic Attainment of the Lady Amateur', *October*, 91 (2000): pp. 101–39, and *Scenes in a Library: Reading the Photograph in the Book, 1843–75* (Cambridge MA, 1998); Lindsay Smith, *The Politics of Focus* (Manchester, 1998); and Patrizia Di Bello, *Women's Albums and Photography in Victorian England* (Aldershot, 2007).

10. For a compelling discussion of Lady Filmer's albums, see Patrizia Di Bello's chapter 'Photographs, Fun and Flirtations', in *Women's Albums*, pp. 107–37.

11. Marsha Meskimmon, *The Art of Reflection: Women Artists' Self-Portraiture in the Twentieth Century* (New York and Chichester, 1996), p. 64.

12. Artist's statement, 'Remarkable and Curious Conversations', online at: http://www.remarkablecurious.co.uk/lydia-maria-julien.html, accessed February 2012.

13. Lydia Maria Julien, interview with the author, 10 May, 2010.

14. For information including an interview with the curator Jolanta Jagiello see the project's website at http://www.watfordjunction.org.uk and http://www.watfordjunction.org.uk/page_id__43_path__0p3p19p.aspx, accessed February 2012.

15. Julien, interview with the author, 2010.

16. Lydia Maria Julien, artist's statement, http://www.watfordjunction.org.uk/page_id__69_path__0p12p20p.aspx, accessed February 2012.

17. Jolanta Jagiello, http://www.watfordjunction.org.uk/page_id__43_path__0p3p19p.aspx, accessed February 2012.

18. See Linda Haverty Rugg's analysis of Benjamin's autobiographical writings as they appear in *Berlin Chronicle (Berliner Chronik)* (published in Michael Jennings, Howard Eiland and Gary Smith (eds), *Walter Benjamin: Selected Writings, 1931–1934* (Harvard, 1999), pp. 595–637, and *Berlin Childhood Around 1900 (Berliner Kindheit um Neunzehnhundert)* (Cambridge MA, 2006), in her *Picturing Ourselves: Photography and Autobiography* (Chicago, 1997), pp. 133–229. Benjamin's use of photographic metaphor is also explored in David Darby, 'Photography, Narrative and the Landscape of Memory in Walter Benjamin's Berlin', *The Germanic Review*, 75/3 (Summer, 2000): pp. 210–26.

19. Benjamin, 'A Short History of Photography', p. 203.

20. These photographic metaphors are particularly evident in Freud's work on memory and the topography of the unconscious in 'The Unconscious' (1915), and 'Note on the Mystic Writing Pad' (1925).

21. Benjamin, 'Berlin Chronicle', in Jennings et al. (eds), *Walter Benjamin*.

22. See Stuart Hall, 'Cultural Identity and Diaspora', in Nicholas Mirzoeff (ed.), *Diaspora and Visual Culture: Representing Africans and Jews* (London, 2000), p. 32.

23. Julien, interview with the author, 2010.

24. For details of this project, see www.marketestateproject.com, accessed February 2012.

25. Sidonie Smith, 'Identity's Body', in Kathleen Ashley, Leigh Gilmore and Gerald Peters (eds), *Autobiography and Postmodernism* (Amherst, 1994), p. 267.

26. Michel Foucault, *Discipline and Punish: The Birth of the Prison* (New York, 1977). His discussion of the institutional 'gaze' is elaborated in 'The Eye of Power' (1974); see Michel Foucault, 'The Eye of Power', in C. Gordon (ed.), *Power/Knowledge: Selected Interviews and Other Writings, 1972-1977* (New York, 1980), pp. 146–65. David Green has used Foucault's theories in his analysis of photography, for example in 'On Foucault: Disciplinary Power and Photography', in Jessica Evans (ed.), *The Camerawork Essays: Context and Meaning in Photography* (London, 1997).

27. John Tagg's ground-breaking work on the effects of a photographic gaze on the construction of modern identity and subjectivity is explored in his *The Burden of Representation: Essays on Photographies and Histories* (Minneapolis, 1988).

28. Julien, interview with the author, 2010.

29. Estelle Jelinek, *Women's Autobiography* (Bloomington, 1980), p. 17.

The Private Self: Interior and the Presenting of Memory

Vesna Goldsworthy

Louise Bourgeois: Memoir of Homesickness

Yes, the feeling of being trapped … and the theme of escape … On the one
hand you are trapped by the past, and there is nothing you can do about it
except running from it … The art comes from those unsatisfied desires.[1]

In January 2008, I surprised myself by crying inside one of the Cells
installations at the Tate Modern's Louise Bourgeois Retrospective. The
narrow spaces Bourgeois creates in this particular work possibly seemed
claustrophobic to most visitors. They hint at 'rooms which enforce solitary
confinement, such as prison cells, as well as rooms which provide private
thinking space, such as bedrooms or monks' cells'.[2]

My 'breakdown' was the culmination of a gradual epiphany which
began outside the gallery, in front of the sculpture of an enormous black
spider in the forecourt (Figure 12.1). I knew little of Bourgeois's work.

The spider figure seemed abject and mysterious, but I was drawn to it.
Because of its title – *Maman* – I assumed that the sculpture represented
some predatory maternal principle (the Black Widow), yet the intimacy
of the title ('Mummy' rather than 'Mother'), made me respond to it with
protective anxiety. Passing children reacted to it with gasps of repugnance,
as though it was something from a science fiction movie, but the creature
was also sublime and willowy, starkly outlined against the whiteness of
the birch trees planted in neat rows in front of the gallery. I remembered
the birch sapling I planted with my father in front of our house in the
summer of 1973: the tree was now two stories high. At night, when
the windows were open, its shiny leaves rattled in the wind like coins
in a jar shaken by a distant hand. The same noise now echoed in front
of the Tate.

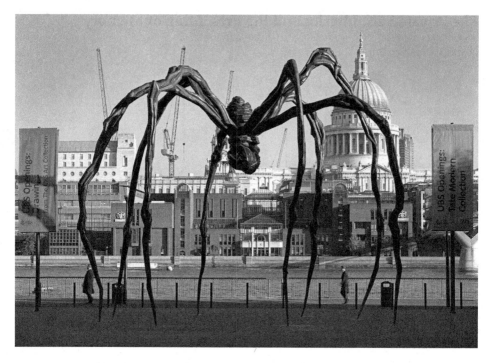

12.1 Louise Bourgeois, *Maman*, 1999. Installed at Tate Modern, London in 2007.

I grasped the significance of the spider-mummy only when I entered the cell which represented Bourgeois's reconstruction of the workshop in which her mother used to repair fabric in their family tapestry restoration business. Bourgeois's mother, who died in 1932, when her daughter was 21, was that oldest of female archetypes, a weaver, like Penelope. She was a woman who makes a home and stays in it, the mother you have to abandon yet can never leave.

Threads of equation between the female body, the home and the maternal principle are everywhere in Bourgeois's work. We find them in her sculpture and in her paintings. *Femme-Maison* (*House-Wife*) for example depicts a body of a creature who is half woman, half house. In creating a woman bound to the home, a house-wife, a spider-mummy, Bourgeois addresses a universal feminine, while also articulating an autobiographical anxiety.

I cried because I identified with the artist as another daughter who leaves home – who refuses to be Femme-Maison – but also because I felt the ambivalence inherent in maternal representation. My own mother used to cover every surface in my childhood home with crocheted mats which resembled circular spider's webs. She used the crochet to relax, to keep at bay

the depression to which she was prone. Those elaborate webs of cotton were culturally significant. In the Yugoslavia of my childhood naked tables were socially unacceptable, and 'shop-bought' coverings were considered inferior to handmade ones. The doilies embodied my mother's petty-bourgeois taste, which I both disparaged and felt protective of.

When I moved to England in 1986, Mother offered her crochet work as one of many parting gifts. I could take as many pieces as I like, she said. I politely refused. The delayed guilt of that refusal was working its way up my throat from the moment I began to grasp the meaning of the spider to the threshold of the Cells. The symbolism somehow made it easier to relate to than any realistic portrait of Bourgeois's mother might have done. The arachnid hinted at the oppressive but never fully articulated role depression played in my relationship with my mother, and spoke of threads and connections which were, for me, still sticky.

Clearly, in moving to England, I was choosing clean slates, new interiors, better taste. But what was I refusing in turning down my mother's gift? Was it my mother's version of femininity (I left, she stayed, a 'House-Wife') or my mother's depression? I had refused to recreate my mother's ideal interiors, yet here, against the brick solidity of Tate Modern, I missed her elaborate crocheted rings.

The Double Bind of Memory

In an often quoted definition of the autobiographical genre, Philippe Lejeune explains that autobiography is 'a retrospective prose narrative produced by a real person concerning his own existence, focusing on individual life, in particular on the development of his personality'.[3] The autobiographer's pact with the reader – to tell the truth of his or her own life – removes the intermediaries of character and story inherent in fictional writing. Instead of the triangle 'author-narrator-reader', there is a straight line; in autobiography, the author and the narrator are – supposedly – one and the same. The performance of intimacy which this direct address implies is one of the essential elements in autobiographical writing.

The practical implications of this assumption became clear to me while I toured with my memoir, *Chernobyl Strawberries*, after it was published in English in 2005. The intimacy with the reader, imagined in the process of writing (one critic likened the experience of reading my book to a 'wonderful, slightly drunken, tête-à-tête with a new friend')[4] became tangible in these public readings. People I had never met approached me at book signings as though they were long-lost friends. They had every reason to feel a sense of kinship: they knew the details of my life which were unfamiliar to people I had known for years.

Chernobyl Strawberries tells the story of an ordinary person growing up in Yugoslavia in the 1960s and 1970s. It contains no revelations of dark secrets I needed to feel anxious about. (I have none.) Neither did I have to worry about any political implications of my writing. While my country of birth has disintegrated in a series of bloody wars since I left a quarter of a century ago, my book depicts it bathed in a warm sepia glow of nostalgia. I feel more homesick for my vanished youth than for the place itself, though I loved the place too.

What I did worry about is the reality of the people depicted inside the book. It concerned some of those closest and dearest to me, members of my family and my friends. I was taking thousands of visitors inside their homes. *Chernobyl Strawberries* does not focus on a public life or a glitzy career. I would have precious little to write about if that were the case. Rather, the 'front line' here was domestic. Depicting the life of one family against the backdrop of a fast disappearing world, my book dwells on the interior, inside the home. In communist and socialist societies, with their varying degrees of repression, the private sphere was the place of resistance and often subversion, and this seemed to me more interesting than any public spectacle.

It was while reading from *Chernobyl Strawberries* and taking questions from the audience that I became aware of the double bind of the autobiographical genre. This concerns the continuing life of my 'characters' off the page versus the fixity of memory, the shape of which my 'characters' may not have agreed on in the first place. The most likely question the readers of autobiographical work tend to ask is one which does not trouble a novelist: 'What is so-and-so doing nowadays?' The ongoing life of the 'characters' outside the book means that the boundaries which need to be protected continue to multiply.

At the same time, once written down, memory becomes fixed and unchangeable. Mikhail Bakhtin rightly observed that memory consists not only of itself but of each subsequent recollection of it.[5] The memoir freezes the memory and cuts it off from those subsequent accretions. In addition, it does not so much represent the past as substitute it with an edited version of itself. It is both the representation of a life and an interpretation of it. As a text, the memoir is not mimetic but symbolic. Like a photograph, it replaces memory, a dynamic process of signification, with a fixed, metonymical procession of signs, more or less carefully selected by the author for the specific purpose of revelation as a performance art.

The performance of 'revelation' yields a collection of ordered snapshots. Even when the memory is photographic, its relationship with reality is as complex as that described by Roland Barthes in *Camera Lucida* in relation to the photograph. We take the photograph as a document, as authentication of reality, but Barthes talks about it as a 'temporal hallucination': 'Photography, in order to surprise, photographs the notable, but soon, by a familiar reversal,

it decrees notable whatever it photographs.'[6] Whatever a memoir chooses to depict becomes notable by the act of depiction.

My ordinary self, my ordinary home, become simultaneously extraordinary in the literary process which enshrines them as worthy of depiction, and more ordinary than I deem them to be, in that I come to represent a group/a nation/a community. The memoir is both representational and representative. I become unique by declaring myself typical. *Chernobyl Strawberries* may be a private story of an individual inside a family, yet I cannot but be aware that an individual story, once written in English, becomes an act of witnessing on behalf of a community to which I myself may or may not feel I belong: it becomes an 'ethnic' memoir.

The Inward Turn

An interest in the private self characterizes contemporary culture as profoundly as the commemoration of public life marked the Victorian age. Evidence of 'self-obsession' is all-pervasive: in the press, in publishing, in reality television and in chat shows, and in the predominance of explicitly autobiographical elements in contemporary art. We are not only gripped by celebrity lives but are just as prurient about the lives of the so-called 'ordinary' people, particularly when they are rendered extraordinary by their behavioural excesses. It seems that – as if to compensate for alienation from the communities we once lived in (neighbourhoods, temples or tribes) – we expect to be taken ever further 'inside', into the homes, minds, hearts and often the bodies of people we may not know personally, but who are willing to perform ever more self-revealing acts.

While the popularity of literary fiction is allegedly in decline, autobiographical non-fiction dominates bestseller charts in an expanding range of permutations and subgenres which now include illness memoirs ('sick-lit'), tales of abuse and deprivation ('mis-lit'), and celebrity life stories ('sleb-lit'). The self is similarly exploited in the gallery space. Lives, faces and bodies of artists – including the most intimate parts – are the mainstay of contemporary art. We know the faces – and often considerably more than the faces – of Marina Abramović, Grayson Perry or Gilbert and George, whereas we would not necessarily have recognized Francis Bacon, Barbara Hepworth or James Whistler. We are as familiar with the details of Tracey Emin's biography as we are with her artwork.

Indeed it is often difficult to draw the dividing line between the work, the body and the life. Mark Quinn's eponymous 'Self' represents a sculpture of the artist's head made from four and a half litres of his own, frozen blood, a project Quinn has been repeating at five-yearly intervals since 1991. In this self-referential, solipsistic work, the body provides both the

theme and the material for self-commemoration. Equally self-referential is Mona Hatoum's *Corps Etranger* (1995), a Turner Prize nominated video installation in which Hatoum takes the camera through the passages of her own body.

A full inward turn has been accomplished in less than a century: we have moved from the outward didacticism of Victorian autobiography to the full confessional mode of contemporary 'lives', whose subjects feel disadvantaged if they have no dark history to divulge; from the stately marble surfaces of Lord Leighton's sculptures to the 'Naked Shit Pictures' of Gilbert and George, which show not only the artists's bodies in their spread-eagled nudity, but also the microscopic images of all their fluids and excretions. How much further can self revelation take us?

Why did this inward turn happen? Arguably, one of the crucial moments was in the early decades of the twentieth century arising from the work of the Bloomsbury Group, with its twin heritage in visual arts and in writing, and its 'new' lifestyle defined by friends and lovers rather than political party, church, regiment, business or even family. Their work in literary (auto) biography, interior design and visual arts was matched by their highly visible and sometimes scandalous domestic arrangements and liberated lifestyle, offering ample nourishment for celebrity preoccupations in the form we know them today.

In effecting this turn, Bloomsbury selfhood became inseparably enmeshed with the Bloomsbury 'look'. The home interior is the central trope of the Bloomsbury self. It embodies the change which is taking place as the Group moves, metaphorically and physically, from Kensington and Bayswater to Bloomsbury. In that move, the parental home is exposed and symbolically destroyed. While the Victorian façades are removed and the stuffy Victorian interiors opened to unforgiving scrutiny in a series of highly polemical works, the newly created interior becomes both an expression of the new self and a clean slate for its construction.

The Heart of Darkness: Journey Into the Interior

In their written form, Victorian 'lives' were defined by public office and the performance of public duty, and they were, as a consequence, predominantly male. Women's lives were deemed less worthy of record because they were confined to the domestic sphere. Assumptions of their irrelevance remained unchanged well into the twentieth century. 'Who am I that I should be asked to read a memoir?', Virginia Woolf agonized when she was asked to present something of her own life before the Memoir Club, a Bloomsbury forum for autobiographical readings established in 1922: 'A mere scribbler; what's worse, a mere dabbler in dreams … My memoirs, which are always

private, and at their best only about proposals of marriage, seductions by half-brothers, encounters with Ottoline, must soon run dry'.[7]

In a way which has now been radically reversed, to a significant degree by her own work, Woolf assumed, whether genuinely or rhetorically, that her private, and female, memories were less significant than the public works of her male colleagues in the Bloomsbury Group:

> I am not the most widely lived or the most richly memoried. Maynard, Desmond, Clive and Leonard all live stirring and active lives; all constantly brush against the greats; all constantly affect the course of history one way or another. It is for them to unlock the doors of their treasure houses and to set before us those gilt and gleaming objects which repose within.[8]

The 'treasure houses' of Desmond MacCarthy's, Clive Bell's and Leonard Woolf's lives, with their public achievements, are now half-forgotten, while Woolf's own life fuels a publishing industry. Leonard Woolf is remembered mainly as her husband. Even Virginia's own work fades before her biography. Accounts of her mental and eating disorders, sexual abuse, lesbian affairs – those 'seductions by half-brothers' and 'encounters with Ottoline' she teasingly claimed to be uninteresting – and in particular the details of her suicide, are familiar to many who have never read a line of *Mrs Dalloway* or *Orlando*.

If a shift of emphasis from collective to individual identity has been at the heart of the enlightenment project as it evolved from the eighteenth century onwards, then – within it – the spotlight moves from the public to the private self in the early twentieth century, and this move affects male lives as profoundly as female ones. The relocation is perhaps most clearly illustrated by the birth of psychoanalysis and its subsequent impact. Some cultural critics, most famously Christopher Lasch, go as far as to see the current cultural moment as the dead end of individuality, and call it the 'culture of narcissism'.[9]

In so far as it is possible to ascribe the shift of attention from public to private, it is clear that Bloomsbury played a major role. Lytton Strachey's iconoclastic *Eminent Victorians* (1918) reinvented the biographical genre by demolishing the façade of the Victorian public persona in a series of irreverent sketches of some of the nineteenth-century's best known figures. In her essay 'Mr Bennett and Mrs Brown' (1923), Virginia Woolf famously hazarded the assertion that 'on or about December 1910 human character changed'.[10] Hers was an attack on the methods of external characterization employed by Edwardian novelists such as H.G. Wells, John Galsworthy and Arnold Bennett, but also a programme for a new style of writing with characterization based on consciousness, emotion and intimacy. Although supposedly dealing with the novel, Woolf's essay identifies a change in the notion of selfhood in general.

As I argue in 'The Bloomsbury Narcissus',[11] the Bloomsbury Group's way of seeing the self and its meaning – framed by sensibility and sexuality rather than faith, obligations, family responsibilities, the creation of wealth and the performance of public duty – has been one of the major influences on contemporary ideas of identity and self-fulfilment. The group's reaction against Victorianism, and in particular against the Victorian 'lives', as represented by the work of Virginia Woolf's father Leslie Stephen, editor of the Dictionary of National Biography, is best reflected in the series of intimate, irreverent memoir pieces which were produced to be read in the gatherings of the Memoir Club. Virginia Woolf's '22, Hyde Park Gate', and Lytton Strachey's '69, Lancaster Gate', two of the most famous of these short sketches, belong to the genre Victoria Rosner has defined as 'household memoir'.[12]

The immediate connection these two pieces make between interior and interiority is telling. Where the Victorians focused on outward appearance and propriety, Woolf and Strachey's taboo-breaking pieces describe the rich detail of household interiors in order to reveal the family secrets behind the Victorian facade. As if into 'the heart of darkness', they lead us deep into the Victorian home, passing quickly through decorous reception rooms into the kitchens, bedrooms and bathrooms. Tellingly, both end by throwing open the bedroom door to reveal scenes of scandalous sexuality. Strachey casts his uninhibited homosexual gaze over the naked body of his sleeping 19 year old cousin (although he claims satisfaction at the absence of any sexual desire at that particular moment, his acknowledgement of the possibility of desire would have been shocking enough). In Woolf's piece, George Duckworth throws himself into the bed of Virginia (his half-sister) and forces himself on her: 'Yes, the old ladies of Kensington and Belgravia never knew that George Duckworth was not only father and mother, brother and sister to those poor Stephen girls; he was their lover also.'[13]

Like the rooms of homes whose external walls were demolished in the Blitz – as was Woolf's own in 52 Tavistock Square – the two writers expose childhood interiors to outsiders' gaze in a way which is both brutally analytical and unsentimental. The spotlight thrown into the recesses of rooms enveloped in mounds of plush and velvet, 'naturally dark and thickly shaded in summer by showers of Virginia creeper',[14] shines a merciless light on Victorian hypocrisies and pretensions. The dirt therein is both real – 'packets of dirt' and smells of sewage permeate the Stracheys' enormous and uncomfortable residence in Lancaster Gate – and metaphorical (incestuous desire, homo- and heterosexual). Simultaneously enormous and claustrophobic, these houses are representative of the decaying societal and family structures of Victorian Britain.

The 'interior' is unsurprisingly a key trope of their representation. Its 'demolition work' has to be carried out before the move to Bloomsbury, where

the new walls are whitewashed and the windows opened to the world. Again, the interior is both a physical and a metaphorical theatre of change:

> To begin with it was astonishing to stand at the drawing room window and look into all those trees … The light and the air after the rich red gloom of Hyde Park Gate were a revelation. Things one had never seen in the darkness there – Watts pictures, Dutch cabinets, blue china – shone out for the first time in the drawing room at Gordon Square … To make it all newer and fresher, the house had been completely done up … Needless to say the Watts-Venetian tradition of red plush and black paint had been reversed; we had entered the Sargent-Furse era; white and green chintzes were everywhere; and instead of Morris wall-papers with their intricate patterns we decorated our walls with washes of plain distemper. We were full of experiments and reforms.[15]

Just as Strachey and Woolf's writings often depicted the interior space, so the paintings by their fellow artists in the Group – Vanessa Bell, Roger Fry and Duncan Grant – captured Bloomsbury interiors. Portraits and interiors which depict walls with other interiors or other portraits represent a typical circle of Bloomsbury self-referentiality and *mise-en-abyme*. The 'experiments and reforms' relate to the new Bloomsbury aesthetics in interior design, but also to private life. As Victoria Rosner argues, 'it was interior design and not architecture that articulated a visual and spatial vocabulary for describing the changing nature of private life':

> As the canons of morality and behaviour shifted the designed environment of the home both reflected and helped give shape to what Woolf describes as the new tone of 'human relations', 'between masters and servants, husbands and wives, parents and children'.[16]

This 'new tone' pushed the boundaries of socially acceptable conversation deep into the realm of sexuality. Once again Lytton Strachey stands at the threshold of change, and once again that threshold is both physical and a metaphor:

> I talked, egotistically, excitedly, about my own affairs no doubt. Suddenly the door opened and the long sinister figure of Mr Lytton Strachey stood on the threshold. He pointed his finger at a stain on Vanessa's white dress.
>
> 'Semen?', he said.
>
> Can one really say it? I thought and we burst out laughing. With that one word all barriers of reticence and reserve went down. A flood of the sacred fluid seemed to overwhelm us. Sex permeated our conversation. The word bugger was never far from our lips. We discussed copulation with the same excitement and openness that we had discussed the nature of good.[17]

Such compulsively uninhibited discussion is one of the key traits of Bloomsbury modernity. The group's aesthetics and its lack of sexual

inhibition have been equally influential. The Bloomsbury influence – its whitewashed walls and dirty conversations – has exerted a lasting change on the way we live now. That taboo-busting talk on that Bloomsbury threshold is the all-pervasive subject-matter of our confessional age.

The link between the recreations of interiors in the work of the Bloomsbury Group and contemporary artists has been hinted at elsewhere.[18] It is found in an ambivalence about the home, a kind of mourning which echoes in the circle of escapes and returns, demolitions and recreations. We find it at work in Louise Bourgeois's *Cells*, in Rachel Whiteread's 'negative spaces', or in Tracey Emin's Tent (*'Everyone I Have Ever Slept With'*), but, surprisingly, it is also strongly present in the painstaking replications of Michael Landy's working-class *Semi-Detached*.

Michael Landy: *Semi Detached*

'Nothing reminds me of home', I write in *Chernobyl Strawberries*. It is, of course, a paradoxical sentence. Repeat it several times and it turns into its own opposite: nothing *does* therefore everything *can*. The lost home and the palimpsests of lost ancestral homes which it contains (inherited objects, paintings and books, salvages from wars and migrations which constitute my family history), haunted me when I wrote the memoir. The quest for prelapsarian fullness – what Virginia Woolf describes as the moment of oneness for nature we achieve in childhood and perhaps never again – fuels many memoir projects.

From the Talland House in Woolf's memoir 'A Sketch of the Past', to Vyra in Nabokov's *Speak, Memory*, or even to the confines of Joseph Brodsky's 'A Room and a Half', the recreation of lost dwelling places is often the main aim of a memoir writer. Whether by poeticizing its lost beauty or recreating its claustrophobia and demolishing it again in order to confirm the validity of leaving, the lost childhood home is that which endlessly asks to be reconstructed, and is offered up, impossibly, to the reader, by the act of remembering. As in Woolf's 'A Sketch', which opens with the memory of a child's cheek pressed against the maternal breast, the lost home often stands for a parent or parents lost. The work of mourning is two-fold.

My own book, *Chernobyl Strawberries*, is both a representation of a childhood home and a re-contextualization of it – its translation into Englishness. A different translation – now literally the 'carrying over' – is the process which takes place in the installation work carried out by Michael Landy in *Semi-Detached* (2004), which represented an exact to scale replica of his childhood home at 62 Kingswood Road, Ilford, in the Duveen Galleries at Tate Britain (Figure 12.2).

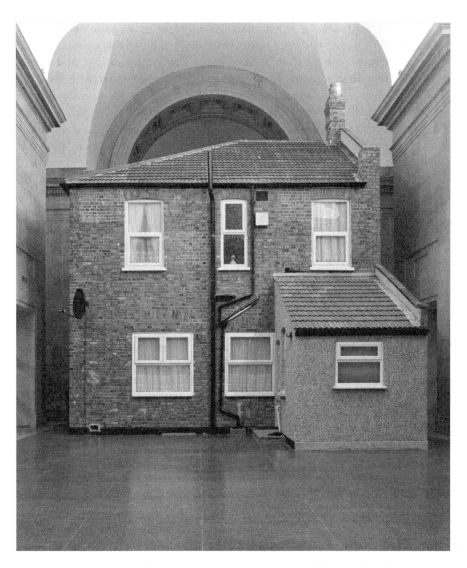

12.2 Michael Landy, *Semi-Detached*.
Installation shot at Tate Britain (back view), 2004.

It was a work precise in every last detail, right down to the pebbledash façade, PVC doors and windows, with their old Neighbourhood Watch stickers. Landy recreated his parents' house, then cut it in half, and finally separated the front and rear elevation in order to project films of the interiors of his real house to the soundtrack of his father's slightly wheezy whistling of well known ballads such as *Danny Boy*. Although its painstaking hyperrealism says a great deal about semi-detached housing in Britain, the installation is there primarily – like Bourgeois's or Woolf's work – to represent a relationship with a parent. Here, it is Landy's father, John Landy, a former tunnel miner, who retired in 1977, when Landy was 13, because of an industrial accident. The monumental, meticulous effort of recreating the house and its interior conveys the sadness of a parent's wasted life.

In 'Irony, Nostalgia and the Postmodern', Linda Hutcheon writes about the double-coding of post-modern architecture, the deliberate interplay of irony and nostalgia and the sometimes uneasy tension between the two. When people of my generation watch films like *Mamma Mia* for example, are they being nostalgic or ironical? Does irony open the floodgates of feelings which we would not otherwise permit? The startling juxtaposition of a quotation – a huge replica of a working-class home in a grand gallery – misleads us into thinking that Landy's project is ironical, but the smirk is very quickly replaced by melancholy. The specificity and the painstaking realism make the project even more symbolic. Like Borges's story about Pierre Mennard's Don Quixote (a writer who copied Don Quixote and then claimed it as his own) Landy's recreation is an act of simultaneous copying and the creation of something new. The detailed interiors and exteriors of a working-class home speak of the experience of family life in general. The coinage of illness and loss represent the universal currency: that claustrophobia and love which define the family.

Conclusion: The Performance of the Private Self

The current hegemony of the private self in autobiographical discourse is repeatedly asserted through the narratives of relationships with houses and dwellings, where houses, it soon becomes clear, stand for the people we wish to talk about: our mothers, our fathers, our spouses, our lovers. The Victorian certainties of Leslie Stephen and Sir Richard Strachey are attacked through the exposure of 22 Hyde Park Gate and 69 Lancaster Gate. The presence of a mother prematurely lost is captured in the light-filled rooms of Talland House in Woolf's 'A Sketch of the Past' and in the recreation of a tapestry workshop in Bourgeois's Cells. The richness of detail of Landy's 62 Kingswood Road only underlines the poverty and sadness of a father's life. Interiors are invoked, celebrated and contested, in a way which seems superficially self-centred and specific but which connects with universal experiences of loss and mourning.

'Nothing here reminds me of home', I write of England on the first pages of *Chernobyl Strawberries*, denying a homesickness, only to proceed to recreate a lost home inside the book. Louise Bourgeois identifies the impetus behind this kind of memorializing move: 'I re-created all the people I had left behind in France. They were huddled one against the other, and they represented all the people that I couldn't admit I missed.'[19]

We recreate our houses in order to remember our parents and we remember our parents because we will lose them.

Notes

1. Barbara Flug Colin, 'A Conversation with Louise Bourgeois', *Frigate*, 1/2 (November 2000– September 2001). http://www.frigatezine.com/essay/lives/eli02bou.html, accessed February 2012.

2. *Louise Bourgeois Retrospective Exhibition*, 10 October 2007 to 20 January 2008, Tate Modern, Room Guide – Room 8. http://www.tate.org.uk/modern/exhibitions/louisebourgeois/rooms/room08. shtm, accessed February 2012.

3. Philippe Lejeune, 'The Autobiographical Contract', in Tzvetan Todorov (ed.), *French Literary Theory Today: A Reader* (Cambridge, 1982), p. 193.

4. Scarlett Thomas, 'The Fruit of an Unusual Background', *Scotland on Sunday*, 13 March 2005. http:// www.scotsman.com/lifestyle/books/the_fruit_of_an_unusual_background_1_1388245, accessed February 2012. Quoted in Vesna Goldsworthy, *Chernobyl Strawberries* (London, 2006), back cover, paperback edition.

5. M.M. Bakhtin, *The Dialogic Imagination. Four Essays*, ed. Michael Holquist, trans. Caryl Emerson and Michael Holquist (Austin, 1981), p. 293.

6. Roland Barthes, *Camera Lucida: Reflections on Photography*, trans. Richard Howard (London, 2000), p. 84.

7. Virginia Woolf, 'Am I a Snob? (1936)', in Virginia Woolf (author) and Jeanne Schulkind (ed.), *Moments of Being: Unpublished Autobiographical Writings* (London, 2000), p. 62.

8. Ibid.

9. Christopher Lasch, *The Culture of Narcissism: American Life in an Age of Diminishing Expectations* (New York, 1991).

10. Virginia Woolf, 'Mr Bennett and Mr Brown', in S.P. Rosenbaum (ed.), *The Bloomsbury Group: A Collection of Memoirs and Commentary*, revised edition (Toronto, 1995), pp. 233–51.

11. Vesna Goldsworthy, 'The Bloomsbury Narcissus', in Victoria Rosner (ed.), *The Cambridge Companion to the Bloomsbury Group* (Cambridge, forthcoming).

12. Victoria Rosner, *Modernism and the Architecture of Private Life* (New York, 2005), p. 62.

13. Virginia Woolf, '22, Hyde Park Gate', in Woolf, *Moments of Being*, p. 42.

14. Ibid., p. 31.

15. Virginia Woolf, 'Old Bloomsbury', in Rosenbaum, *The Bloomsbury Group*, pp. 358–9.

16. Rosner, *Modernism*, p. 9.

17. Woolf, 'Old Bloomsbury', p. 367.

18. For example, in Chiara Briganti and Kathy Mezei, *Domestic Modernism, the Interwar Novel and E.H. Young* (Aldershot, 2006), p. 57.

19. *Louise Bourgeois: The Spider, the Mistress and the Tangerine. A Film by Marion Cajori and Amei Wallach*, Press Kit, p. 7. http://www.zeitgeistfilms.com/films/louisebourgeois/louisebourgeois.presskit.pdf, accessed February 2012.

Bibliography

Manuscript Sources

Birmingham Central Library Archives, Birmingham, Hutton 12 (UK).

British Library, George Lillie Craik: correspondence. Ref. Add MSS 61894–61896.

British Library, Reverend William John Loftie (1839–1911) 1875–81: Correspondence with Macmillan. Ref. Add MSS 55075.

British Library, Macmillan & Co Ltd, publishers 1833–1969: Ref. Add MSS 54786–56035, 61894–96 etc.

British Library, Morrell, Lady Ottoline, *Vol. xli. Miscellaneous notes and lists*, MS 88886/3/6.

British Library, Morrell, Lady Ottoline, *Vol. lxvii. Journal for 26 October 1925–28 May 1926*, MS 88886/4/17.

Doncaster Metropolitan Archives, Doncaster (UK), Davies Cooke of Ouston, DD.DC/H7/1/1.

Instituto Lina Bo e P.M. Bardi, São Paulo (Brazil), Sketches and drawings for *Casa de Vidro* by Lina Bo Bardi, CV023ARQ.

Norfolk County Record Office, Norwich (UK), Bolingbroke Collection, Leahes Family Papers, BOL. 2/13, 2/15.

Queensland State Archives (AUS), Item ID666183, murder file.

Somerset County Record Office, Taunton (UK), Gore Family Papers, 1521–1814, DD/GB, 148–9.

State Records Office of Western Australia (AUS), Colonial Secretary's Office, File 3371/1898.

Time Inc. Picture Collection, 001114357 (John Phillips, Elsa Schiaparelli, photographed 1937).

University of Maryland Libraries (USA), Special Collections, Morrell, Lady Ottoline, *Garsington*, 1916, LMSS 78–8.

Victoria and Albert Museum, London (UK), *E.W. Godwin Office Diaries*, 1879, AAD4/4–1980.

Victoria and Albert Museum, London (UK), *E.W. Godwin Office Diaries*, 1880, AAD4/5–1980.

Wiltshire County Record Office, Trowbridge (UK), 776/922A.

Women's Library, London (UK), Holme, Constance, *Letter to Vera Holme*, 7 March 1919, 7VJH/4/3/005.

Printed Primary Sources

'A Deep Half-Globe by Lina Bo Bardi', *Interiors*, 11 (New York: Whitney, 1953): 98–9.

'A Designer Makes her Home in Paris – in London', *Arts and Decoration* (May 1934): 38–9.

A Third Collection of Scarce and Valuable Tracts, on the Most Interesting and Entertaining Subjects: but Chiefly such as Relate to the History and Constitution of these Kingdoms. … Particularly that of the Late Lord Somers. Revised by Eminent Hands (4 vols, London, 1751).

Agatha; or, a Narrative of Recent Events. A Novel, in Three Volumes (London, 1796).

'Art at Home', *The Spectator*, 13 April 1878.

'Christmas Books: A Christmas Cake in Four Quarters', *The Times*, 25 December 1871.

'Christmas Books: Stories About', *The Times*, 23 December 1870.

'Decorator's Preview', *Vogue* (15 September 1934): 76–7.

'Display Ad 32 – no Title [Saks Fifth Avenue]', *New York Times* (7 December 1941): 33.

'French Flair', *Vogue* (1 July 1936): 72–3.

Human Vicissitudes; or, Travels into Unexplored Regions (2 vols, London, 1798).

Illustrated London News (19 April 1924): 710.

'In Brasil: a Glass *Casa* in the Air, by Lina Bo Bardi', *Interiors*, 5 (New York: Whitney, 1953): 74–83.

'Lelong Branches Out', *Vogue* (15 December 1934): 59.

Louisa Matthews. By an Eminent Lady (3 vols, London, 1793).

'Museu de Arte: Esculturas', *Habitat: Revista das Artes no Brasil*, 1 (1950): 31.

'No. 79 … To the Author of the Lounger', *The Lounger. A Periodical Paper Published at Edinburgh in the Years 1785 and 1786* (3 vols, Edinburgh, 1787).

Nobody and Somebody, with the True Chronicle History of Elydure (London, 1606).

North Queensland Register, Townsville, 25 January 1926.

'Obituary: Lady Broome', *The Times*, 7 March 1911.

Parliamentary Register, vol. 12, pp. 108–9 (11 June 1800).

'Qualifications of a Modern Maidservant', *The Wit's Magazine* (2 vols, London, 1784–5).

'Review: Station Amusements in New Zealand', *The Times* (10 October 1873).

'Review: A Year's Housekeeping in South Africa', *The Times* (20 August 1877).

'Sparks from the Paris Openings', *Vogue* (1 March 1937): 59–66.

The Adventures of a Pin, Supposed to be Related by Himself, Herself, or Itself (London, 1790).

The Complete Letter-Writer. Containing Familiar Letters on the Most Common Occasions in Life. Also a Variety of Elegant Letters for the Direction and Embellishment of Style, on Business, Duty, Amusement, Love, Courtship, Marriage, Friendship, and other Subjects (Edinburgh, 1768). http://www.archive.org/details/completeletterw00unkngoog

The Studio, 1894.

Trial of Betty the Cook-Maid, Before the Worshipful Justice Feeler, for Laying a Bed in the Morning (London, 1795).

Western Australian, 8 December 1882.

Ballard, Bettina, *In My Fashion* (New York: D. McKay Co., 1960).

Bardi, Lina Bo, 'Residência no Morumbi', *Habitat*, 10 (1953): 31–40.

Bardi, Lina Bo and Carlo Pagani, 'Tre Arredamenti degli Architetti Lina Bo e Carlo Pagani', *Stile*, 1 (January 1941): 88–103.

Bardi, Pietro Maria, "I 'pittori della domenica", *Il secolo Illustrato*, 5 August 1933.

Bardi, Pietro Maria, 'L'Antico e Noi', *Stile*, 3 (March 1941): 57–8.

Barker, Lady, *Station Life in New Zealand* (London: Macmillan, 1870).

Barker, Lady, *A Christmas Cake in Four Quarters* (London: Frederick Warne, 1871).

Barker, Lady, 'New Zealand Amusements', *Evening Hours*, vol. 2, 1872.

Barker, Lady, *Station Amusements in New Zealand* (London: William Hunt, 1873).

Barker, Lady, *First Lessons in the Principles of Cooking* (London: Macmillan, 1874).

Barker, Lady, 'Notes on Cooking', *Evening Hours*, vol. 4, 1874.

Barker, Lady, 'Houses and Housekeeping', *Evening Hours*, vol. 5, 1875.

Barker, Lady, *Houses and Housekeeping* (London: William Hunt, 1876).

Barker, Lady, 'Life in South Africa', *Evening Hours*, vol. 6, 1876.

Barker, Lady, *A Year's Housekeeping in South Africa* (London: Macmillan, 1877).

Barker, Lady, *The Bedroom and Boudoir* (London: Macmillan & Co., 1878).

Barker, Lady, *Letters to Guy* (London: Macmillan, 1885).

Bird, James Barry, *Laws Respecting Masters and Servants, Articled Clerks, Apprentices, Manufacturers, Labourers and Journeymen* (3rd edn) (London, 1799).

Broome [Barker], Lady, *Colonial Memories* (London: Smith, Elder & Co., 1904).

Burney, Fanny, *Camilla: or, a Picture of Youth. By the Author of Evelina and Cecilia. In Five Volumes* (London, 1796).

Cook, Clarence M., *House Beautiful: Essays on Beds and Tables, Stools and Candlesticks* (New York: Scribner, Armstrong and Co., 1878).

Crespigny, Mary de, *The Pavilion. A Novel. In Four Volumes* (London, 1796).

Eastlake, Charles L., *Hints on Household Taste in Furniture, Upholstery, and Other Details* (London: Longmans, Green and Co., 1868).

Garnett, David, *The Flowers of the Forest: Being Volume Two of The Golden Echo* (London: Chatto and Windus, 1955).

Garrett, Rhoda and Agnes, *Suggestions for House Decoration in Painting, Woodwork and Furniture* (London: Macmillan, 1876).

Garrett, Rhoda and Agnes, *Suggestions for House Decoration in Painting, Woodwork and Furniture* (Philadelphia: Porter & Coates, 1877).

Gathorne-Hardy, Robert (ed.), *Ottoline: The Early Memoirs of Lady Ottoline Morrell* (London: Faber and Faber, 1963).

Gathorne-Hardy, Robert (ed.), *Ottoline at Garsington: Memoirs of Lady Ottoline Morrell, 1915–1918* (London: Faber and Faber, 1974).

Genet, Jean, *The Thief's Journal* (Paris: Ed. Gallimard, 1949).

Gladstone, Mrs, *Healthy Nurseries and Bedrooms including the Lying in Room* (London: W. Clowes, 1884).

Gronniosaw, James Albert, *A Narrative of the Most Remarkable Particulars in the Life of James Albert Ukawsaw Gronniosaw, an African Prince, as Related by Himself* (Bath, Bristol and London, 1780?).

Gunning, Susannah, *Family Pictures, a Novel. Containing Curious and Interesting Memoirs of Several Persons of Fashion in W-----re. By a Lady. In Two Volumes* (Dublin, 1764).

Haweis, Mary Eliza, *The Art of Decoration* (London: Chatto and Windus, 1881).

Hays, F., *Women of the Day: A Biographical Dictionary of Notable Contemporaries* (London: Chatto & Windus, 1885).

Haywood, Eliza, *The Invisible Spy. By Explorabilis. In Two Volumes* (3rd edn) (London, 1767). http://www.archive.org/details/invisiblespy01haywiala

Huxley, Juliette, *Leaves of the Tulip Tree* (London: John Murray, 1986).

Jocelyn, J. Colonel, *The History of the Royal Artillery: Crimean Period* (London, 1911).

Johnson, Richard, *Tea-Table Dialogues, between a Governess, and Mary Sensible … and Emma Tempest* (London, 1796).

Kerr, Robert, *The Gentleman's House: Or, How to Plan English Residences, from the Parsonage to the Palace; with Tables of Accommodation and Cost, and a Series of Selected Plans* (London: J. Murray, 1864).

Kilner, Dorothy, *Life and Perambulation of a Mouse. In Two Volumes* (London, 1790).

Locke, John, *An Essay Concerning Human Understanding. In Four Books* (1689) (7th edn, London, 1715–16).

Locke, John, *Two Treatises of Government* (1689) (London: Everyman's Library, 1993). http://www.efm.bris.ac.uk/het/locke/government.pdf

Locke, John, *An Essay Concerning Human Understanding. In Four Books* (1689) (7th edn, London, 1715–16). http://oregonstate.edu/instruct/phl302/texts/locke/locke1/Essay_contents.html

Locke, John, *Some Thoughts Concerning Education* (London, 1693).

Loftie, Mrs M.J., 'The Spare Room', *The Saturday Review*, vol. XLI, April 29 1876.

Loftie, W.J., *A Plea for Art in the House* (London: Macmillan and Co., 1876).

Mackail, John William, *The Life of William Morris* (2 vols, London: Longmans, Green and Co., 1899).

O'Keeffe, John, 'The Doldrum, or, 1803', in John O'Keeffe, *The Dramatic Works of John O'Keeffe, Esq. Published under the Gracious Patronage of His Royal Highness the Prince of Wales. Prepared for the Press by the Author. In Four Volumes* (London, 1798). http://www.ebooksread.com/authors-eng/john-okeeffe.shtml

Panton, Jane Ellen, *From Kitchen to Garret* (London: Ward and Downey, 1889).

Persico, Edoardo, 'Un Teatro a Busto Arsizio', *Casabella* (June 1935): 36–43.

Pilkington, Mary, *Tales of the Cottage; or Stories, Moral and Amusing, for Young Persons. Written on the Plan of … Les Veillées du Chateau, by Madam Genlis* (London, 1799).

Ponti, Gio, 'Casa al Parco', *Domus*, 263 (1951): 28–33.

Ponti, Gio, 'La "Casa de Vidro"', *Domus*, 279 (1953): 19–26.

Ray, Man, '*L'Âge de la lumière*', *Minotaure*, 3/4 (1933): 1.

Sassoon, Siegfried, *Siegfried's Journey* (London: Faber and Faber, 1982).

Schiaparelli, Elsa, *Shocking Life* (New York: Dutton, 1954).

Showes, Mrs, *The Restless Matron. A Legendary Tale. In Three Volumes* (London, 1799).

Smythies, Miss, *The Brothers. In Two Volumes. By the Author of The Stage-Coach and Lucy Wellers* (2nd edn, 2 vols) (London and Colchester, 1759).

Smythies, Miss, *The History of a Pin, as Related by Itself. … By the Author of The Brothers*, *a Tale for Children* (London, 1798).

Spender, Stephen, *World Within World* (1951) (London: Faber, 1997).

Stevens, Geo. Alex, *A Lecture on Heads with Additions by Mr Pilon, as Delivered by Mr Charles Lee Lewes, to which is added an Essay on Satire, with Forty-Seven Heads by Nesbit, from Designs by Thurston* (London, 1812). http://www.gutenberg.org/files/21822/21822-h/21822-h.htm, accessed February 2012.

Stevenson, John James, *House Architecture* (2 vols, London: Macmillan, 1880).

Topham, Edward, *The Life of Mr Elwes, the Celebrated Miser. With Singular Anecdotes, &c* (London, 1792).

Townley, James, *High Life Below Stairs. A Farce of Two Acts. As it Is Performed at the Theatre-Royal in Drury-Lane* (London, 1759).

Turner, Walter James Redfern, *The Aesthetes: A Philosophical Dialogue* (London: Wishart & Co., 1927).

Woolf, Leonard, *Beginning Again: An Autobiography of the Years 1911–1918* (London: Hogarth Press, 1964).

Woolf, Virginia, 'Lady Ottoline Morrell', *The Times* (22 April 1938): 16.

Secondary Sources

Albini, Franco, 'Le Mie Esperienze di Architetto nelle Esposizioni in Italia e all'Estero' (Venezia, 1957), in Federico Bucci and Fulvio Irace (eds), *Zero Gravity, Franco Albini: Costruire le Modernità* (Milan: Triennale/Electa, 2006).

Amarante, Leonor, 'Um Presentão para a Cidade', *O Estado de São Paulo*, 17 September 1988.

Anelli, Renato Luiz Sobral, *Interlocuções com a Arquitetura Italiana na Constituição da Arquitetura Moderna em São Paulo*, Habilitation Thesis, University of São Paulo (São Carlos, 2001).

Anelli, Renato Luiz Sobral, 'Da Integração à Autonomia: Arte, Arquitetura e Cultura no Brasil, 1950–1980', *8th DOCOMOMO Brazil* conference (Rio de Janeiro, 2009). http://www.docomomo.org.br/seminario%208%20pdfs/086.pdf

Anelli, Renato Luiz Sobral, 'O Museu de Arte de São Paulo, o Museu Transparente e a Dessacralização da Arte', *Arquitextos*, 10.112 (2009). http://www.vitruvius.com.br/revistas/read/arquitextos/10.112/22

Anelli, Renato Luiz Sobral, 'Ponderações sobre os Relatos da Trajetória de Lina Bo Bardi na Itália', *Pós: Revista do Programa de Pós-Graduação em Arquitetura e Urbanismo da FAUUSP*, 17/27 (2010): 86–101. http://www.usp.br/fau/public/pos/27/revista_pos_27.pdf

Armstrong, Carol, *Scenes in a Library: Reading the Photograph in the Book, 1843–75* (Cambridge MA: The MIT Press, 1998).

Armstrong, Carol, 'From Clementina to Käsebier: The Photographic Attainment of the Lady Amateur', *October*, 91 (2000): 101–39.

Arnold, Dana and Joanna Sofaer (eds), *Biographies and Space: Placing the Subject in Art and Architecture* (London: Routledge, 2008).

Ashmore, Sonia and Yasuko Suga, 'Red House and Asia', *The Journal of William Morris Studies* (Winter 2006): 5–26.

Auslander, Leora, *Taste and Power: Furnishing Modern France* (Berkeley and Los Angeles: University of California Press, 1996).

Auslander, Leora, 'The Gendering of Consumer Practices in Nineteenth-Century France', in Victoria de Grazia and Ellen Furlough (eds), *The Sex of Things: Gender and Consumption in Historical Perspective* (Berkeley and Los Angeles: University of California Press, 1996).

Aynsley, Jeremy and Charlotte Grant (eds), *Imagined Interiors: Representing the Domestic Interior since the Renaissance* (London: V&A Publications, 2006).

Bachelard, Gaston, *The Poetics of Space* (1958) (Boston MA: Beacon Press, 1994).

Bailey, Margery (ed.), *Boswell's Column. Being his Seventy Contributions to the London Magazine, under the Pseudonym The Hypochondriack from 1777 to 1783* (London: William Kimber, 1951).

Bakhtin, Mikhail M., *The Dialogic Imagination. Four Essays*, ed. Michael Holquist, trans. Caryl Emerson and Michael Holquist (Austin: University of Texas Press, 1981).

Barthes, Roland, 'The Death of the Author', in Roland Barthes, *Image – Music – Text*, ed. and trans. Stephen Heath (New York: Hill and Wang, 1977).

Barthes, Roland, *Camera Lucida: Reflections on Photography* (1983), trans. Richard Howard (London: Vintage Classics, 2000).

Benjamin, Walter, *Illuminations* (New York: Schocken Books, 1969).

Benjamin, Walter, 'A Short History of Photography' (1931), reproduced in Alan Trachtenberg (ed.), *Classic Essays on Photography* (Stony Creek: Leete's Island Press, 1980).

Benjamin, Walter, 'Berlin Chronicle', in Michael Jennings, Howard Eiland and Gary Smith (eds), *Walter Benjamin: Selected Writings 1931–1934* (Harvard: Harvard University Press, 1999).

Benjamin, Walter, *Berlin Childhood around 1900 (Berliner Kindheit um Neunzehnhundert)* (Cambridge MA: Harvard University Press, 2006).

Benjamin, Walter, *The Writer of Modern Life* (Cambridge MA: Harvard University Press, 2006).

Bennett, Alan, *The Complete Talking Heads* (London: BBC/Ebury, 2007).

Bergdoll, Barry, *European Architecture, 1750–1890* (Oxford: Oxford University Press, 2000).

Blum, Dilys, *Shocking! The Art and Fashion of Elsa Schiaparelli* (Philadelphia PA: Yale University Press, in association with Philadelphia Museum of Art, 2003).

Blum, Dilys, 'Fashion and Surrealism', in Ghislaine Wood (ed.), *Surreal Things* (London: V&A Publications, 2007).

Bo Bardi, Lina (texts) and Marcelo Ferraz (ed.), *Casa de Vidro, São Paulo, Brasil, 1950–1951* (Lisbon/São Paulo: Editorial Blau, Instituto Lina Bo e P.M. Bardi, 1999).

Boehmer, Elleke, *Colonial and Postcolonial Literature* (Oxford: Oxford University Press, 1995).

Bonfanti, Ezio and Marco Porta, *Città, Museo e Architettura: Il Gruppo BBPR nella Cultura Architettonica Italiana, 1932–1970* (Florence: Vallechi, 1973).

Bosman, Anton, 'Renaissance Intertheater and the Staging of Nobody', *ELH*, 71/3 (2004): 559–85.

Braudel, Fernand, *The Structures of Everyday Life: The Limits of the Possible*, trans. Siân Reynolds (New York: Harper & Row, 1981).

Brémont, Anna, Comtesse de, *Oscar Wilde and his Mother: A Memoir* (London: Everett & Co., 1911).

Briganti, Chiara and Kathy Mezei, *Domestic Modernism, the Interwar Novel and E.H. Young* (Aldershot: Ashgate, 2006).

Bucci, Federico and Augusto Rossari (eds), *I Musei e gli Allestimenti di Franco Albini* (Milan: Mondadori/Electa, 2005).

Bucci, Federico and Fulvio Irace (eds), *Zero Gravity, Franco Albini: Costruire le Modernità* (Milan: Triennale/Electa, 2006).

Burckhardt, Jakob, *The Civilization of the Renaissance in Italy* (New York: The Modern Library, 1954).

Callan, Hilary and Shirley Ardener, *The Incorporated Wife: In the Police, Oil Companies, Armed Services, Expatriate Communities, Colonial Administrations, Oxford & Cambridge Colleges* (Beckenham, Kent: Croom Helm, 1984).

Calloway, Stephen, *Baroque Baroque: The Culture of Excess* (London: Phaidon Press, 1994).

Campello, Maria de Fátima de Mello Barreto, *Lina Bo Bardi: As Moradas da Alma*, MA Diss., University of São Paulo (São Carlos, 1997).

Canella, Guido, 'La Pittura del "Novecento" e l'Architettura', in Guido Canella (texts) and Enrico Bordogna, Enrico Prandi and Elvio Manganaro (eds), *Architetti Italiani del Novecento* (Milan: Marinotti, 2010): 33–43.

Cannadine, David, *Ornamentalism. How the British Saw Their Empire* (London: Penguin Books, 2001).

Cecil, Lord David, 'Introduction', in Carolyn G. Heilbrun (ed.), *Lady Ottoline's Album: Snapshots and Portraits of her Famous Contemporaries (and of Herself), Photographed for the Most Part by Lady Ottoline* (New York: Alfred A. Knopf, 1976).

Christmas, William J., *The Lab'ring Muse: Work, Writing and the Social Order in English Plebeian Poetry, 1730–1830* (Newark NJ: University of Delaware Press, 2001).

Clifford, Marie J., 'Helena Rubinstein's Beauty Salons, Fashion and Modernist Display', *Winterthur Portfolio*, 38/2–3 (Summer/Autumn 2003): 83–108.

Cohen, Deborah, *Household Gods: The British and their Possessions* (New Haven CT: Yale University Press, 2006).

Colin, Barbara Flug, 'A Conversation with Louise Bourgeois', *Frigate*, 1/2 (November 2000–September 2001). http://www.frigatezine.com/essay/lives/eli02bou.html, accessed February 2012.

Colomina, Beatriz, *Privacy and Publicity: Modern Architecture as Mass Media* (Cambridge MA: The MIT Press, 1994).

Cooper, Nicholas, 'Red House: Some Architectural Histories', *Architectural History*, 49 (2006): 207–21.

Crang, Mike and Nigel Thrift (eds), *Thinking Space* (London: Routledge, 2000).

Crawford, Alan and Colin Cunningham (eds), *William Morris and Architecture (Papers from the Annual Symposium of the Society of Architectural Historians of Great Britain)* (London, 1996).

Dalporto, Jeannie, 'Landscape, Labor and the Ideology of Improvement in Mary Leapor's "Crumble Hall"', *The Eighteenth Century. Theory and Interpretation*, 42/3 (2001): 228–44.

Darby, David, 'Photography, Narrative and the Landscape of Memory in Walter Benjamin's Berlin', *The Germanic Review*, 75/3 (Summer, 2000).

Di Bello, Patrizia, *Women's Albums and Photography in Victorian England: Ladies, Mothers and Flirts* (Aldershot: Ashgate, 2007).

Dinnage, Rosemary, *Alone! Alone! Lives of Some Outsider Women* (New York: New York Review of Books, 2004).

Dow Adams, Timothy, 'Introduction: Life Writing and Light Writing: Autobiography and Photography', *Modern Fiction Studies*, 40/3 (1994): 459–92.

Dow Adams, Timothy, *Light Writing & Life Writing: Photography in Autobiography* (Chapel Hill and London: University of North Carolina Press, 2000).

Doy, Gen, *Picturing the Self: Changing Views of the Subject in Visual Culture* (London and New York: I.B. Tauris and Co. Ltd, 2005).

Drew, Phillip, *The Coast Dwellers: A Radical Reappraisal of Australian Identity* (Ringwood, Victoria: Penguin Books, 1994).

Ealham, Chris, 'An Imagined Geography: Ideology, Urban Space, and Protest in the Creation of Barcelona's "Chinatown", c.1835–1936', *International Review of Social History*, 50 (2005): 373–97.

Eastlake, Charles L., *Hints on Household Taste in Furniture, Upholstery and Other Details* (London: Longmans, Green, 1868).

Edwards, Elizabeth and Janice Hart (eds), *Photographs Objects Histories: On the Materiality of Images* (London and New York: Routledge, 2004).

Elias, Norbert, *The Civilizing Process: Sociogenetic and Psychogenetic Investigations* (Malden MA: Blackwell Publishing, 2000).

Elkins, James (ed.), *Photography Theory* (London: Routledge, 2007).

Ellmann, Richard (ed.), *Artist as Critic: Critical Writings of Oscar Wilde* (New York: Random House, 1969).

Ellmann, Richard. *Oscar Wilde* (New York: Vintage Books, 1988).

Evans, Caroline, 'Masks, Mirrors and Mannequins. Elsa Schiaparelli and the Decentered Subject', *Fashion Theory*, 3/1 (March 1999): 3–32.

Evans, Robin, 'Figures, Doors and Passages', in *Translations from Drawing to Building and Other Essays* (London: Architectural Association, 1997).

Fernandes, Fernanda, 'Arquitetura no Brasil no Segunda pós-Guerra: A Síntese das Artes', in *6th DOCOMOMO Brazil Conference*, Niterói, 16–19 November, 2005. http://www.docomomo.org.br/seminario%206%20pdfs/Fernanda%20Fernandes.pdf

Ferraz, Marcelo (ed.), *Lina Bo Bardi* (São Paulo: Instituto Lina Bo e P.M. Bardi, 1994).

Ferry, Emma, 'Home and Away: Domesticity and Empire in the Work of Lady Barker', *Women's History Magazine* (Autumn 2006): 4–12.

Ferry, Emma, '"… information for the ignorant and aid for the advancing …" Macmillan's "Art at Home Series", 1876–1883', in Jeremy Aynsley and Kate Forde, *Design and the Modern Magazine* (Manchester: Manchester University Press, 2007).

Fewings, John B, 'Arcadian simplicity: J.B. Fewings memoirs of Toowong', in Rod Fisher and Brian Crozier (eds), *The Queensland House: A Roof Over Our Heads* (Brisbane: Queensland Museum, 1994).

Fisher, Rod and Brian Crozier (eds), *The Queensland House: A Roof Over Our Heads* (Brisbane: Queensland Museum, 1994).

Foakes, R.A., *Illustrations of the English Stage, 1580–1642* (Stanford CA: Stanford University Press, 1985): 94–5.

Forino, Imma, 'Living in "The Sense of the Past": Solipsistic Impulses in the Domesticscapes of Edmond de Goncourt and Mario Praz', *Interiors: Design, Architecture, Culture*, 2/1 (March 2011): 7–26.

Foucault, Michel, *Discipline and Punish: The Birth of the Prison* (New York: Random House, 1977).

Foucault, Michel, 'The Eye of Power', in Colin Gordon (ed.), *Power/Knowledge: Selected Interviews & Other Writings, 1972–1977* (New York: Pantheon Books, 1980).

Frazier, Nancy, 'Salvador Dalí's Lobsters: Feast, Phobia, and Freudian Slip', *Gastronomica*, 9/4 (Fall 2009): 16–20.

Friedman, Alice T., 'Home on the Avocado-Green Range: Notes on Suburban Decor in the 1950s', *Interiors: Design, Architecture, Culture*, 1/1–2 (2010): 45–60.

Gallo, Antonella (ed.), *Lina Bo Bardi Architetto* (Venezia: Marsilio, DPA, 2004).

Gallop, Jane, 'Observations of a Mother', in Marianne Hirsch, *The Familial Gaze* (Hanover NH: Dartmouth College, 1999).

Gameren, Dick van, 'Casa de Vidro de Lina Bo Bardi', *Arquitextos*, 01.004 (September 2000). http://www.vitruvius.com.br/revistas/read/arquitextos/01.004/980

Gere, Charlotte, *Nineteenth-Century Decoration: The Art of the Interior* (New York: Abrams, 1989).

Gibbons, Peter, 'Non-Fiction' in Terry Sturm (ed.), *The Oxford History of New Zealand Literature in English* (Auckland: Oxford University Press, 1991).

Gilderdale, Betty, *The Seven Lives of Lady Barker* (Auckland: David Bateman, 1996).

Girouard, Mark, *Sweetness and Light: The Queen Anne Movement, 1860–1900* (New Haven CT: Yale University Press, 1984).

Glancey, Jonathan, 'Edward Hollamby', *The Guardian* (Monday 24 January 2000), http://www.guardian.co.uk/news/2000/jan/24/guardianobituaries, accessed October 2012.

Goldsworthy, Vesna, *Chernobyl Strawberries* (London: Atlantic, 2005).

Goldsworthy, Vesna, 'The Bloomsbury Narcissus', in Victoria Rosner (ed.), *The Cambridge Companion to the Bloomsbury Group* (Cambridge: Cambridge University Press, forthcoming).

Goody, Jack, *The Interface between the Written and the Oral* (Cambridge: Cambridge University Press, 1987).

Green, David, 'On Foucault: Disciplinary Power and Photography', in Jessica Evans (ed.), *The Camerawork Essays: Context and Meaning in Photography* (London: Rivers Oram Press, 1997).

Haggis, Jane, 'White Women and Colonialism: Towards a Non-Recuperative History', in C. Midgley (ed.), *Gender and Imperialism* (Manchester: Manchester University Press, 1998).

Hall, Stuart, 'Cultural Identity and Diaspora', in Nicholas Mirzoeff (ed.), *Diaspora and Visual Culture: Representing Africans and Jews* (London: Routledge, 2000).

Hasluck, Alexandra, 'Lady Broome', *Western Australian Historical Society Journal*, 5/part 3 (1957): 1–16.

Hasluck, Alexandra, *Remembered with Affection* (Melbourne: Oxford University Press, 1963).

Hatt, Michael, 'Space, Surface, Self: Homosexuality and the Aesthetic Interior', *Visual Culture in Britain*, 8 (Summer 2007): 105–28.

Haverty Rugg, Linda, *Picturing Ourselves: Photography and Autobiography* (Chicago: Chicago University Press, 1997).

Hayes, Richard W., 'Objects and Interiors: Oscar Wilde', in Claire I.R. O'Mahony (ed.), *Symbolist Objects: Materiality and Subjectivity at the Fin de Siècle* (High Wycombe, Buckinghamshire: Rivendale Press, 2009).

Hirsch, Julia, *Family Photographs: Content, Meaning and Effect* (Oxford: Oxford University Press, 1981).

Hitchcock, Henry-Russell, *Architecture: Nineteenth and Twentieth Centuries* (Harmondsworth: Penguin Books, 1958).

Hollamby, Edward, *Red House. Philip Webb* (London: Phaidon Press, 1991).

Hollamby, Ted, 'The Influence of William Morris: A Personal Recollection', in Alan Crawford and Colin Cunningham (eds), *William Morris and Architecture (Papers from the Annual Symposium of the Society of Architectural Historians of Great Britain)* (London, 1996).

Holland, Merlin, 'Introduction', in Oscar Wilde, *The Complete Letters of Oscar Wilde*, ed. Merlin Holland and Rupert Hart-Davis (New York: Henry Holt, 2000).

Holland, Vyvyan, *Son of Oscar Wilde* (New York: E.P. Dutton & Company, Inc., 1954).

Hollis, Edward, '*The House of Life* and the Memory Palace: Some Thoughts on the Historiography of Interiors', *Interiors: Design, Architecture, Culture*, 1/1–2 (July 2010): 105–17.

Hyde, H. Montgomery, 'Oscar Wilde and His Architect', in *The Architectural Review*, 109 (March 1951): 175–6.

Jay, Paul, 'Posing: Autobiography and the Subject of Photography', in Kathleen Ashley, Leigh Gilmore and Gerald Peters (eds), *Autobiography and Postmodernism* (Boston: University of Massachusetts Press, 1994).

Jelinek, Estelle, *Women's Autobiography* (Bloomington: Indiana University Press, 1980).

Jennings, Michael, Howard Eiland and Gary Smith (eds), *Walter Benjamin: Selected Writings 1931–1934* (Cambridge MA: Harvard University Press, 1999).

Jobson Darroch, Sandra, *Ottoline: The Life of Lady Ottoline Morrell* (London: Chatto & Windus, 1976).

Kahan, Gerald, *George Alexander Stevens and the Lecture on Heads* (Athens GA: University of Georgia Press, 2008).

Kaplan, Rachel, *Little-Known Museums in and around Rome* (New York: Abrams, 2000).

Kidman, Fiona, 'Introduction' to Lady Barker, *Station Life in New Zealand*, reprinted with notes by Fiona Kidman (London: Virago Press, 1984).

Kirkham, Pat, 'Dress, Dance, Dreams, and Desire: Fashion and Fantasy in *Dance Hall*', *Journal of Design History*, 8/3 (1995): 195–214.

Kohl, Norbert, *Oscar Wilde: The Works of a Conformist Rebel*, trans. David Henry Wilson (Cambridge: Cambridge University Press, 1989).

Krauss, Rosalind E., 'A Note on Photography and the Simulacral', *October*, 31 (Winter 1984): 49–68.

Lasch, Christopher, *The Culture of Narcissism: American Life in an Age of Diminishing Expectations* (New York: W.W. Norton & Company, 1991).

Lawson, Henry, *Australian Classics: While the Billy Boils. 87 Stories from the Prose Work of Henry Lawson* (Windsor: Budget Books, 1979).

Le Corbusier, 'Le Tendenze dell'Architettura Razionalista', in Fondazione Alessandro Volta, *Convegno di Arti: Rapporti dell'Architettura con le Arti Figurative* (Roma: Reale Accademia d'Italia, 1937).

Le Corbusier, 'A Arquitetura e as Belas-Artes', trans. Lucio Costa, *Revista do Patrimônio Histórico e Artístico Nacional*, 19 (1984): 53–68.

Leapor, Mary, '*Poems upon Several Occasions*' (two volumes, 1748 and 1751), in Richard Greene and Ann Messenger (eds), *The Works of Mary Leapor* (Oxford: Oxford University Press, 2003).

Lejeune, Phillippe, 'The Autobiographical Contract', in Tzvetan Todorov (ed.), *French Literary Theory Today: A Reader* (Cambridge: Cambridge University Press, 1982).

Lima, Zeuler, 'The Faces of Janus: Modernism and Hybridization in the Architecture of Lina Bo Bardi', *Journal of Architecture*, 11/2 (2006): 257–67.

Lima, Zeuler, *Verso un'Architettura Semplice* (Roma: Fondazione Bruno Zevi, 2007).

Locke, John, *Two Treatises of Government* (1689) (London: Dent, 1993).

Lorenzi, Angelo, 'Tre Interni Milanesi di Ignazio Gardella', in Maria Cristina Loi and Raffaella Neri (eds), *Anatomia di un Edificio* (Naples: Clean Edizioni, forthcoming).

Luca, Ioana, 'Post-Communist Life Writing and the Discourses of History: Vesna Goldsworthy's *Chernobyl Strawberries*', *Rethinking History*, 13/1 (2009): 79–93.

MacCarthy, Fiona, *William Morris* (London: Faber and Faber, 1994).

Macdonald, Jean, 'Red House after Morris', *The William Morris Society Newsletter* (Winter 2004): 6–10.

Marsh, Jan, *Bloomsbury Women: Distinct Figures in Life and Art* (London: Pavilion Books, 1995).

Marsh, Jan, *William Morris and Red House* (Great Britain: National Trust Books, 2005).

Martin, Richard, *Fashion and Surrealism* (New York: Rizzoli, 1987).

Martin-Vivier, Pierre-Emmanuel, *Jean-Michel Frank: L'Étrange Luxe du Rien* (Paris: Norma, 2006).

Massey, Anne, *Hollywood Beyond the Screen: Design and Material Culture* (Oxford: Berg, 2000).

Mavor, Carol, *Becoming: The Photographs of Clementina, Viscountess Hawarden* (Durham NC: Duke University Press, 1999).

Maxwell, Anne, *Colonial Photography and Exhibitions: Representations of the 'Native' People and the Making of European Identities* (London: Leicester University Press, 1999).

McKellar, Susie and Penny Sparke (eds), *Interior Design and Identity* (Manchester: Manchester University Press, 2004).

Meskimmon, Marsha, *The Art of Reflection: Women Artists' Self-Portraiture in the Twentieth Century* (New York and Chichester: Columbia University Press, 1996).

Meyer, Esther Da Costa, 'After the Flood: Lina Bo Bardi's Glass House', *Harvard Design Magazine*, 16 (2002): 4–13.

Mills, Sara, *Gender and Colonial Space* (Manchester: Manchester University Press, 2005).

Miotto, Laura and Savini Nicolini *Lina Bo Bardi: Aprirsi all'Accadimento* (Torino: Testo & Immagine, 1998).

Moran, Maureen, 'Walter Pater's House Beautiful and the Psychology of Self-Culture', *English Literature in Transition, 1880–1920*, 50/3 (2007): 291–312.

Morris, Bede, *Images: Illusion and Reality* (Canberra: Australian Academy of Science, 1986).

Munby, Alan Noel Latimer (ed.), *Sale Catalogues of Libraries of Eminent Persons*, vol. 1 (London: Mansell Information/Publishing Ltd, 1971).

Muncey, Tessa, *Creating Autoethnographies* (London: Sage, 2010).

Muthesius, Hermann, *The English House*, trans. Janet Seligman (London: Crosby Lockwood Staples, 1979).

Myzelev, Alla and John Potvin (eds), *Fashion, Interior Design and the Contours of Modern Identity* (Aldershot: Ashgate, 2010).

Oliveira, Olívia de, *Hacia Lina Bo Bardi*, MS Diss., Universidad Politecnica de Cataluña (Barcelona, 1994).

Oliveira, Olívia de, 'Quarto do Arquiteto: Lina Bo Bardi e a História', *Óculum*, 5–6 (1995): 82–7.

Oliveira, Olívia de and Marcelo Ferraz, 'Lina bo Bardi: Architetture senza Età e senza Tempo', *Casabella*, 64/681 (2000): 36–55.

Oliveira, Olívia de, 'Lina Bo Bardi: Obra Construída', *2G*, 23/24 (2002).

Oliveira, Olívia de, *The Architecture of Lina Bo Bardi: Subtle Substances* (São Paulo/Barcelona: Romano Guerra/Gustavo Gili, 2006).

Parejo Vadillo, Ana, 'Aestheticism "At Home" in London: A. Mary Robinson and the Aesthetic Sect', in Gail Cunningham and Stephen Barber (eds), *London Eyes: Reflections in Text and Image* (New York: Berghahn Books, 2007).

Pater, Walter, *The Renaissance: Studies in Art and Poetry* (Oxford: Oxford University Press, 1986).

Pereira, Juliano Aparecido, *Lina Bo Bardi: Bahia, 1958–1964* (Uberlândia: EDUFU, 2008).

Phillips, John, *Free Spirit in a Troubled World* (Zurich and New York: Scalo, 1996).

Pinson, Stephen, 'Trompe l'oeil: Photography's Illusion Reconsidered', *Nineteenth-Century Art Worldwide: A Journal of Nineteenth-Century Visual Culture*, 1/1 (2003). http://www.19thc-artworldwide.org/index.php/spring02/195-trompe-loeil-photographys-illusion-reconsidered

Pommer, Richard and Christian Otto, *Weissenhof 1927 and the Modern Movement in Architecture* (Chicago: University of Chicago Press, 1991).

Ponti, Gio, 'Considerazioni sulla pittura murale', *Domus*, 134 (1939): 37.

Popkin, Jeremy, *History, Historians and Autobiography* (Chicago: University of Chicago Press, 2005).

Potvin, John (ed.), *The Places and Spaces of Fashion, 1800–2007* (New York: Routledge, 2009).

Praz, Mario, 'An Empire Flat in a Roman Palace', *Decoration*, no. 25, new series (June 1937): 11–15.

Praz, Mario, *Studies in Seventeenth-Century Imagery* (vol. 1 1939 and vol. 2 1947) (London: The Warburg Institute, 1939–1947 [revised edn, 1964–74]).

Praz, Mario, *The House of Life*, trans. Angus Davidson (New York: Oxford University Press, 1964).

Praz, Mario, 'Genre Painting and the Novel', in Mario Praz, *The Hero in Eclipse in Victorian Fiction*, trans. Angus Davidson (London and New York: Oxford University Press, 1969).

Praz, Mario, *On Neoclassicism*, trans. Angus Davidson (Evanston IL: Northwestern University Press, 1969).

Praz, Mario, *Conversation Pieces: A Survey of the Informal Group Portrait in Europe and America* (University Park PA: Pennsylvania State University Press, 1971).

Praz, Mario, *The Romantic Agony* (1930) (Oxford: Oxford University Press, 1978).

Praz, Mario, *An Illustrated History of Interior Decoration: From Pompeii to Art Nouveau*, trans. William Weaver (New York: Thames and Hudson, 1982).

Ray, Man, *Photographs by Man Ray: 105 Works, 1920–1934* (New York: Dover, 1979).

Reade, Aleyn Lyell, *Johnsonian Gleanings. Part II. Francis Barber, the Doctor's Negro Servant* (London: printed privately, 1952).

Rebello, Cristiane Maria Nascimento, *A Diana Adormecida do Museu de Arte de São Paulo: Um Caso da Estatuária Barroca*, MA Diss., Universidade Estadual de Campinas (Campinas, 1994). http://www.bibliotecadigital.unicamp.br/document/?code=000082039&fd=y

Reid, Aileen, '7 Hammersmith Terrace, London', *The Decorative Arts Society Journal*, 28 (2004): 184–203.

Rice, Charles, *The Emergence of the Interior: Architecture, Modernity, Domesticity* (London: Routledge, 2007).

Riffaterre, Michael, *Semiotics of Poetry* (Bloomington: Indiana University Press, 1984).

Rilke, Rainer Maria, *Letters of Rainer Maria Rilke* (vol. 2, 1910–1926) (New York: Norton, 1947).

Risério, Antonio, *Avant-garde na Bahia* (São Paulo: Instituto Lina Bo e P.M. Bardi, 1995).

Rizzo, Betty, 'The Patron as Poet Maker: the Politics of Benefaction', *Studies in Eighteenth-century Culture*, 20 (1990): 241–66.

Roiphe, Kate, *Uncommon Arrangements: Seven Portraits of Married Life in London Literary Circles, 1910–1939* (New York: The Dial Press, 2007).

Rosazza-Ferraris, Patrizia (ed.), *Museo Mario Praz: Inventario Topografico delle Opera Esposte* (Rome: Edizioni di Storia e Letteratura, 2008).

Rosner, Victoria, *Modernism and the Architecture of Private Life* (New York: Columbia University Press, 2005).

Rusconi, Paolo, 'Le Riviste Popolari Illustrate di Rizzoli (1931–1934)', in Raffaele Berti e Irene Piazzoni (eds), *Forme e Modelli del Rotocalco Italiano tra Fascismo e Guerra, Quaderni di Acme*, 115 (2009): 527–73.

Sabatino, Michelangelo, 'Spaces of Criticism: Exhibitions and the Vernacular in Italian Modernism', *Journal of Architectural Education*, 3 (2009): 35–52.

Santos, Cecília Rodrigues dos, 'A Arquitetura e as Artes Menores', *8ᵗʰ DOCOMOMO Brazil Conference: Cidade Moderna e Contemporânea: Síntese e Paradoxo das Artes*, Rio de Janeiro, 1–4 September, 2009. http://www.docomomo.org.br/seminario%20 8%20pdfs/003.pdf

Sartre, Jean-Paul, *Being and Nothingness: An Essay on Phenomenological Ontology* (1943), trans. Hazel E. Barnes (London: Methuen, 1966).

Schaffer, Kay, *Women and the Bush: Forces of Desire in the Australian Cultural Tradition* (Cambridge: Cambridge University Press, 1988).

Sekula, Allan, 'The Body and the Archive', *October*, 39 (Winter 1986): 3–64.

Selzer, Anita, *Governor's Wives in Colonial Australia* (Canberra: National Library of Australia, 2002).

Sennet, Richard, *The Fall of Public Man* (New York: Norton, 1977).

Seymour, Miranda, *Ottoline Morrell: Life on the Grand Scale* (London: Hodder and Stoughton, 1998).

Sidlauskas, Susan, 'Psyche and Sympathy: Staging Interiority in the Early Modern Home', in Christopher Reed (ed.), *Not At Home: The Suppression of Domesticity in Modern Art and Architecture* (London: Thames and Hudson, 1996).

Sironi, Mario, 'Pittura murale', *Il Popolo d'Italia* (1 January 1932).

Smith, Lindsay, *The Politics of Focus* (Manchester: Manchester University Press, 1998).

Smith, Shawn Michelle, *American Archives: Gender, Race and Class in Visual Culture* (Princeton NJ: Princeton University Press, 1999).

Smith, Sidonie, 'Identity's Body', in Kathleen Ashley, Leigh Gilmore, and Gerald Peters (eds), *Autobiography and Postmodernism* (Amherst: University of Massachusetts Press, 1994).

Soros, Susan Weber, 'E.W. Godwin and Interior Design', in Susan Weber Soros (ed.), *E.W. Godwin: Aesthetic Movement Architect and Designer* (New Haven CT: Yale University Press, 1999).

Sparke, Penny, *As Long As It's Pink: The Sexual Politics of Taste* (London: Pandora, 1995).

Steedman, Carolyn, *Landscape for a Good Woman* (London: Virago, 1986).

Steedman, Carolyn, 'The Servant's Labour: The Business of Life, England 1760–1820', *Social History*, 29/1 (2004): 1–29.

Steedman, Carolyn, 'Poetical Maids and Cooks Who Wrote', *Eighteenth-Century Studies*, 39/1 (2005): 1–27.

Steedman, Carolyn, 'Sights Unseen, Cries Unheard: Writing the Eighteenth-Century Metropolis', *Representations*, 118 (Spring 2012).

Stoler, Anne, *Race and the Education of Desire: Foucault's History of Sexuality and the Colonial Order of Things* (Durham NC: Duke University Press, 1995).

Strachey, Lytton, *Eminent Victorians* (London: Penguin Books, 1986).

Suzuki, Marcelo (ed.), *Tempos de Grossura*: *O Design no Impasse* (São Paulo: Instituto Lina Bo e P.M. Bardi, 1994).

Suzuki, Marcelo, 'Lina e Lucio', PhD Diss. University of São Paulo (São Carlos, 2010). http://www.teses.usp.br/teses/disponiveis/18/18142/tde-05012011-151425/pt-br.php

Tagg, John, *The Burden of Representation: Essays on Photographies and Histories* (Minneapolis: University of Minnesota Press, 1988).

Tentori, Francesco, *P.M. Bardi: Con le Cronache Artistiche de 'L'Ambrosiano', 1930–1933* (Milan: Mazzotta, 1990).

Tentori, Francesco, *Pietro Maria Bardi: Primo Attore del Razionalismo* (Torino: Testo & Immagine, 2002).

Thornton, Peter, *Authentic Décor: The Domestic Interior, 1620–1920* (New York: Viking, 1984).

Todorov, Tzvetan (ed.), *French Literary Theory Today: A Reader* (Cambridge: Cambridge University Press, 1982).

Troy, Nancy, *Couture Culture: A Study in Modern Art and Fashion* (Cambridge MA: The MIT Press, 2003).

Uglow, Jenny, *Hogarth. A Life and a World* (London: Faber & Faber, 1997).

Vallance, Aymer, *The Life and Work of William Morris* (London: Studio Editions, 1986 [1897]).

Veikos, Catherine, 'To Enter the Work: Ambient Art', *Journal of Architectural Education*, 59/4 (2006): 71–80.

Vickery, Amanda, *Behind Closed Doors: At Home in Georgian England* (New Haven CT and London: Yale University Press, 2009).

Vitale, Daniele, 'La Ciudad, el Museo, la Colección', in Aa.Vv., *El Museo* (Sevilla, Colegio Oficial de Arquitectos de Andalucía Occidental, 1990): 330–47.

Wainwright, Clive, *The Romantic Interior* (New Haven CT and London: Yale University Press, 1989).

Watkin, David, 'The Psychology of the Interior View', in *Inside Out: Historic Watercolour Drawings, Oil Sketches, and Paintings of Interiors and Exteriors, 1770–1870* (London: Charles Plante; Stair & Co. Ltd, 2000).

Watt, Judith 'The Lonely Princess of Bohemia', *The Guardian Weekend Magazine* (18 November 2000): 29–35.

Wattie, Nelson, 'An English Lady in the Untamed Mountains: Lady Barker in New Zealand', in K. Gross and W. Klooss, *English Literature of the Dominions: Writings on Australia, Canada and New Zealand* (Würzburg: Königshausen & Neumann, 1981).

Wevers, Lydia, 'The Short Story', in Terry Sturm (ed.), *The Oxford History of New Zealand Literature in English* (Auckland: Oxford University Press, 1991).

White, Edmund, *Genet: A Biography* (New York: Alfred A. Knopf, 1993).

White, Palmer, *Elsa Schiaparelli: Empress of Paris Fashion* (London: Aurum, 1995).

Whitlock, Gillian, 'A "White Souled State" Across the "South" with Lady Barker', in Kate Darian-Smith, Liz Gunner, and Sarah Nuttall (eds), *Text, Theory, Space: Land, Literature and History in South Africa and Australia* (London: Routledge, 1996).

Wild, Tessa, 'More a Poem than a House', *Apollo: The International Magazine for Collectors* (April 2006).

Wilde, Oscar, 'The Decay of Lying: An Observation', in Richard Ellmann (ed.), *Artist as Critic: Critical Writings of Oscar Wilde* (New York: Random House, 1969).

Wilde, Oscar, *The Complete Letters of Oscar Wilde*, ed. Merlin Holland and Rupert Hart-Davis (New York: Henry Holt, 2000).

Wilson, Edmund, 'The Genie of the Via Giulia', *The New Yorker*, 41 (20 February 1965): 152.

Wodzicka, Helen, 'The Emery Walker photographs at St Brides', *The Journal of the William Morris Society* 2/4 (1970): 26.

Womack, Peter, 'Nobody, Somebody, and King Lear', *New Theatre Quarterly*, 23 (2007): 195–207.

Woolf, Virginia, 'Mr Bennett and Mr Brown', in S.P. Rosenbaum, ed., *The Bloomsbury Group: A Collection of Memoirs and Commentary*, revised edition (Toronto: University of Toronto Press, 1995).

Woolf, Virginia, 'Old Bloomsbury', in S.P. Rosenbaum, ed., *The Bloomsbury Group: A Collection of Memoirs and Commentary*, revised edition (Toronto: University of Toronto Press, 1995).

Woolf, Virginia, 'Am I a Snob?', in Virginia Woolf (author) and Jeanne Schulkind (ed.), *Moments of Being: Unpublished Autobiographical Writings* (London: Pimlico, 2000).

Woolf, Virginia, '22, Hyde Park Gate', in Virginia Woolf (author) and Jeanne Schulkind (ed.), *Moments of Being: Unpublished Autobiographical Writings* (London: Pimlico, 2000).

Young, Linda, *Middle-Class Culture in Nineteenth Century America, Australia and Britain* (New York: Palgrave Macmillan, 2003).

Zollinger, Carla, 'Lina Bo Bardi. 1951: Casa de Vidro, 1964: "Niente Vetri"' (Pavilhão e Recinto: O Desenvolvimento de Dois Tipos)', *Arquitextos*, 07.082 (March 2007). http://w.vitruvius.com.br/revistas/read/arquitextos/07.082/265

Internet Sources

Emery Walker House: www.emerywalker.org.uk

FamilySearch™ International Genealogical Index: Familysearch.org

Group show 'Dream Landings', Lydia Maria Julien, artist's statement: http://www. watfordjunction.org.uk/page_id__69_path__0p12p20p.aspx

Group show 'Dream Landings', interview with curator Jolanta Jagiello: http://www. watfordjunction.org.uk/page_id__43_path__0p3p19p.aspx

Louise Bourgeois: The Spider, the Mistress and the Tangerine. A Film by Marion Cajori and Amei Wallach, Press Kit, p. 7. http://www.zeitgeistfilms.com/films/louisebourgeois/ louisebourgeois.presskit.pdf, accessed February 2012.

Lydia Maria Julien's contribution to the Market Estate Project, Islington, 2010: www. marketestateproject.com

Malouf, David, 'The Making of Australian Consciousness', in *The Boyer Lectures* (Sydney, 1988). First broadcast 22 November 1988. http://www.abc.net.au/ radionational/programs/boyerlectures/lecture-2-a-complex-fate/3460262

National Trust's Red House: http://www.nationaltrust.org.uk/red-house/ Project's website of the group show 'Dream Landings' supported by Arts and Business East and the John Lewis Partnership Watford in 2006: http://www.watfordjunction.org. uk and http://www.watfordjunction.org.uk/page_id__43_path__0p3p19p.aspx

'Remarkable and Curious Conversations' at: http://www.remarkablecurious.co.uk/ lydia-maria-julien.html

Interviews

Barbara Penner and Charles Rice, interview with Edward Hollamby at Red House, Bexleyheath, 1 December 1999.

Harriet Riches, interview with the artist Lydia Maria Julien at Rollo Contemporary Art, London, February 2010.

Index

References to illustrations are in **bold**